D1547134

The End of Cinema?

FILM AND CULTURE SERIES

Film and Culture
A series of Columbia University Press
Edited by John Belton

For the list of titles in this series, see page 241.

The End of Cinema?

A Medium in Crisis in the Digital Age

André Gaudreault and Philippe Marion

TRANSLATED BY TIMOTHY BARNARD

Columbia University Press *New York*

Columbia University Press
Publishers Since 1893
New York Chichester, West Sussex
cup.columbia.edu
Adapted from *La fin du cinéma: Un média en crise à l'ère du numérique*
Copyright © Armand Colin, Paris, 2013, first edition. ARMAND-COLIN is a trademark of
DUNOD Éditeur—5, rue Laromiguière—75005 PARIS
Translation © 2015 Columbia University Press

French Voices Logo designed by Serge Bloch

*This work, published as part of a program providing publication assistance, received
financial support from the French Ministry of Foreign Affairs, the Cultural Services of the
French Embassy in the United States, and FACE (French American Cultural Exchange).*

Library of Congress Cataloging-in-Publication Data

Gaudreault, André.
 [Fin du cinéma? English]
 The end of cinema? : a medium in crisis in the digital age / André Gaudreault and
Philippe Marion ; translated by Timothy Barnard.
 pages cm. — (Film and culture)
 "Adapted from *La fin du cinéma: Un média en crise à l'ère du numérique* . . . Armand Colin,
Paris, 2013, first edition."
 Includes bibliographical references and index.
 ISBN 978-0-231-17356-8 (cloth : alk. paper) — ISBN 978-0-231-17357-5 (pbk. : alk. paper)
— ISBN 978-0-231-53938-8 (ebook)
 1. Motion pictures—Philosophy. 2. Motion pictures—Technological innovations.
 3. Motion pictures—Social aspects. 4. Digital media. I. Marion, Philippe. II. Title.

 PN1995.G335 2015
 791.4301—dc23

 2014034184

Columbia University Press books are printed on permanent and durable acid-free paper.
This book is printed on paper with recycled content.
Printed in the United States of America

c 10 9 8 7 6 5 4 3 2 1

COVER DESIGN: Catherine Casalino

References to websites (URLs) were accurate at the time of writing. Neither the author nor
Columbia University Press is responsible for URLs that may have expired or changed since the
manuscript was prepared.

For Sylvie
For Grégoire

For Catherine, Julien, and Sébastien

Contents

Preface ix

Introduction The End of Cinema? 1

One Cinema Is Not What It Used to Be 13

Two Digitalizing Cinema from Top to Bottom 41

Three A Brief Phenomenology of "Digitalized" Cinema 63

Four From Shooting to Filming: The *Aufhebung* Effect 84

Five A Medium Is Always Born Twice . . . 104

Six New Variants of the Moving Image 127

Seven "Animage" and the New Visual Culture 152

Conclusion A Medium in Crisis in the Digital Age 177

Notes 189
Acknowledgments 219
Selected Bibliography 221
Index 233

Preface

This two-headed, four-handed volume is the fruit of extended and sustained collaboration between two scholars who, since 1992, and despite the ocean separating them, have been in the habit of collaborating on joint conference presentations and publications and cherished the idea of writing this book for at least five years. The text is the product of a true labor of coauthorship, which explains why the process took some time; it is also the product of a complete rewriting, even if it contains a few passages from a previously published work.[1]

This book is also the authors' first contribution to TECHNÈS, a new international initiative that since 2012 has joined the efforts of three French-language university research groups, each of which is associated with a film archive and film school.[2] TECHNÈS researchers are especially interested in periods whose technological innovations are of such intensity that they call into question cinema's identity as a medium. First and foremost among these are the time when moving image recording technologies were invented in the late nineteenth century and the time when sound film technologies were introduced in the late 1920s and early 1930s. Another such period was when the hegemony of the photochemical was upset in the 1950s with the advent of television as a mass medium, such as the advent of the "digital revolution" that has beset us since the early 1990s and whose shocks and aftershocks we are still in the process of absorbing. TECHNÈS members intend to carry out extensive

research into the connections between film aesthetics and technology, film forms and practices, and conceptions of cinema and cinematic hardware during these periods of technological turbulence through both diachronic and synchronic analysis of these periods of instability, when cinema underwent profound changes. This international research effort seeks not only to better understand the repercussions of the technological innovations that shook up cinema's identity, but also to grasp the very manner in which cinema was conceived in a given era. *The End of Cinema?* is a first step in this direction.

On the Quebec side, this volume was written under the aegis of GRAFICS (Groupe de recherche sur l'avènement et la formation des institutions cinématographique et scénique) at the Université de Montréal, which receives funding from the Social Sciences and Humanities Research Council of Canada and the Fonds de recherche du Québec—Société et culture. GRAFICS is part of the Centre de recherches intermédiales sur les arts, les lettres et les techniques (CRIalt). André Gaudreault also thanks the John Simon Guggenheim Memorial Foundation, which made it possible for him to complete the research that culminated in the publication of this volume. On the Belgian side, the thinking and research that went into writing the present volume took place under the aegis of the Observatoire du récit médiatique (ORM) at the Université catholique de Louvain.

Our book is accompanied by a Web site designed for readers who wish to find out more; there they will find more detailed information, digressions, and supplementary bibliographical references, as well as information that would be difficult or impossible to include in a bound book (hypertext links, videos, e-mail screen captures, etc.). This site, hosted by GRAFICS, can be found at www.theendofcinema.com, and the additional material in question is indicated in the notes by the remark "Find out more." We should point out, however, that this book has been conceived as an autonomous entity, something we hope will reassure readers who are not tempted to venture beyond its covers.

The End of Cinema?

Introduction

The End of Cinema?

Thirty-five years of silent cinema is gone, no one looks at it anymore. This will happen to the rest of cinema. *Cinema is dead.*
PETER GREENAWAY, QUOTED IN CLIFFORD COONAN, "GREENAWAY ANNOUNCES THE DEATH OF CINEMA—AND BLAMES THE REMOTE-CONTROL ZAPPER," 2007

Cinema . . . is more alive than ever, more multi-faceted, more abundant, more omnipresent than it has ever been.
PHILIPPE DUBOIS, "PRÉSENTATION," *EXTENDED CINEMA/LE CINÉMA GAGNE DU TERRAIN*, 2010

The two quotations forming an epigraph to this introduction appear to advance contradictory theses. Paradoxically, that is not the case. For, as the saying goes, there is death and then there is death. Thus it is not really cinema-as-a-medium whose death the British film-maker Peter Greenaway is observing, but rather a form of cinema, the form that dominated the twentieth century: *classical narrative cinema* (or something like it). This form of cinema involves plunging a passive viewer into the darkness of a "traditional" movie theater. What Greenaway is lashing out at is something he describes as "old fashioned ideas of a narrative, sit in the dark, Hollywood centered narrative bookshop cinema."[1]

For Greenaway, then, cinema-as-a-medium is not dead, but because its dominant *form* is dead (or in the process of dying), one should not use the word *cinema* to describe the new *form* that has appeared or the *medium* in which it has appeared: "All the new languages will certainly be soon giving us, I won't say cinema because I think we have to find a new name for it, but cinematic experiences."[2]

On the other side of the fence sits Philippe Dubois who, in the other statement quoted above, is concerned with cinema-as-a-medium: because moving images are now found in new media,

travel across new platforms, are watched on new screens, and are shown in new spaces, we should conclude that cinema is proliferating and is now everywhere—hence the corollary "Cinema is more alive than ever, more multi-faceted, more abundant, more omnipresent than it has ever been." We can see that for Dubois, who would undoubtedly agree with Greenaway about the death of cinema's classical form, any moving image, whatever its *form*, is fully a part of the medium cinema. Cinema is not just films consumed in dark movie theaters, but a medium whose name there is absolutely no point in changing: "Cinema is not in the process of regressing, or disappearing, of being consigned to oblivion. Rather, with the increasingly boundless diversity of its forms and practices, it is more alive than ever, more multi-faceted, more abundant, more omnipresent than it has ever been."[3]

Ever since digital technology arrived and turned their ways and customs topsy-turvy, the various interested parties (producers, technicians, distributors, exhibitors, viewers, teachers, scholars, etc.) have been wondering what is happening to cinema. In this age of media hybridity, cinema-as-a-medium has been called on to share with other media the same screens and the same platforms that, not that long ago, were foreign to it, or simply did not exist. The result is that today, more often than not, the word *cinema* is something that has to be handled with kid gloves.

What Remains of Cinema?

For the past few years the media world in which we live has been going through an unprecedented degree of turbulence. Lines are moving, boundaries are constantly shifting, and the classical media have lost many of their bearings. Lately, we here on planet cinema have begun to feel a little hemmed in. What remains of cinema in what cinema is in the process of becoming? Or rather: what remains of *what we thought*, just yesterday, *cinema was* in what cinema is in the process of becoming?

The crisis brought about by the emergence of digital media is not the first upheaval to rock the cinematic realm. It must be said and repeated over and over, tirelessly: *cinema's entire history has been*

punctuated by moments when its media identity has been radically called into question. What people have called "cinema" for over a century has seen a series of technological mutations throughout its history.[4] Whether when sound arrived or widescreen formats were introduced, to mention just those two examples, every new technology has, in its own way, gradually and lastingly turned upside down the way in which films are produced and distributed, along with their reception by viewers. Today this other technological mutation widely known as the "digital revolution" is bringing enormous changes to the institution of cinema in turn. From production to preservation by way of distribution and projection, digital technologies are gradually taking over and established practices are losing ground. Take the so-called "movie" theater, which, because of digital technology, is now open to exhibiting sporting and musical events (usually live) and transmissions of "living performances," as they call them in France. This situation is at the very least paradoxical, because on the one hand cinema is seeing its modes of expression (let's describe them in this way) spread into other "audiovisual" practices ("audiovisual" in scare quotes because the term does not always have the same connotations and the same value for everyone everywhere), whereas on the other hand it is losing its hegemony in the very place, the movie theater, that for the longest time had been dedicated to it alone.

The list of upheavals brought about by the shift to digital media is long and the process far from over. As the American scholar John Belton reports in a special issue he edited of the influential journal *Film History*, entitled "Digital Cinema," news reports in the United States in 2012 (meaning just yesterday) recounted three major events, each of which hit home:[5]

- the Eastman Kodak company filed for bankruptcy;
- Panavision and Arriflex 35-mm movie cameras went out of production;
- the major American distributors announced that in 2013 they would cease all 35-mm film distribution.

The wane of 35-mm film, long foretold but not easy to imagine, *has thus now become a cold, hard reality.*

Despite everything, in the eyes of Belton and the contributors to this issue of *Film History*, the *emergence of digital media* is no way a *revolution*, contrary to the arguments of digital cinema's proponents, such as George Lucas, James Cameron, and Robert Zemeckis.

We might say that with this recent publication Belton is simply continuing on a course he had already mapped out earlier: In 2002, he published an article with the provocative title "Digital Cinema: A False Revolution." This article contained a good many paradoxes, as one alert reader pointed out:[6]

> [Belton] stays fairly focused throughout. Interestingly, he refutes digital cinema as a revolution but refers to it as a revolution. This may not have been completely intentional, but perhaps it reflects the controversial nature of this issue. There is no general consensus on whether digital cinema was in fact a revolution. Being revolutionary would imply great change and reform. In many cases this is true of digital cinema, but it has not, and hopefully will not, become the only option.[7]

This "revolution/false revolution" debate is not just semantic in nature, because it raises a number of fundamental questions. One of the arguments used by some of the journal's contributors to deny revolutionary status to the new technology is the fact that digital cinema restricts itself to *imitating* the results achieved for ages by celluloid cinema. Thus Gregory Zinman, Belton comments, goes so far as to argue that "digital cinema does not constitute a radical break with 'older forms of the moving image.'"[8] As always, one's view of the situation depends on which end of the telescope one is looking through. To say that there has been no radical break between older forms and digital cinema one has to know how to play with nuance and employ a touch of rhetoric. Consider for example the case of images produced using motion capture technology, one of the modes of digital "recording": it is difficult to assert that there has been no major rupture with older forms. It is true, however, as Zinman and Belton argue, that the emergence of digital technology has not brought about a rupture as radical as that introduced by the talkie "revolution," which was founded on a new technology and moreover

met resistance in certain quarters. In the end, "silent" cinema and "the talkies" are two forms so different from one another that we might ask ourselves whether they belong to the same "species."

The More Things Change, the More They Stay the Same

Nevertheless, we must acknowledge that, even if many things are changing with the shift to digital media, many other things appear not to have budged, if only because a film's "digital fingerprint" is not easily perceived by moviegoers. In the end, the shift to digital media is more of a turn than a revolution. A car making a turn certainly changes direction (this is a principle of discontinuity). But the car-before-the-turn nevertheless remains the same (this is a principle of continuity). But what would happen if, as in a James Bond movie, the car began to fly? Would it become a *flying car*? Or an *airplane*? What happens if it suddenly skims across or goes under water? Would it become a *floating car*? Or, rather, a *boat*? Would it become a *submersible car*? Or a *submarine*? When it observes a certain number of continuity principles alongside the irruption of a large number of discontinuities, what becomes of the car's identity? Does some unshakable quality persist?

What we thus need to know is whether cinema, in its shift to the digital, has simply made a turn (in which case we could speak of a *digital turn*) or whether it is in the process of becoming something else—whether it is undergoing a true *mutation* (in which case we could speak of a *digital mutation*). Apart from rhetorical problems alone, opinion is divided on these questions. An editorial in the magazine *Cahiers du cinéma*, for example, remarks that "We must not forget that digital projection is *also* projection. In this sense, there is nothing new under the sun."[9] Despite the seeming discontinuities (projection is now carried out with digital technology), those elements of continuity that persist are not negligible (digital projection is projection) and the rupture is not complete.

Let us take as an example a middle-aged viewer going to a movie theater to see a recent Pedro Almodóvar film, *La piel que habito* (*The Skin I Live In*, 2011). We might imagine that this viewer was dazzled and saw no difference between the nature of this experience

in 2011 and the experience she recalls having in 1988 when she saw *Mujeres al borde de un ataque de nervios* (*Women on the Verge of a Nervous Breakdown*) by the same director. Indeed the two film experiences are relatively similar, even though the 2011 film, unlike the 1988 film, was shot and projected using digital technology.[10] At first glance, nothing about the "film-projection"[11] entitled *The Skin I Live In* reveals that it is a pure product of the digital era.

There are thus a certain number of films produced in the digital era that by all appearances remain quite close to films made before the introduction of digital technology. This resemblance between films made before and after the introduction of digital technology is not a product of chance. It is in some way inherent and consubstantial with the digital process itself, which is first and foremost an encoding process (and not a "transfer" or a recording process as such): when a film is shot directly on digital media, a kind of command is given to the camera to convey the light information found in the profilmic reality into digital values, encoding them according to protocols that may vary but whose principle remains the same, and to store this information at the moment it is encoded. There results from these operations a film-text that, rather than finding itself recorded on film-film, is encoded in a film-file. In the end the result is a film-projection that, even if it reaches the viewer by means of information stored in a computer file, can throw us off the scent: for most people, this film-projection is not radically different from a film-projection produced by a succession of traces of light thrown onto a screen after having passed through geometric forms spread across a piece of celluloid film.

Similarly, when a 35-mm film is transferred to a digital format, a command is given to the device to encode the light information coming not from the profilmic reality but from the already made film, to which it assigns digital values according to the same protocols as those used for "filming real images" (to use a common expression that appears quite strange to our eyes) in digital media. To transfer a film from celluloid film stock onto a digital format is thus to produce something like a facsimile of the original. One might thus infer (with or without lament, depending on which camp you are in) that

the day *every* movie theater is converted entirely to digital, it will no longer be possible for the average person to experience a projection whose immediate source is a film-film of the work. Once entirely digital technology has completely taken over and flooded the film exhibition network, screenings of films shot on celluloid will thus take place using not a film-film but rather a film-file (except in film archives if, and only if, they do not also convert entirely to digital). In other words, viewers will no longer have access to that artifact on celluloid film stock and will be reduced to watching all films *only in a digital format*, which some people consider a *pale reflection* of a film-film. It is, in other words, a different object, an object of a different species—an alien in a sense.

In the presence of this object of another species, we no longer have access to the film itself (here the word *film* is well chosen), because it now reaches us only by way of an *ersatz digital version*. With a nod in the direction of the Jean-Luc Godard of *Vent d'est* (*Wind from the East*, 1969), we might say that this object has become *just an image* of the film, which reaches us through the intermediary of an electronic file.[12] Chris Marker would agree: seemingly also inspired by Godard, he went so far as to say that "on TV we can see the shadow of a film, the regret of a film, the nostalgia and echo of a film, but never a film."[13] We will thus no longer have access to the film itself, or even to its luminous emanation projected onto a screen, but rather to a mere *imitation*. Imitation: the word seems quite appropriate to speak of the digital universe, within which, according to Belton and his contributing authors, simulation, duplication, and the "look" of a film now reign supreme:

> Several essays in this issue challenge the status of digital cinema as "revolutionary," arguing that it merely *simulates* what has been done for decades on 35mm film. . . . Julie Turnock argues that the *look* of contemporary special effects sequences originates in the pre-digital, photorealistic aesthetic developed in the ILM in the 1970s. My own essay insists on understanding digital cinema as a means of *simulating* codes and practices associated with 35mm film in order to *duplicate* its "*look*."[14]

The Whirlwind of Moving Images

Some films produced since the digital turn remain quite close (*the principle of continuity*) to films shot before digital media's arrival—even when shot in digital (because celluloid and digital media coexisted for many years), even when projected in a digital format. Today, however, there are films (such as Steven Spielberg's *The Adventures of Tintin: The Secret of the Unicorn* [2011]) that are light years (*the principle of discontinuity*) from what was being done just a few short decades ago using celluloid. They appear in a "get-up" that was scarcely imaginable before the introduction of digital technology. This means, then, in the imaginary catalogue of films shot on planet Earth more or less since cinema's supposed centenary, that there is continuity *and* discontinuity from *one film to the next*.[15] There is sometimes even continuity and discontinuity *at the same time in the same film*. A film such as *Avatar* (James Cameron, 2009), for example, has forms ("acted," let's call them) without any connection whatsoever with what one might have imagined or seen on a screen before the motion capture process was devised. Nevertheless, we see in the film narrative forms that are completely in keeping with the first adventure films ever made; their continuity with certain archetypal forms of this corny old genre is so clear that the film was lambasted from every quarter when it was released. Continuity and discontinuity: in one and the same work, in one and the same film-file.

Whether one emphasizes the *continuity* between the two paradigms that arise from celluloid and digital formats or focuses on their *discontinuity*, it remains the case that cinema's entry into the third millennium has taken place amid upheaval and reversals. And amid things being thrown topsy-turvy, we dare add. The "death throes" into which digital media have plunged cinema have come about, to a certain extent, by means of a veritable process of "transubstantiation." Not to beat around the bush, we can say that *cinema is no longer what it used to be*! In some respects at least. If André Bazin were to ask the question "What is cinema?" today, we would reply without hesitation: "Cinema has changed a lot, my dear Bazin. You would no longer recognize it!" *For what has changed with digital*

formats are not the films, nor every film, nor every part of a film, *but first and foremost cinema itself*. There was twentieth-century cinema and there will be twenty-first-century "cinema." First cousins in some respects, distant relatives in others. The factors of continuity and discontinuity exist in not at all the same proportion in the production, exhibition, or reception spheres, or in the spheres of preservation and archiving, or that of the works' iconic system.

One of the principal effects of the digital shift has been the big screen's loss of its hegemony. To borrow the British novelist Will Self's description, we would say that we are living today in a veritable "whirlwind of moving images"—on our television screens, computer screens, and game consoles, when these images are not on our telephones and tablets (portable, in both cases).[16] In fact projection onto a movie screen has become just *one way* among others to consume images. The screen may have a greater *aura*, but it is now just one means of consumption among others. The digital "revolution" is thus no longer at our doors, but has completely overrun our humble homes. For some people this "revolution" is even a thing of the past.

Within the dominant paradigm there has thus taken place something like a *fissure*, turning upside down both the rules of film consumption (distribution and exhibition) and those of film manufacture (producing and directing). Consider, in the case of film consumption, the extraordinary access to films of all kinds that the proliferation of DVDs has provided and, in the case of film production, the great (though relatively illusory) democratization of filming that easy access to high-quality digital cameras has made possible.[17] All these changes, all these "transfers," have had considerable impact on film culture as a whole, as Thomas Elsaesser foresaw already back in 2004: "The successor of the CD-ROM, on the other hand, the DVD, is destined for an illustrious future as it *changes our film culture, viewing habits and the production/packaging* of feature films at least as decisively as did the video cassette and the remote control."[18]

Is the shift to digital media thus a revolution or not? Public opinion seems to have opted for a positive response to this question, if we are to believe *Cahiers du cinéma*, for whom the revolution in question is even complete in light of the announcement of the abandonment of celluloid. In November 2011, the front cover of the

magazine proclaimed loud and clear: "So Long 35. The Digital Revolution Is Complete." As Jean-Philippe Tessé explained, with a touch of nostalgia, in the lead article in that issue, "Most films are now shot digitally and screenings of celluloid film will soon be a museum attraction. So long, 35, we loved you dearly."[19]

An Identity Crisis from Top to Bottom

Revolution or not, one thing, at least, is certain: *cinema is going through a major identity crisis*. One of the signs of this crisis is the questions that film scholars have been asking themselves the past few years, taking up the fundamental question once asked by Bazin and reformulating it in various ways: "When is there cinema?"; "Where is cinema headed?"; "Is it cinema?"; etc. This is something seen time and again in recent film studies books. Another sign of crisis: the new names many film institutions have adopted to avoid appearing to confine themselves to cinema alone. Yet another sign is the incredible inventiveness with which the people behind new university degree programs also avoid giving the unfortunate impression (to their future "student customers") that these programs are limited to cinema.

And it is not only scholars who are affected, far from it. The current identity crisis is affecting anyone who uses films and the various players in the film industry, which is going through a turbulent period. Cinema has been knocked off its pedestal and film buffs are having trouble getting over it, that much is clear. Some go so far as to maintain that celluloid, which is *chemical* in nature, is a sine qua non condition for there to be *chemistry* between a film and its viewer. This view can be found in remarks such as these in the *Cahiers du cinéma* editorial by Stéphane Delorme we mentioned above: "At the latest Cahiers film-club screening Bruno Dumont, who had come to introduce *Hors Satan* (*Outside Satan*, 2011), advised viewers to see his film on 35mm and not digitally: '*We're made up of chemistry, and celluloid is chemistry, so we react in a particular way, chemistry against chemistry, which is not possible with digital media.*'"[20]

In the current hybrid media confusion, viewers no longer know quite what to expect and are losing their bearings one after the other.

True, it is possible to see more films than was ever possible before. These films can even be seen on all kinds of screens, anytime and anywhere. But the laments continue (too many habits have been turned upside down and the rules of the game are constantly changing). This shaking up of cinema's foundations is accompanied by numerous questions about the very identity of the medium, in that the boundaries between it and other media, which until just recently were seen as stable and easy to demarcate (something that in reality was far from the case), are gradually being erased, revealing to increasing degrees these boundaries' true nature, that of a pure theoretical and cultural construction (something they have always been, but that is a story for another day). Depending on the definition one gives it, cinema today can be seen as a nearly extinct species (this is Peter Greenaway's view, as quoted in one of the epigraphs to this chapter) or a medium going through a period of expansion (this is the view of Philippe Dubois, quoted in the other epigraph). In truth, the two points of view are complementary and underpin a fundamental principle: recent technological transformations, bringing upheaval not only to production practices but also to the way we watch and think about the medium, are prompting a major rethinking of the very definition and status of cinema.

We might also ask ourselves when this blurring of boundaries began and whether it has always existed (this is probably the case) without our realizing it. Moments of crisis probably bring out concealed tensions. It seems apparent that the overturning of photo-chemical cinema's hegemony by the emergence of television as a mass medium in the 1950s was a quite singular disturbance in the established order. Indeed the emergence of television came at the outset of the long period of technological turbulence through which digital media are leading us today. We might even view the emergence of the small (but highly cathodic) screen as the point of rupture between a "hegemonic cinema" and this "cinema in the process of being demoted and shared," which is often called "expanded cinema" but which we believe would be more appropriately described as "fragmented cinema."[21] Indeed some parts of cinema appear to have literally broken into pieces these past few years.[22]

The Digital Assassin

It is true that cinema is, and has been for some time, going through a particularly intense period of turbulence. For some people, *the advent of digital media has bought with it nothing less than the death of cinema*. This is not the only death of cinema that commentators have remarked throughout film history. We will identify a total of eight deaths since the advent of moving pictures. The death brought about by the digital crisis is the latest of the bunch, so we will assign it number eight, following chronological order.[23]

It remains the case that what cinema has been providing for more than a hundred years is a model of media communication based on moving images and on audiovisual culture. This model had a profound effect on the past century. Cinema was the source of a new conception of the performing arts, themselves an extension of various kinds of popular attractions. At the same time, it broke with these attractions. We might in fact position cinema at the crossroads of technology, industry, art, education, and popular entertainment. We might also describe cinema as a singular and especially significant example of the path that can be taken by a simple technological invention (the moving picture camera) to become the basis of a clearly identified media configuration in a given space-time. For the future events affecting a medium are never set in advance, as the Internet and mobile telephone demonstrate today.

In this respect, we believe that study of the *genealogy* and *archaeology* of cinema are essential to an understanding of present-day media. Is cinema not the form of moving images par excellence? Is it not, in a sense, the model for hypermedia and contemporary media culture? This does not prevent its identity from being shaken up, in particular because of technological innovations that affect the cultural ways in which it is used. The least one can say is that the topics of debate in cinema today are clearly dominated by the great digital mutation, because for the past few years now we have been able to say: *cinema is no longer* anything *like what it used to be!*

Cinema Is Not What It Used to Be

"Cinema" . . . is dead. What happened to it?

ROGER BOUSSINOT, *LE CINÉMA EST MORT. VIVE LE CINÉMA!*, 1967

More than any other art, the cinema has died repeatedly and with great regularity over the course of its relatively brief . . . existence.

STEFAN JOVANOVIC, "THE ENDING(S) OF CINEMA: NOTES ON THE RECURRENT DEMISE OF THE SEVENTH ART," 2003

Some people see the crisis cinema finds itself in the midst of today as a mild foreshadowing of its death, visible on the horizon. The various heralds of the "death" of cinema do not generally believe in its true death, in any real cessation of its vital activity. In the context of the digital turn, the "death" foretold is indicative, rather, of the medium's decline within the great chorus of media and also of the end of a situation in which cinema exercised an across-the-board hegemony. This is what is in the process of dying, not the medium itself. What we are experiencing today is the end of cinema's supremacy in the vast kingdom of the moving image. This is the sense with which the term is used by the British novelist Will Self in an investigation he carried out for an article published in 2010, "Cut! That's All Folks." Recalling one of his dialogues with his colleague Jonathan Coe, Self remarks: "'Film is dead,' I said. 'By which I don't mean that people aren't making films, or that other people aren't watching them—it's just that *film is no longer the dominant narrative medium*, its near century-long hegemony over the imaginations of the greater part of the world's population has ended.'"[1]

The death of cinema is thus clearly likened to the end of its hegemony—a hegemony, moreover, of a certain kind: its domination

is carried out through its narrative mode, the same mode the institution chose, over other possible modes (such as the attractional mode, for example), to establish as the standard with respect to cinema's identity.[2] In light of this reasoning, we might conclude that although cinema is moribund on the narrative level it demonstrates considerable vitality on the level of special effects, in particular because of the new possibilities that digital technology provides it.

Continuing his musings, Self reports that his literary agent, asked her opinion of this death foretold, expressed the hope that cinema end up like the theater, that it become "a secondary medium . . . but still a revered one." Understood in the sense of the end of its hegemony, the end of cinema would thus not necessarily mean a qualitative impoverishment (even though veneration gives off the musty smell of embalming and mummification). Concerning this lost hegemony, Self adds that cinema is still making excellent films, but that what has been lost forever is its "cultural preeminence":

> When I eavesdrop on [my children] goofing out with their friends, I have no sense of film's centrality for them; instead they are at the vortex of so much full-motion imagery—on TVs, computer screens, games consoles, CCTV, 3G phones—that the silver screen hovers only in their mid-distance, a ghostly presence unless animated by the next big, novelty spectacle.[3]

What we take away from this is that cinema needs the big screen to exist and that what is shown on other screens is just a *vortex of moving images.* In this context, for cinema to escape its relative media anonymity and recover its precedence it must return to the days of the "big spectacle" (which is precisely what it is in the process of doing with the powerful return of 3D and the proliferation of extravaganzas).

The decline of cinema and its loss of hegemony are topics that will recur frequently in the present volume, in which we will often address the question of hybrid moving images but also the difficulty—highly revelatory in our view—of finding an appropriate name, one that would achieve consensus, for this non-hegemonic-cinema-in-the-digital-era. What has incontestably changed today is that cinema no

longer has exclusive claim on our heart and is having a lot of trouble getting over the fact. What is more, it "no longer has exclusivity when it comes to moving images," in the words of Jacques Aumont, who goes on to add that "the dispossession process began more than half a century ago with television."[4] The movie theater's loss of hegemony has become a central question for viewers of course, but also for creators. This can be seen in a highly significant conversation Will Self reports having with David Lynch:

> Production has become so wilfully corrupted [but also] dissemination. Last year I spoke to David Lynch—a true auteur—about the reasons why he had distributed his latest film, *Inland Empire*, himself: "I love the film, Will," he told me, "but theatrical is dying, DVD sales are going down—it's all going to the internet, and it got caught up in this. Besides, it's three hours long, Will, and no one understood it." Then he began to hymn the virtues of what he termed "a perfect screening, in a quiet movie theatre, with great sound—because then you can really go into that world." He sighed about the loss of movie theatres: "It's a sadness." It is, and the sadness is at the loss of a specifically collective experience.[5]

In the end, then, cinema's decline is accompanied by a loss of its social significance, in particular through the drop in movie theater attendance. The American essayist Susan Sontag remarked the same loss of social significance in a famous article on the decline of cinema back in 1996, a loss she associated with the disappearance of cinephilia—an affection (and an affectation) that grows in movie theaters. Without the aura cinephilia confers upon it, this dying cinema is a kind of hollow medium. And if by some chance it were to be reborn someday, it would be, for Sontag, through this cinephiliac passion: "The conditions of paying attention in a domestic space are radically disrespectful of film. . . . To be kidnapped, you have to be in a movie theater, seated in the dark among anonymous strangers. . . . If cinephilia is dead, then movies are dead too. . . . If cinema can be resurrected, it will only be through the birth of a new kind of cine-love."[6]

Investigation into the R.I.P. Effect

This commonplace of the death of cinema recurs with remarkable frequency throughout film history. Yet it is easy to see that it has never been as present as it has since the turn of our new century. So much so that the new century saw the publication of numerous books calling into doubt cinema's survival or musing about its future. Paolo Cherchi Usai got the ball rolling in 2001 with a book that set the tone and didn't beat around the bush with its cold title *The Death of Cinema*.[7] The rest of the decade gave us much of the same: after Cherchi Usai a group of scholars in 2003 asked the question "Where is cinema headed?" in a special issue of the French journal *Cinergon* edited by Maxime Scheinfeigel, providing an early survey of what in cinema was in the process of disappearing.[8] They announced that the "collective viewer" was in the process of being transformed into a mere *reader*.[9] As François Amy de la Brèteque remarked in a review of this journal issue, "The conclusion one draws from this nuanced and stimulating group of texts may be that cinema still exists but questions around its relations with reality, its representation of time and the role of the viewer are in the process of shifting considerably."[10] These three questions address three aspects of the considerable changes taking place in the constellation cinema within the digital galaxy: seizing and encoding reality; the "digitalized" time of moving images;[11] and the greater diversity of products on offer to the viewer or, more generally, to users of filmic media.

In 2007 photo-realism and digital encoding were, precisely, at the center of the concerns of the American scholar D. N. Rodowick (who was also a contributor to the issue of *Cinergon* mentioned above).[12] In a book entitled *The Virtual Life of Film*,[13] Rodowick attempts to define what we might describe as cinema's new mode of existence. He believes that an image recorded digitally no longer creates causality or photo-realist contingency; it creates only illusion. From indexicality we necessarily pass to simulacrum when the captured image is immediately transcoded and converted into discrete and modular units. Hence for Rodowick it is impossible for what he calls the "digital event" to achieve duration even when the movement present in the image is perfect.

Let us return to Europe, in 2009, with an edited volume entitled, in a properly resolute manner, *Oui, c'est du cinéma* (*Yes, It's Cinema*), in which Philippe Dubois—who earlier urged us to adopt an extended and extendable conception of cinema—proclaims loud and clear that cinema is everywhere:

> More and more, cinema is in museums, art galleries, the theater, the opera, the concert hall. In bars, cafés, restaurants, nightclubs. It is in offices, workplaces and places we pass through or wait in. It is in homes, in every room. It is in planes, trucks, taxis, trains and on train station platforms. On the walls of the city and our mobile phones.[14]

And so on and so forth. Then, that same year, the pendulum swung back the other way, over in North America this time, with Chuck Tryon and his volume *Reinventing Cinema*, in which he examines the impact that the passage to digital may have had on popular culture and tries to evaluate the extent to which film culture has been redefined by digital media.[15] According to Tryon, our historical relations with film have radically changed. Up next, at the very end of the decade, is Dudley Andrew, who transformed Bazin's famous question into a resounding assertion, *What Cinema Is!*, by attempting to define the essential "idea of cinema" ("an overriding conception that can be felt at every level of the film phenomenon") that runs throughout the development of what has become our *audiovisual culture*.[16,17]

Cinema That Isn't Cinema

The song remains the same in a few books and lectures by major figures in the film studies field in the 2010s. To take just two examples of such lectures, we could mention that by James Lastra in November 2011, in which he went so far as to suggest that any definition of cinema is, in the end, only provisional, and that by Tom Gunning in May 2012, which suggested "Let's Start Over: Why Cinema Hasn't Yet Been Invented."[18,19]

Lastra, at the end of his talk, which addressed cinema's media identity problems, arrived at a thoroughly "relativistic" position:

"There are no autonomous media, only media embedded in changeable social and cultural frameworks. The contradiction between technological media—devices—and aesthetic media, and even within each, are an essential and defining feature of our media worlds, and the cause of their capacity to change."[20]

Gunning, for his part, adopts the proposal made by Bazin in the second version (in 1958) of his famous article "Le Mythe du cinéma total" ("The Myth of Total Cinema").[21] He suggests in particular that the answer to Bazin's piercing question "What is cinema?" will never be answered because every technological innovation, at the same time as it lays out cinema's future path, constantly brings it back to the idea that the people who conceived it had in the beginning. It should be noted that Gunning shares the genealogical conception of cinema that the present authors outlined in 2009, according to which crises and ruptures are an integral part of cinema's storytelling identity:[22]

> The modernity of cinema entails cycles of both destruction and renewal. As a historian I defend preservation and memory against the sort of giddy amnesia the myth of progress engenders. But nostalgia and despair about the future can be as blinding as ignoring our past. History is created by bridging seemingly uncrossable ruptures (not ignoring, but *incorporating* their fissures). . . . Thus our current moment of transition involves not just a vision of the future, but a dynamic sense of our past.[23]

In a sense, we might view the vision that the "positive" historian Gunning develops, in the tradition of his self-avowed mentor André Bazin, as not incompatible with the idea of an *extended* cinema, or perhaps we should say *extendable* cinema. Indeed the *diachronic* extension found in Gunning is not unlike the *synchronic* extension of cinema claimed by Dubois (and company).[24] Like Bazin, Gunning displays *optimism in history* based on a tenacious belief in the constant renewal of this phoenix-like medium: "The apocalypse was not quite what we expected. . . . Tomorrow we may just have to start over.[25]

Tension Around an Extension

To pin down the issue we are outlining here, we must make special room for two leading French authors who have been writing about film since the 1960s and who today are putting up resistance. The first is Raymond Bellour, the title of whose 2012 book, *La Querelle des dispositifs* (*The Apparatus Dispute*), is a good indication that film studies today is the site of burning theoretical discussions;[26] the second is Jacques Aumont, with his book *Que reste-t-il du cinéma?* (*What Remains of Cinema?*), published in 2013.

According to Bellour, the debate within film studies will rage around the question of the dividing line that needs to be established between what deserves to be called "cinema" and what perhaps may not. In this respect the subtitle of his book, *Cinéma—installations, expositions* (*Cinema—Installations, Exhibitions*), is a good indication of the contrast he wishes to set out, if we take him at his word in an interview he gave when the book was published:

> There are films everywhere, including in contemporary art, but to my mind there is no cinema in the strict sense of the term . . . in contemporary art. So I denounce somewhat this sort of collusion . . . which attracts everything from curators of art exhibitions to art critics and certain film theorists who, in the end, peg cinema's future to its inclusion in contemporary art and, at the same time, want cinema to become a province of art history.[27]

For Bellour, then, "we must not confuse, as we too often have a tendency to do, cinema's *moving image* and the *moving images of contemporary art installations*."[28] He is particularly critical of the positions championed by Dubois, who tends to see any moving image as cinema, believing neither more nor less (this at least is how Bellour sees Dubois' argument) that cinema, "properly" speaking, has more or less disappeared or, at the very least, is in the process of doing so. To play out our astronomical metaphor, we could use it to suggest this other evocative image: if cinema has become a supernova (that is, all the phenomena resulting from the explosion of a

star), it is because it is already dead, despite the extreme yet fleeting light it is giving off. This metaphor works to such an extent that the following comment could practically take the place of what Bellour finds perverse in the notion of an extended cinema: "Seen from the Earth, a supernova thus often appears to be a new star when in fact it represents the disappearance of a star."[29]

The "experience unique to cinema" or, in other terms, what for Bellour is specific to cinema, is movie-theater projection. This alone defines cinema. Any other manner of viewing a film (from television to the telephone) is quite simply a "degraded" form of audio-vision:[30]

> One thing alone is certain: cinema will live as long as there are films being made to be projected or shown in a movie theater. The day its apparatus disappears (or becomes a museum piece, a machine among many other machines in the cemetery of a film archive-museum) will be the day cinema truly dies. This will be a death much more real than its mythical and oft-announced death.[31]

We thus have, on the one hand, classical cinephiles (in the purest sense of the term), in the Bellour or Aumont mold, for whom the dark movie theater is the ideal place for a viewer to enter into a film. On the other hand we have a specialist of photography and video (art video in particular) used to seeing images through a viewfinder and for whom the dark movie theater, in the end, is nothing more than one way of consuming images. And who rages (like a "narrow-minded ayatollah,"[32] Aumont would add) against the defenders of "unique and monocentric models, clutching their supposed 'identity' or historical 'specificity.'"[33] They are "purists, fundamentalists of every description," Dubois exclaims, going so far as to say, without naming names, that "those who refuse to see the incredible living variety of the forms [of cinema] today are the ones who are dead, or mummified."[34,35] The context is explosive, in France at least, and the debate is beginning to take on the appearance of a modern remake of the famous battle of Hernani.

According to Bellour, the dispute (over cinema's apparatus) can be summed up very simply:

A film projected in a movie theatre in the dark for the fixed dura-tion of a screening that is to varying degrees collective has become and remains the condition of a unique experience of perception and memory. It defines its viewer. Every other viewing situation alters this experience to varying degrees. And this thing alone merits being called "cinema" (whatever meaning that word may have).[36]

No more beating around the bush; move along, there is nothing to *see*, apart from these images, some of which are appealing—but this is not a necessity—and which strut about on this wide screen, where they can really show their stuff! These images remain "cinema" only as long as they are not called upon to migrate outside cinema (by which is meant outside *the* cinema, the movie theater) onto the plat-forms of our hypermodernity. David Lynch would agree; for him, the so-called film you watch on your smart phone is simply an alien: "If you're playing the movie on a telephone, you will never in a tril-lion years experience the film. You'll think you've experienced it, but you'll be cheated. It's such a sadness that you think you've seen a film on your . . . fucking telephone. Get real."[37]

Jacques Aumont, for his part, drives Bellour's point home and puts cinema's good old *specificity* back on the table (which here takes the form "exclusivity"): "My point of view . . . is simple: I believe that cinema is far from having disappeared in its usual form and that, among the new forms of the moving image, it continues to stand out as one that combines certain values which are *exclusive to it*."[38]

Bellour and Aumont's recent outbursts are due in particular to the fact that Dubois, calmly and without betraying the slightest emotion, and with the utmost enthusiasm, declared in 2010 that

what is remarkable in the title [of Gene Youngblood's book *Expanded Cinema*] is not the descriptive *expanded*, it is that peo-ple continue to call cinema new forms such as installation, per-formances accompanied by projection, television's closed circuit, computer manipulation of the image, holography and everything that has happened to images since the arrival of the computer and the telephone.[39]

Once the storm has blown over, once we have finished with the identity worries that cinema has been instilling in us for some time, we might notice that the year 2013 was fairly representative, in the French-speaking world at least, of the way people's certainties have been shaken up throughout the long and slow passage to digital media: that year at least two important books were published that directly address questions around cinema's identity. The titles of these two works end with a question mark: first, Aumont's *Que reste-t-il du cinéma?* (*What Remains of Cinema?*);[40] and next, the original French publication of the volume *The End of Cinema?*, which you are holding in your hands, dear reader (unless you are reading it on a digital tablet, an e-book reader, or some other kind of screen?).

"Unless you are reading it on a digital tablet, an e-book reader, or some other kind of screen?" we just wrote, in a sentence also punctuated with a question mark: lately it seems, allow us to repeat, that the question mark is in fashion in film studies. Everything is looking for its identity, and no one really knows anymore what are the boundaries of these studies we continue to call (but for how much longer?) *cinema* studies. It is a field of study in the midst of redefinition in which two opposing camps are facing off. Two camps? No: three, rather.

For while on the one side there is the camp of those who say that cinema is everywhere and on the other the camp of those who maintain that cinema can only be found in a cinema, there is at least one other camp, that of the die-hards struck by what we have called elsewhere the dead cinema syndrome.[41] There are quite a few members of this group, which assures you that cinema is, one way or another, in its death throes. They foretell its imminent death, when they do not claim that this death has already occurred.

The TV Zapper, or Minimal Interactivity

This, in any event, is what the famous British filmmaker Peter Greenaway has been proclaiming hither and yon for over ten years now. He took the opportunity of his participation in the Pusan film festival in South Korea in October 2007 to make the following statement:

Cinema's death date was 31 September 1983, when the remote-control zapper was introduced to the living room, because now cinema has to be interactive, multi-media art. . . . [U.S. video artist] Bill Viola is worth 10 Martin Scorseses. Scorsese is old-fashioned and is making the same films that D.W. Griffith was making early last century. . . . Thirty-five years of silent cinema is gone, no one looks at it anymore. This will happen to the rest of cinema. . . . We're obliged to look at new media . . . it's exciting and stimulating, and I believe we will have an interactive cinema which will make *Star Wars* look like a sixteenth-century lantern lecture.[42]

In these oft-quoted remarks Greenaway expresses the view that the rupture that brought about the death of cinema was the introduction of the remote-control zapper into our living rooms (an event he says occurred on September 31, 1983). According to Greenaway, this moment marked a threshold in film history because the new gadget made it possible for the viewer to interact with the device screening the film. This moment was also a threshold because the appearance of the gadget in question brought about the decline of the classical form to which Greenaway objects, that of a linear cinema watched by a passive viewer. This is the form whose death (despite a few last convulsive movements) Greenaway attests. The arrival of the TV remote on the market thus made possible the creation of a squarely interactive model based on the principle of VJing, a public audiovisual performance consisting of images projected onto a screen chosen in real time and accompanied by music. Greenaway is an inveterate adherent of this practice.[43,44]

Nevertheless, there are two rather strange things about Greenaway's declaration: first, why give a precise date—September 31, 1983—for a phenomenon that is necessarily occurring over time (it cannot be maintained in all seriousness that the television remote landed in every living room in the space of twenty-four hours), and second, why choose as the date of the supposed death of cinema one that quite simply never existed? For there is no and never has been a September 31, the month of September having only thirty days.

In this sense Chuck Tryon, the author of the book *Reinventing Cinema*, made the following remarks on his website about Greenaway's comments:

> I think that what fascinates me most, especially in Greenaway's case, is the will to declare cinema dead. In fact, Greenaway seems to relish standing over the dead medium of film with the murder weapon—the remote control—in hand as cinema is replaced by something else. Greenaway also defines the cinema experience in a somewhat limited way, with passive viewers seated in a darkened auditorium looking in a single direction, which is of course, not how most of us experience movies today (most people watch at home on VHS, DVD, or TV in rooms that are not fully darkened).[45]

First off, Tryon provides us with a probable explanation for the incongruities we remarked upon in Greenaway's comments: the lack of precision matters little;[46] what counts for Greenaway is his desire to hit the point home and have an effect on people's way of thinking. In fact the interactivity made possible by the television remote is relatively minimal. We are not entirely certain what exactly Greenaway is alluding to when he singles out the year 1983 (surely something directly related to the proliferation of videocassette machines in people's homes), but there were television remote controls well before that date.[47,48] In those bygone days, the viewer could alter only television reception, giving rise to a much reduced level of interactivity (limited to switching immediately, at will, from one channel to another—if more than one channel was available—and to turning the set on and off). Nevertheless, this remote control of screen images, as limited as it was, was a brand new and in a sense revolutionary phenomenon at the time. This interactivity produced a minimal montage effect (viewers could subject their eyes and minds to a cascade of diverse images from different sources). Through this new interactivity, viewers now had access to something they previously could have only dreamt of: *controlling*, as the gadget's name indicates, if only a little, the images being shown. It was a first step toward VJing. Opening the door to controlling the images made possible the emergence of a new paradigm, which nevertheless continues

to coexist with the old one (in movie theaters we still see moving images over which we have no control).

The zapper said to be found in our living rooms in 1983 to which Greenaway refers was, more specifically, surely the one that offered remote control not only over our television set but also over our *video playback machine*. This time it was a tsunami: viewers chose the images they watched in the manner and the order in which they wanted. The absolute reign of the submotility of the viewer was over! The remote control, what in French we call the *télécommande*, in fact issues commands: *I*, mere viewer, command Jean-Luc Godard's actors to go backward, to repeat what they just said, when *I* want, as often as *I* want: the remote control's interactivity and the way it enables the viewer to intervene in the way the film unfolds appear fundamentally incompatible with our idea of cinema, or in any event with Bellour's idea of cinema. For Bellour, only "the experience of a movie-theater projection in the dark" is worthy of being called *cinema*.[49] This interactivity and this intervention are equally incompatible with Aumont's idea of cinema: "This today," he writes, "is a crucial point which I believe can be a good criterion for what cinema is: any presentation of a film which lets me interrupt or modify the experience is *not* cinema."[50]

We can thus see that Greenaway, even though he made his statement in the midst of the digital revolution (in 2007), was not imputing the death of cinema to the emergence of *digital* media, but rather to the appearance of a merely *electronic* (not digital) device on the television and video recording market: the remote control. We must conclude that the death of cinema of which Greenaway speaks is *a different death* than that with which it is threatened by the passage to digital media.[51] This death, he claims, occurred in 1983, when the digital project was still in its infancy.

In the view of some people, the widespread use of the remote control thus brought about the death of cinema (this will be our death number seven).

Cinema Just Keeps on Dying

Here we are then, at grips with two successive deaths of cinema (deaths numbers seven and eight) occurring a dozen years apart.

It is not at all surprising, when we go back in history, to find cinema's perceived corpse here and there, because the twentieth century sorely tested the medium.

"Poor cinema!" we might cry. The numbers of people who have been quick to announce your death! Poor cinema! You were barely "born" before papa Antoine (Lumière), father of the inventors (Louis and Auguste Lumière) of your base apparatus (on this concept, see Jean-Louis Baudry and Jean-Louis Comolli),[52,53] was ready to write your obituary ("Cinema is an invention with no future," papa Lumière is reported to have said at the precise moment the Lumière Cinématographe was experiencing its very first moments of glory)![54] *Et tu, pater?*

Here, chronologically speaking, was the very first of cinema's deaths foretold. This will be our death number one, the death of a stillborn medium.

The death of cinema is thus a recurring theme in film history that did not come along yesterday. The fact is that *cinema just keeps on dying.* Or, to put it a better way, *cinema will never see the end of people declaring it dead!* Among the long string of death notices that have accompanied cinema, consider, in addition to the three deaths we have just identified (numbers one, seven, and eight), the death that many distressed souls announced when television, a new technology that many people saw as a direct threat to cinema's survival, became a mass medium. Thus the magazine *Paris Match*, for example (see fig. 1.1), asked the following question on the cover of one of its issues in July 1953: "Will Cinema Disappear?" and pointed a finger at a guilty party: "Hollywood's dramatic crisis and the desperate battle between new techniques and television."[55]

This death—which will be our death number five, because we will soon mention another death, located between this one (number five) and the one caused in the 1980s by the arrival of the zapper (number seven)—has already been commented on abundantly since *Paris Match* and we will not belabor the point here. Except to make a profitable detour to a brief and undeservedly little known French book from which we have learned many things. Written by Roger Boussinot and published in 1967, the book (a "pamphlet," it describes itself on the cover—a visionary pamphlet, we are tempted

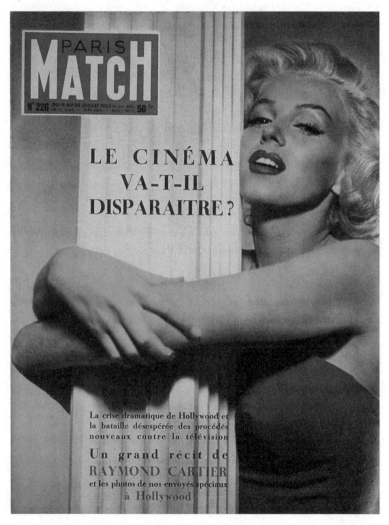

Figure 1.1 Cover of *Paris Match* 226 (July 18–25, 1953), "Will Cinema Disappear?" © Paris Match/Scoop.

to add), opportunely entitled *Le Cinéma est mort. Vive le cinéma!* ("Cinema is Dead. Long Live Cinema!"), attracted our attention not only because of its title but also, or even more so, because it lumps together two of cinema's successive deaths, occurring a few years apart, the most recent being perhaps not well enough known today.[56] The first of course is that caused by the arrival of television on a massive scale:

> Cinema is no longer contemporaneous with its present-day economic and social structures.
> Soon it will no longer have any connection to the movie theater.
> Because there will be no more movie theaters.
> "Cinema"—and what people still call cinema—is dead.
> What happened to it?
> The upheaval goes back to the 1950s. At that time, every time someone installed a television set in their home, the death of cinema was foretold.[57]

For some people, then, the arrival of television on a massive scale brought about the death of cinema (chronologically, this will be our death number five).

We might note in passing that Boussinot, in his comments above, wraps up one of the occurrences of the word *cinema* in his text in a nice pair of "scare quotes" the way many people do today.[58] In 1967, very few people in film circles used quotation marks to distance themselves from the thing itself. Further on, Boussinot goes so far as to add: "'Cinema'—that which is universally called cinema today [footnote to the text: "The term 'cinema,' at once too general and too specific, should be used more precisely"]—has been in existence for a little less than a hundred years."[59]

That is not all, however. For Boussinot, although television stabbed cinema in the back, the coup de grâce came from elsewhere. The guilty party this time was not television, but that very simple device known as the video playback machine, which liberated the television set from its subservience to exogenous programming because it did not limit it to broadcasting only programs on a given channel, according to a fixed schedule and upon which the

viewer could not act. The video playback machine, on the contrary, offers everyone the freedom to do their own programming, in their own home (hence the term *home theater,* precisely). For Boussinot, the invention of the video playback machine was liberating in every respect, and its introduction represents what historians generally call a threshold. Here there is more than a turn; there is a *rupture.*

A Historical Threshold: The Advent of the Video Playback Machine

One of the most important effects of video recording was to enable people to free themselves of the dictates of an industry that Boussinot detests. To such an extent that for him this invention represents a *historical mutation.* Worse still (or better, depending on your point of view!), Boussinot elevates this invention to the omega of film history, its alpha having been the invention of the Lumière Cinématographe:[60] "Film history is entirely contained in the seventy years that separate the successive appearances of these two very simple mechanical devices: the Lumière Cinématographe in 1895 and the video recorder with electronic camera (and the possibility of adding an Eidophor) in 1965."[61]

The arrival of the video-recording-machine-with-electronic-camera thus brought about a major rupture. Boussinot, who was too close to events to see them clearly, announced that cinema would not have long to live once the video recording machine had begun its work. It is as if the death of cinema in favor of television he announced earlier had not yet definitively occurred, as if the video recorder was the lance used by television technology to deal the final blow, the finally fateful blow. In this respect Boussinot's conclusion is not at all surprising: "The history of 'cinema' is now finished." One thinks one is reading Rodowick, forty years before the fact: "Film is no longer a modern medium; it is completely historical."[62]

Boussinot, in his charge against the film industry, but giving the reader a dizzying sense of peering into the future (do not forget that the book was written in 1967), goes so far as to foresee the ways we use video playback machines today: he announces that individual

"reading" will soon rival collective screenings, or overtake them, thanks to the private collections of video recordings people will have in their homes:[63]

> Have I not sufficiently clarified the differentiation that will come about, within cinema itself, between the individual screen and the giant screen, between "reading" on the one hand and the ever-increasing quest for "total spectacle" on the other? Between your future private film collection, whose works you will "read" how-ever you like on your television screen (or, better yet, on your blank wall if you own an eiphodor), and all the ultra-perfected cineramas and kinopanoramas yet to be invented? The fracture exists already. It can only get bigger and become a yawning chasm. It is into this chasm that cinema's present-day structures and their cornerstone, the ordinary "commercial" 35mm movie theater, will disappear.[64]

It is all there, absolutely everything! So much so that we will dispense with all comment. "The fracture exists already. It can only get bigger and become a yawning chasm," Boussinot adds. A chasm in which the movie theater risks being swallowed up, as well as cinema's present structures.

The next threshold, that of the arrival of television, was thus crossed with this major event, the advent of the video recording machine; this machine, according to Boussinot, was the cause of cinema's most important mutation since 1895: "In comparison," he writes, "the transition from 'silent' to 'talking' film was a mere incident."

The widespread use of the video recording machine will bring the death of cinema: this is another death of cinema (this will be our death number six).

This technological innovation, which made it possible for the viewer to record what was shown on television (including films) and to buy or rent prerecorded films on cassette, propelled home the-ater to the front of the stage. The arrival of the video recorder thus brought about a major "fracture," a term used by Boussinot that we believe to be quite appropriate to describe the phenomena we are examining.

Another Historical Threshold: The Arrival of Talking Film

As for that mere "incident," in Boussinot's pamphleteer rhetoric—the arrival of talking film—we should of course not be led astray. The passage from so-called silent cinema to so-called talking cinema had the effect of a tsunami on the forces of the day.[65] Around 1930, the columns of the temple were literally shaken up, giving rise in particular to the fear that words would subjugate visual cinematic expression—that cinema would become "talky" and its specificity would be erased. The very expression "talkies," bearing the traces of this colonization by words, could only have fed this fear that cinema would break away from what we might call cinema's "last redoubt," or the last redoubt of *silent* cinema at least. Moreover, is not the expression "the talkies," in which any reference to cinema itself vanishes, a sign of an implicit acknowledgment of the death of cinema, or at least its relative erasure, in favor of that striking novelty, sound? The problem looming on the horizon is the identity of the medium itself, as Édouard Arnoldy remarks: "The reason the talking film, to take just this one example, had so many detractors in the late 1920s was because in their eyes cinema was about to lose a part of its identity and confuse its interests with those of the live entertainment industry (Broadway) and the 'new technologies' of the day (the phonograph record, radio, the telephone)."[66]

In the end, the authors of the numerous articles of the day on the talkie revolution all invoke the medium's *singularity* and *specificity*. In the polemics to which the arrival of the talkies gave rise, cinema's silence itself was seen by some as the last redoubt of its identity. Lucien Wahl, for example, wrote in 1928 that "cinema is always pure when it does not speak," while for his part Pierre Desclaux argued that same year that "this silence is its identity, what gives it its special qualities."[67] Desclaux even added that "the only future of film art lies in an increasingly ingenious use of images alone. . . . Film art should be itself or should resign itself to *dying*."[68]

Other figures in the film world were more undecided and formulated hypotheses that the present authors would not challenge. Alexandre Arnoux, for example, also writing in 1928, made remarks that foreshadowed by seventy years the concept of the double birth

of cinema that we proposed in 1999:[69] "We are witnessing either a death or a birth, no one can tell for sure yet which. Something crucial is happening in the world of screen and sound. . . . Second birth or death? This is the question facing cinema.[70]

Note Arnoux's uncertainty: he cannot tell if the arrival of talking films is bringing with it a birth or a death. Even though it is always a case of hyperbole, this obsession with the death of the medium is an interesting idea. Cinema will clearly not die, but something *about it* will die, something *within it* will die. And because nature abhors a vacuum, the "death" foretold turns out also to be a birth. Better yet: this death *is* a birth! Of a kind.

For some people, then, the arrival of talking film brought about the death of cinema—the death of silent *cinema at least* (this will be our death number four).

In the polemics that rage around a medium in crisis, the ultimate defense of a media identity that is on its last legs is often accompanied by emotionally charged reactions. This passionate quality of the debate quickly turns to forced arguments (whence the hyperbole). Like a cartoon caricature, such exaggerations can nevertheless have significance and bring out latent features that, once they are visible and hypertrophied, suddenly and paradoxically appear obvious. These "forced" descriptions of the medium also contribute to making more apparent the cultural series assembled to establish a medium in a given era.

The "digital revolution" shares more than one feature with the talkie revolution, but where they most clearly differ is their outcome. Unlike what is happening today with the passage to digital media, the passage to talking films was a relatively linear phenomenon: silent cinema was literally replaced by talking cinema (*this killed that*, to modify for our own purposes what a character in a Victor Hugo novel says about the relation between printing and architecture).[71] In other words, *talking film killed silent film.*

This is a widely accepted idea; it is championed by a film historian such as Pierre Leprohon in a volume whose subtitle unequivocally speaks of the death of cinema (or at the very least of a certain kind of cinema): "The abolition of silence marked the end of what was known as the Seventh Art, but more accurately as the 'Silent Art.'

With speech another kind of cinema was born."[72] For Leprohon, film history is made up of two great periods coming one after the other: first silent cinema, then talking cinema. The first period, which he describes as that of the Cinématographe, became a "dead language" once silence was done away with.[73,74]

Compared to the passage to talking film, the passage to digital media is a relatively multilinear phenomenon: at first sight, *this has not really killed that*. We are, rather, at grips with a system that is coming to the forefront by way of the fragmenting of media (which are sometimes described as *hypermedia*). This system is replacing an older one in which media enjoyed relative autonomy. To put it more extremely, we might even say that the media at greatest risk of acute crisis in today's media chorus, those media that risk becoming isolated, are those that do not hybridize. The boundaries of the identity of these media are not porous.

Naturally there is a touch of *this killed that* in the passage to digital media, but nothing as monolithic or drastic, it would seem, than in the passage to talking film—unless the replacement of the film-film by the film-file is as drastic. Nothing as monolithic and drastic in the sense that the arrival of the talking film was like a change of medium. The rupture does not appear as radical in the case of the digital, even though the medium is affected. If we put aside the commonplaces we have discussed here, one of the ambiguities of the passage to digital media lies precisely in the fact that this passage affects the stuff of the film medium itself while at the same time leaving the *look of the cinematic image* unchanged.

Death by Institutionalization

A little more than fifteen years before this death number four, brought about around 1930 by the emergence of the talking film, another death occurred, this time in the first half of the 1910s. This death passed relatively unnoticed, for it apparently did not give rise to explicit commentary on the part of film people at the time (unlike our seven other deaths). This death is particularly dear to the authors of the present volume (if the reader will excuse such a seemingly morbid statement), simply because it occurred in step with the second

birth of cinema, according to our hypothesis of the "double birth of media." We believe, first of all, that the death in question (this will be our death number three) is in fact the death of the *kinematograph* rather than the death of *cinema*. Of the kinematograph in the sense in which we use this word in some of our earlier writings, because, according to the hypotheses of one of the present authors, cinema as such was not born until some time in the 1910s:

> Following [Edgar] Morin, we must therefore conclude that the [early cinema] period, a period in almost complete synchrony with Méliès's film activity, was one in which the *kinematograph* "transubstantiated" to become *cinema* by means of a change in *paradigm* . . . of such extent that we would be justified in seeing the two entities as completely separate.[75]

This is a hypothesis that, since that time (1997), became the subject of a book, published in 2008, whose ambition was, precisely, to validate the hypothesis: "The emergence of cinema, in the sense we understand the term today, dates instead from the 1910s. The principal task of the present volume is to validate this hypothesis."[76] Thus one might find it a little startling to read Dudley Andrew declare the following in 2010: "So let me be forthright: the cinema came into its own around 1910 and it began to doubt its constitution sometime in the late 1980s. I'm not the one to send out this tardy birth-announcement; Edgar Morin did that in 1956 in *Cinema: Or the Imaginary Man* when he headed a chapter 'Metamorphosis of the Cinematographe into Cinema.'"[77] Startling because the desired effect of this announcement falls a little flat, it seems to us, in the context of the research that has been carried out over many years now into so-called early cinema. Startling too because the reference to Morin also falls flat, because for Morin the passage from the *kinematograph* to *cinema* did not take place in 1910 but much earlier, as early as 1896, as one of the present authors has pointed out:

> For Morin, the passage from the kinematograph to cinema occurs at the very dawn of Georges Méliès's film career around 1896. For

Morin, Méliès's arrival made this transformation possible. In my approach, which is more historical and theoretical (while Morin's approach is more anthropological), the transformation in question takes place, rather, in the early 1910s, or virtually at the end of Méliès's film career.[78]

We will not belabor this death of cinema in the early 1910s, as we have already described it in detail in our previous publications, but we will say that this "death" is also, and at the same time, a *beginning*, a "second coming" that appears on the horizon of (film) history at the moment when the First World War appeared on the horizon of (world) history. This beginning was the "moment" in film history when cinema was institutionalized.

Thus for some people (and we count ourselves among them) *cinema's passage through the mill of institutionalization brought about the death of what we call the kinematograph* (this will be our death number three).

An Industry's New Practices

Barely a few years before our death number three another "death" of cinema came along, this time about 1907–1908, just as the process of institutionalization was getting underway. This death was also quite relative and was the result of a truly protean crisis. Those years, when the process leading to the institution "cinema" began, were a turning point that foretold the end of a model and the death of a paradigm. They were a time when a series of actions and events shook up the world of the kinematograph (mainly in France, but also in the other major film-producing countries):

- the gradual phasing-out of a *sales* system by film "production" companies, to be replaced by a new *rental* system;
- the growth of venues specifically devoted to cinema, bringing about a reversal in the relationship between the viewer and person showing the animated pictures;
- the beginning of the end for fairground cinema, which started to decline the moment it became difficult to purchase films;[79]

- a serious crisis of over-production (or "over-distribution," as suggested by Laurent Le Forestier);[80]
- the end of France's hegemony, to the benefit initially of the United States (and then Italy, Denmark, etc.).

The years 1907–1908 were thus the end point of a series of practices (some of which were quite significant, such as the sale of films). These years were also fertile ground for new practices (some of which were also quite significant, such as the *film d'art*).

Hence the 1907–1908 bottleneck brought about the death of a model that had dominated until that time (this will be our death number two).

To such an extent, moreover, that one observer of the film milieu believed that the kinematograph, although it had been born before the beginning of the twentieth century, had nevertheless not yet been born in 1907:

> Today, the kinematograph is on the eve of being born. I repeat: THE KINEMATOGRAPH HAS NOT YET BEEN BORN. IT IS ON THE EVE OF BEING BORN.
> And I ask the typesetter to compose the underlined sentence above in very bold characters so that every reader of the *Phono-Ciné-Gazette* will burnish it in their minds.[81]

According to this informed and enlightened commentator in a major trade journal in 1907, the kinematograph was not yet born.[82] It was only on the eve of being born. François Valleiry made such a statement because he deemed it essential that France promote the production of raw film stock to ensure the independence of the French film industry. This topic plagued our commentator, for he returned to it in another article later that same year. Note, moreover, that although he believed that the kinematograph had not yet been born by 1907, it had nonetheless been born—"a first time," we might say—around 1897:[83] "This is why, a few centuries ago, inventors could not propagate their work while today an invention covers the globe in a few years. This was the case with the kinematograph, *born ten years ago*."[84]

The expression "first time" is mentioned nowhere in the texts by Valleiry that we have been able to consult, but it appears to us that the "double birth" hangs over his writings like a scent. This in any event is the only way to reconcile the seemingly contradictory remarks found in an article entitled "Le Cinématographe n'est pas encore né" ("The Kinematograph Is Not Yet Born"), in which Valleiry asserts that the "kinematograph [was] born ten years ago" and adds two paragraphs further on: "It is miserable to think that the largest factory in the world delivers 210 kinematograph cameras per month and 60,000 meters of animated pictures per day when the need is exactly 1,000 times greater. *The kinematograph is not yet born.*"[85] For Valleiry, therefore, the kinematograph was born a first time as a *technological invention* in the late nineteenth century and a second time as an *industry* some time after 1907.

With this second death we have now rounded out our list. Our enumeration of cinema's deaths is complete, having begun with the declaration by Antoine Lumière concerning the kinematograph's lack of future (our death number one).

These foretold and decreed deaths do not, of course, all have the same strength or magnitude. Thus our death number one, which rests on a mere allusion on the part of an "interested" (monetarily, of course) party, did not—to say the least—have very strong social repercussions in the film milieu. We would have to await Georges Sadoul and Jean-Luc Godard for such a declaration to have much effect.

One of the things that nevertheless distinguishes the digital crisis from all other previous crises is that it is taking place over the long term—over even the very long term. The passage to talking films certainly stretched over several years, but not over a period as prolonged as the passage to digital media, which just keeps on going. The passage to digital is anything but a single *event*; it is a *process* taking place over time. The passage to digital media is, precisely, a passage, in every sense of the word. Take cinema, *pass* it through the digital mill and you obtain something else. Cinema is thus in the process of taking the *passage* to digital media: it is in the digital *passage* and it is changing. It is changing because the *digital system* of files and algorithms is too different from the *celluloid system* for us to remain in the same universe. After this passage, cinema will

not be the same as it was in the past. By leaving celluloid behind, cinema is destined or condemned (depending on one's point of view) to *transubstantiation.*

Cinema did not die in 1930, or in 1950, and we can bet that it will not die in 2020, despite the fact that the French daily newspaper *Libération* announced a short while ago that the Cannes film festival might close up shop (see fig 1.2). In a short, hard-hitting editorial entitled "Révolutions," Gérard Lefort summed the situation up in the following manner:

> The largest film festival in the world is in the midst of a two-fold revolution: technological and cultural. Today anyone equipped with a pocket camcorder is, potentially, a filmmaker. Even by filming their feet like feet. At the same time, films are no longer seen only in movie theatres. Whatever innovations 3D has wrought, fiction now also spins its adventures on other screens, those of computers and smart phones. With the risk, and for some the danger, that this profusion will heighten the confusion between reality and its many virtual forms. Cannes, unless it becomes a nice little old lady from a bygone age one visits once a year in the nursing home, will be called upon to bring itself into line with these revolutions. Opening itself up more readily to the public would be a first step. Programming films in tune with the new technologies would be another.[86]

The passage to digital media is a gradual and ongoing process. We might describe this process by a near-neologism, in this context: digitalizing.[87] The *gradual digitalizing* of cinema is thus subjecting it, sector by sector, to the demands of the digital. This gradual digitalizing will only be complete when every sector of the industry has given up the ghost: exhibition and projection, postproduction, and production and manufacture.

To conclude this first chapter, we should say a word about our use of terms formed from the word *digital*. Most often, to transfer an analogue work to a digital format is called, in English, *digitizing*. Some sources use, incorrectly, the term *digitalizing*, which is an unrelated medical term. We propose to borrow this term here deliberately

Figure 1.2 "The Last Cannes Film Festival?" The cover of the French daily newspaper *Libération* 9328 (Wednesday, May 11, 2011). © *Libération.* Photo: Benjamin Rondel/Corbis.

in order to distinguish the process of cinema becoming digital in general terms from the transfer of an analogue work to a digital medium (its digitizing). This is why we will speak throughout this book of the *top-to-bottom digitalizing of cinema* and not the *digitizing* of cinema.

Digitalizing Cinema from Top to Bottom

The relentless glare of the digital image with no shutter reprieve, no back and forth between one forty-eighth of a second of dark followed by one forty-eighth of projected image, with no repetitive pattern as regular as your own heartbeat.

BABETTE MANGOLTE, "AFTERWARD: A MATTER OF TIME," 2004

We can speak romantically about the death of cinema or become infatuated with its extraordinary plasticity.

DIDIER PÉRON, "CANNES À LA CROISETTE DES CHEMINS," 2011

The passage to digital media at the turn of the century brought a profound upheaval to media "ecology." Insofar as digital technology is not exclusive (it affects every medium—and much more than media alone), every time the "Digital Fairy" bats her wings she unleashes a hurricane or, at the very least, severe disturbances, from one end of the media chain to the other.[1] The media of any given society and culture at any given time respond to one another, enter into dialogue or exchange, or crash into one another in spectacular fashion. In short, they constitute a system, even if its contours can appear fuzzy and abstract. They *constitute* a system, or rather *are organized* into a system, as Edgar Morin would say. Morin once endeavored to explain how organization became a system: "Organization interrelationally ties diverse elements, events, or individuals which henceforth become the components of a whole. It assures relative solidarity and solidity to these ties, thus assures the system a certain possibility of duration despite chance perturbations. Organization, therefore: *transforms, produces, binds, maintains.*"[2]

We thus like to imagine the media universe as an ecosystem, as a "complex unity or system," an ensemble of interconnected "components" that interact in a series of exchanges out of which arises

a new phenomenon endowed with "qualities" that are "unknown at the level of components."[3] Cinema, like its media brethren, has its own place in this ephemeral and fragile homeostasis. It is a part of what is commonly known as the media culture of an era. Like any system, the system constituted by what we might call the "intermedia"[4] of an era must manage information and feedback loops.[5] To sum up systemic thought, undoubtedly in too simple a manner, we could say that such feedback is negative (or "stabilizing") if it does not profoundly modify the system.[6] If, on the contrary, it radically affects the system and rocks the foundation of its identity, it is seen as positive. Numerous signs seem to point to the actions of the digital within the media system as generating "explosive" feedback, if only because of its omnipresence. This is the case, at least, with "audio-scripto-vision" media. The *top to bottom digitalization* we are witnessing in the early years of the new millennium thus fits what media scholars, following Pierre Lévy, call an irreversible ratchet.[7] Once it has been ratcheted high enough, it is impossible to go back. This is the case with digital media, to the point that predigital media now seem like a distant continent.

We might even take up a hypothesis very much in the air today: imagine that in the near future there were to take place, through a convergence in every quarter, a *fusion* of all media (accompanied by a *confusion* of genres) in a kind of undifferentiated magma we might call the "Great Intermedia," within which each media field would be nothing more than a mere application among others and through which *homo intermedialis* would be able to meet his or her needs and expectations: a little like the futuristic vision proposed by Harry Grant Dart in a caricature dating from 1911 (see fig. 2.1).

We might note in passing the impressive number of foreshadowed media in this futuristic vision: "The Opera Delivered at Your Door," "The Observiscope" (a device part-way between television and the surveillance camera), and the constant feed of information in the "International Wireless Home News Service."

The convergence of media and platforms, moreover, has brought us into the age of what has begun to be called "wired up" entertainment. This same convergence is beginning to give shape to the Great Intermedia looming on the horizon for whose arrival we are all preparing.

Figure 2.1 "We'll All Be Happy Then," illustration by Harry Grant Dart from *LIFE* magazine in 1911.

Today's intermedia are thus intermedia of a more organic nature than any intermedia of an earlier age. Today's intermedia are *intermedia* in the strong sense of the term (with a hyphen, to highlight the fact that they are made up of two elements). The digital turn is profoundly affecting all media, right down to their most "intimate" fiber, if we can say so; by blowing up the boundaries that separate them, it brings them closer to each other, something that sometimes causes confusion in people's minds. When you watch a film being shown on television, there is no possible confusion: you are not at a movie theater. But is the film you are watching cinema? A film you play on a DVD player has nothing in common with television, but you watch it on a television screen just the same. Here too there is no possible confusion: you are not watching a television program. But is this film on DVD you watch on my television screen cinema? If it is, is it the same film as you see in a movie theater? Is a film seen in a movie theater "more" cinema than the same film on DVD seen on a television screen? The live broadcast of an opera on television is television. But is the live broadcast of an opera in a movie theater cinema? Or is it television? A film shot by a "mobilographer" and shown on television: is it cinema, mobilography, or television?[8] To sum up: is a film that is not on film (on celluloid) still a *film*?

Questions such as these are indicative of the uncertainty today caused by the shattering of boundaries brought about by our thorough subservience to that new god, Digital Code. Everyone who works in media today is affected by this subservience. Hence the proliferation of scare quotes as soon as one begins to speak of a *specific* medium, which as we are aware has in fact lost, or is in the process of losing, a good part of its specificity.

The very notion of a digital "revolution" enjoys solid media visibility today. By exploding the boundaries between media, this alleged revolution is resulting in a kind of *intermingling* that is blurring the boundaries between media and is generating *intermedia, hypermedia,* and other hybrid media worlds. Cinema and the cinema institution, a subsystem of the media system, are also being subjected to this digital "positive feedback."[9] Cinema has been badly shaken up, to the point of reviving predictions—or assertions—of its death. In a context such as this, allow us to repeat, cinema is once again going through an

identity crisis: from filmmaking, which is becoming "virtual" and dematerializing, to exhibition, every sector of the institution cinema must adapt to the pressure of the digital.

Thinking about the very nature of these upheavals and, more precisely, on how to describe them, is not a pointless exercise. The first question: Is the passage to digital, in the case of cinema, a *revolution* or not?

A Digital Revolution

First, let's look at a call for papers for a conference held at the Université de Provence in November 2012 on the topic of digital technology's impact on the arts. Under the title "Digital Images: Technology, Aesthetics and Ideology," the conference proposed to discuss the following: "Initially a mere means of encoding and converting, 'the' digital (the widespread use of the definite article is revelatory) has taken over numerous technologies, in particular those related to the production and dissemination of still or moving images. The digital is now the most widespread means for producing and circulating visual and audio data."[10]

This excerpt sets the scene quite well. It would be naive to think that digitalization could limit its effects to the encoding of data alone. Encoding cannot merely be restricted to an isolated technological operation; it necessarily affects language, for which encoding is, precisely, the primary principle. And when this primary principle becomes universal, it affects every media language and then all the media that transmit—meaning co-construct—these languages. Put more simply, digital encoding is in the process of *digitalizing* our media from top to bottom, from production to reception by way of transmission.

But is this a "revolution"? Is this omnipresence enough to justify the use of the expression "digital revolution"? Compromised as it is, this fashionable term has been used as a slogan by marketing strategists and other prophets of the new media. In addition, as a generic label *digital revolution* mixes up helter-skelter several kinds of phenomena. First of all, it refers to a technological reality: the increasing speed with which the digitizing of information, or

data, is proceeding. More broadly, it also refers to the widespread digitalization of the dissemination of this data on a global scale, by way of the Internet and the proliferation of screens. Finally, people also apply the label *digital revolution* to the many consequences of this technological upheaval. Widespread hybridization, media convergence, the constant flow of information (including images), and their material accessibility are some of the more spectacular effects of this process.

The philosopher Pierre Musso is one of those who are wary, even skeptical, of this revolutionary uproar. There may very well be a *passage* or *mutation*, but does that necessarily mean there is a *revolution*? Musso replies:

> We must question reality and the scale of the present-day muta-
> tion of information and communication technologies, known as
> "digitizing" or even "the digital revolution"—and soon the reality
> and scale of their foretold encounter with biotechnology (people
> are already speaking about NBIC technologies: nano, bio, infor-
> mation and cognitive technologies)—in order to avoid floundering
> in the commonplaces of the dominant ideology and not believe
> complacently in the fictions accompanying this technological
> mutation.[11]

For Musso, a number of "fictions" have coalesced around digi-tal media. One even detects in these fictions a feature that defines a mythology, in the sense of Roland Barthes' use of the term in the 1950s and carried on today in the work of Serge Tisseron and Jérôme Garcin.[12-14] This layer of connotations and the imaginary makes it tricky to evaluate the impact of the revolution in question. Historians and sociologists of technology (from Walter Benjamin to Patrice Flichy by way of André Leroi-Gourhan, Georges Baland-ier, and Régis Debray) are quite familiar with these phenomena of techno-media imageries that have become part and parcel of the medium in this way.[15] In a sense, the digital is thus readily enter-ing the older phantasmal world of videotex, computerization, and cybernetics, exercising its influence on people by turns fascinated and overwhelmed.

Beyond its emotional power, the term *revolution* is thus not anodyne and can even be seen as a form of suspect ideological manipulation. This is Musso's belief:

> In the name of this technological mutation, which many people describe as a "revolution," numerous political and commercial discourses have been produced promoting "digitizing" to the rank of an indisputable or mobilizing rational myth in order to justify political or economic orientations. At that point everything becomes "digital": people (Nicholas Negroponte), cities (Bill Mitchell), the state, countries, the digital fracture and even the "revolution." While the extension of the concept "digital" makes one doubt its consistency, it produces a technologization of the objects it seizes hold of. In this way policies can be "technologized": digitizing serves as inevitable causality to legitimate them.[16]

This leads us to ask, once again, to what exactly the word *revolution* refers when it is applied to technology. A revolution is a "sudden and radical transformation." This is a definition most would agree on and is found in many a dictionary. The quality of suddenness is obviously relative according to the historical scale one adopts. To us, the criterion of being radical is more interesting. Here, before the revolution is clearly distinguishable from after the revolution. Between before and after there exists something along the lines of a rupture, a break, or a fracture. Should we thus speak instead of a *digital fracture*? This is a little-used but, in our view, fitting sense for this now current expression in French to describe the widening of the social chasm between those with access to the Internet and those without. It seems to us that the expression *digital fracture,* rather than making reference to the socio-cultural gap alone, can also refer to this rupture between a before and after of technological upheaval.

In the account of InnoviSCOP, the Société de conseil en organisation et financement de la recherche et de l'innovation, a *technological rupture* is the result of the *conception, development,* and *introduction* of "a radical technological innovation, meaning a technology that is profoundly different from previous dominant technologies."[17]

The word *rupture* is thus given a specific connotation, one that Inno-viSCOP distinguishes from *revolution*:

> Technological *rupture* is sometimes distinguished from technological *revolution*. A technological rupture throws a pre-established market into upheaval by getting out ahead of an existing technology (often over time: initially by creating a niche market and then by conquering the dominant market). A technological revolution has no effect on established markets and existing technologies, at least at first. A technological revolution creates a completely unexpected market by bringing a fundamentally new solution to a problem or need.[18]

In this view, a technological rupture acts on an already established market, where it radically and incontestably gets out in front of existing technology. The examples mentioned by InnoviSCOP—from the introduction of paper ("replacing parchment") to flat screens ("replacing cathode ray tube screens") by way of digital photography ("replacing silver gelatin photography"), and the telephone ("replacing the telegraph")—are all cases when "technological ruptures quickly marginalized the technologies that came before them."[19] A technological *revolution*, for its part, requires that other conditions be met, such as suddenness, surprise, unprecedented upheaval. A technological revolution creates a completely unsuspected and unexpected market space "by bringing a fundamentally new solution to a problem or need." This was the case, for example, with the automobile: "The invention of the automobile, on the contrary, was a technological revolution: its effect on the transportation market was felt only several decades later, as the first automobiles were luxury goods with a narrow market." It is as if "rupture," unlike "revolution," paradoxically involves continuity, something suggested moreover by the word *replacing*: in the end, the place or function occupied remains stable, but is now occupied by a better technology. In the case of revolution a new niche is opened up.

On the Value of a Revolution

For a philosopher such as Michel Serres, on the other hand, the digital upheaval that began some thirty years ago is well and truly a

revolution.[20] In fact Serres bestows on the digital revolution the title *humanity's third revolution.* The first was the passage from oral to written culture, and the second was the advent of the printing press.

The idea of revolution, applied to digital technology, has given rise to a crop of commentary from the camp of both technophobes and technophiles. Between these two extremes we also find more prudent and nuanced judgments. This is the case of those authors who contributed to a special issue of the journal *Esprit* on this topic, including the editorial by Laurent Sorbier:

> The coincidence of the immense and later than expected success of these technologies amongst the general public and of a discourse which tends to minimize the scope of the changes brought about by this very broad dissemination of uses presents a major risk: all the conditions are present, in a sense, for the digital revolution to be rendered overly banal, reduced to its most trivial effects. There is undoubtedly an extreme risk of bypassing the economic and social changes in the process of taking place, at the precise moment when the information society takes itself for granted, as a fact of everyday life, when the mechanisms at work are both more unobtrusive and minute on the one hand and explosive in the long run on the other.[21]

This approach enables us to envisage a stimulating encounter between different conceptions; the very act of bringing them together gives rise to critical relativity, particularly with respect to the Internet, which without too much risk we could see as the media standard-bearer of the digital revolution. As Marshall McLuhan remarked, a media revolution can be measured by the change of scale to which it gives rise: "In operational and practical fact, the medium is the message. This is merely to say that the personal and social consequences of any medium—that is, of any extension of ourselves—result from the new scale that is introduced into our affairs by each extension of ourselves, or by any new technology."[22] In the end, this change itself is the true overall "message" structuring every medium. Laurent Sorbier, following the computer specialist Nicholas Negroponte, expresses such a change of scale by associating it, precisely,

with the Internet:[23] "As Nicholas Negroponte prophesized several years ago, the Internet is pervasive in our daily lives and has become a structuring element of our economy, the backdrop to our *homo numericus* lives."[24]

Some people thus see the Internet and the thorough networking of our lives under digitalization as the realization, finally, of the "rhizome" model proposed by Gilles Deleuze and Félix Guattari:[25] a de-centered, nonhierarchical, and nonsignifying system, an "outside-of-there" (to use Serres' expression)[26] in which another kind of sociability and a new conception of urban life are found. A networked society free of vertical hierarchies in which, in the sociologist Manuel Castells' estimation, individuals can find new resources to revitalize their identity in a de-territorialized world threatened with the loss of the bearings we use to situate our identity.[27] The philosopher Pierre Lévy, sharing this enthusiasm, has endeavored, as Sorbier sums up, to "exhume the new mechanisms for producing collective intelligence, whose emergence will be made possible by the Internet."[28]

The Question of Changes of Scale

Is the passage to the digital thus a revolution? A rupture? A mutation? A turn? An upheaval? Without coming down on one side or other of the preceding debate, in this volume we will use by turns the terms *revolution* and *rupture* (but also the less radical terms *passage*, *turn*, and *mutation*), knowing that the semantic charge of the former is greater than that of the latter. It might even be supposed that this passage varies in intensity over time and that it is distributed in different gradients.

For our part, we share the view of Serres, who believes that the digital is giving rise to a profound and far-reaching transformation. If some people question the legitimacy of the term *revolution*, so be it. But discussion of the impact and changes of scale to which this revolution is giving rise, to the extent that we recognize their existence, is more interesting than merely evaluating the extent of the convulsions it causes. This is that much truer in that, once a technological revolution is proclaimed, people begin clamoring for this revolution to be celebrated or feared. These reactions are not to be taken literally, but

we must be able to decipher the mental and imaginary representations behind them. Pierre Musso, in this respect, insists that

> the fictions and discourses around information and communication technologies bring out not only intellectual and ideological speculation but also financial speculation: their effects are very "practical." We need to consider the formation of a veritable "symbolic economy" tied to technology. This economy is made up of an accelerated circulation of signs, discourses, and reputations.[29]

We should also, in light of some of our remarks here, put into perspective some of the clamor and narratives that seem to arise spontaneously out of the debate. One of the best ways of proceeding consists, precisely, in confronting certain sets of effects with other sets of effects. For example, the digital image suffers from a reputation of being cold, clinical, and dehumanized. By admitting that this qualitative reproach is true and that it can be verified, its meaning can be put into perspective if we compare it with another category of effects: access to information and the incredibly easy way in which it can be communicated, the possibility of multiplying its effect and of circulating it almost instantaneously and ad infinitum, and the ability of users and "spectactors" (not spectators, but spect-*actors*) to appropriate it in increasingly interactive ways.[30] To hazard a somewhat blunt comparison, we might say that Gutenberg's revolutionary invention should also have been reproached for bringing about a dehumanization of interpersonal exchanges and for introducing mechanical coldness at the opposite end of the spectrum from the warmth of manuscript copies and the marvels of illumination. This would be a justified reproach, but this same printing press also made it possible to print and distribute books and writings in large numbers, marking the beginning of cultural democratization and access to knowledge. Comparing the effects of different technologies invites this kind of adjustment. Rupture or revolution, the digital mutation should be approached by viewing the medium it affects not as an undifferentiated mass but as the interaction of complex dimensions out of which the weave of its identity is woven.[31]

One of the regrettable effects of the adjective "revolutionary" is surely its complete lack of nuance. We must reject the idea that digitalization modifies in the same manner every parameter in the media "constellation" and, by extension, in the "intermedia" galaxy. Thus audiences will continue to consume film images, whether they are digitized or not (or whether they were digital from the moment they were shot/filmed or only at the time of making a copy for distribution). They will even continue to frequent movie theaters, whether the projection system has been digitized or not. As Jacques Aumont reminds us, "We still 'go to the movies,' meaning to see most often narrative works, made up of moving images, in specialized theaters we pay to enter."[32]

In the same way, audiences continue to consume graphic novels, or at least sequences of juxtaposed images on a single surface, whether that surface is a tablet or the pages of a book. By putting things into perspective we can predict without too much risk that people will always consume *stories told in fixed, drawn, and sequential images*, whether printed and preserved in book form or in some other format. In the same way, it is certain that music lovers will continue to listen to music archived on some sort of medium or in a database of some description. If there is a revolution underway, its vigor and sphere of influence deserve to be set out and differentiated according to the variety of users of media communication—and, with respect to what concerns us more directly here, according to cinema's "communication" as a whole, while at the same time keeping in mind its heterogeneous nature.

As Aumont remarks, "Today cinema is just one of many manifestations of the power to move that images have acquired."[33] Everyone would agree with Aumont that cinema no longer has a monopoly on moving images (*Did it ever?*). Nevertheless—and here we should qualify, once again, any uniform vision of this supposed revolution—this contemporary flow of images (about which we could say, to distinguish them somewhat from the images of yesteryear, that they are, in Aumont's words, "multiple, digital and nomadic")[34] has, again in Aumont's view, "little affected cinema, but has made television look like a medium from a bygone age."[35] Today moving images lend themselves to the most diverse social uses, but does that truly harm cinema? Our defender of an irreducible last redoubt of cinema's

identity does not think so. His comparison of cinema and literature is worthy of our attention:

> The written word has also been caught up in a dizzying wave of circulation, from constant exchanges on the Internet to contemporary art exhibitions (where *text* is not uncommon). At the same time, no one would confuse a work of literature with a tweet or with a book on view in a museum display case—nor, quite simply, would they confuse the spread of literature with that of language.[36]

It is quite clear what Aumont means when he writes that "no one would confuse a work of literature with a tweet," but just the same it is possible to state today, thanks to the digital "revolution," that there are tweets and then there are tweets. For, over the past few years, a certain kind of tweet has indeed been elevated to the rank of literature. People speak of "twitterature" and there is even an "Institut de twittérature comparée" ("Institute of Comparative Twitterature"),[37] which organizes an international twitterature festival that brings together authors who use "the micro-blogging platform Twitter for literary ends."[38]

What is more, authors as high-brow and well known as Tonino Benacquista, Jacques Godbout, Alexandre Jardin, Michel Tremblay, Yann Martel, and Tahar Ben Jelloun helped support the publication of a "collection of unpublished short stories," each of which was limited to a maximum 140 characters and sought, "by trying to be as modern as possible," to "explore the frontiers of literature in a state of mutation."[39] In this respect, we need also think about those brief forms tied to the new communication of the digital era, such as pocket films made with smart phones. These "mobilograms" can be seen as forms of "mobil*cinema*tography" in the same way that some tweets can become twitterature.[40] We might assume that Aumont would not agree with this proposition, but the question deserves to be asked.[41]

Homo Numericus Cinema

Alongside these intrinsic dimensions of the medium, we need also to understand the digital in the, shall we say, extrinsic way it has

of giving rise to new hybrids and intermedial convergences. While today we are witnessing a mutation related to *multiplied, digital,* and *nomadic* images, this mutation is not necessarily affecting every medium in the same way. Media convergence and the proliferation of screens, both arising from the emergence of digital technology, oblige us to enquire into the consequences of the breakdown of the boundaries between media.

To follow the evolution of this change, let us try to grasp in a more systematic manner the present-day digital mutation according to different aspects of cinema's communicational and media circuit. We will examine it for the most part through the prism of questions that arise from the outset: the *ontology of the filmic image, new creation and production practices,* and the *new ways of consuming films.*

It is clear, first of all, that on the level of the creation and production of moving images, the digital is taking over in every quarter. This is having an effect in particular on the quality of the image, the precision with which images are captured and restored, the means by which images are archived (henceforth in dematerialized form), etc. Techniques such as motion capture make it possible to use digital encoding to record the various positions of objects and living beings so as to then manipulate their virtual replica by computer. A visual reconstruction of these movements in real time can then be stored in an animation file.

Digital technology makes possible almost complete control over the image, facilitating creative work in unprecedented fashion. Thus, while David Lynch is nostalgic about film in the good old days, he nevertheless describes this new creative luxury in the following terms: "loading the film, being able to shoot for only ten minutes, sending the film to the lab, not seeing right away what you have shot: that no longer makes any sense. Digital technology has done away with all those constraints."[42] At the same time, new generations of professional digital cameras, such as the Alexa and the Arriflex, provide image quality of the same caliber and sharpness that was long believed could only be achieved with celluloid film.[43]

Apart from the new equipment and techniques in vogue that succeed one another quickly at the forefront of the techno-cinema world today, not without a minor novelty effect, we should examine the

qualitative impact of digital recording. This, as is well known, does not work on the principle of the impression of light but rather through encoding, something that makes possible all sorts of interventions from the outset. We might even think of digital image recording as constituting this encoding, making possible transfers and manipulations that are both easy and unlimited, because by its very nature encoding makes every kind of manipulation possible. These qualities define what D. N. Rodowick calls the "digital event," which "corresponds less to the duration and movements of the world than to the control and variation of discrete numerical elements internal to the computer's memory and logical processes."[44]

The data that are immediately encoded and thereby dematerialized thus lend themselves, at the very source, to every possible arrangement and rearrangement, a sign of the intrinsic plasticity of the digital image. In a sense, our traditional conception of editing is modified as a result. First of all because a kind of editing we might call intrinsic is inherent in the production of any digital image: even when it has not been retouched, it is always-already a "translation" through encoding and the result of an editing process. Next because these data, already manipulated from the outset through dematerialization, lend themselves to every other kind of manipulation and reconstruction, as Rodowick remarks: "Here montage is no longer an expression of time and duration; it is rather a manipulation of the layers of the modularized image subject to a variety of algorithmic transformations. This is what I call the digital event."[45]

When the Digital Ontologizes Special Effects

Let us try to systematize somewhat this idea of editing (and even pre-editing) which, in the digital kingdom, merges with the very genesis of the images. This genesis can be broken down technically into three overlapping and interconnected phases: digital capture, image synthesis, and compositing. This last operation generally consists in mixing several sources to compose a single shot to be incorporated into the editing. This is one of the final stages in the production of images in a film. Digital media mix these three stages of the expressive process and even do away with the boundaries between them, because

the intervention of the "creator/speaker" can be exercised indistinctly on the whole, because everything is encoding, and because of the manipulation of dematerialized data.

This is where the digital mutation has an effect on cinematic creation. This creativity, founded on manipulation and inscribed in the heart of digital treatment, stimulates and encourages the use of an almost "ontologized" dimension of the special effect we would not have suspected. Special effects, in fact, are no longer an optional supplement or inherent to certain genres, but rather a practice inseparably linked to the elaboration of film images *tout court*. As a result, as Aumont points out, mass cinema has returned to the Méliès tradition: "in its social form as entertainment, cinema has made a massive return to the path set out by Méliès, that of the trick effect, of direct intervention in the image, of retouching, control, drawing."[46] Aumont adds a little further on: "Finally, filmmakers have the right to change their minds and touch up their work, privileges until now reserved to painters."[47] But not just to painters: in keeping with his "classical" French culture, Aumont here overlooks another medium that excels in the art of storytelling with images: the graphic novel. Think in particular, to mention here only the Franco-Belgian school of graphic novels, how the ideas and expressiveness of artists such as André Franquin and Hergé arose from their drawings and the creative freedom of their pencils.[48] Our reference to drawing to celebrate the filmmaker's new creative freedom is thus not insignificant. Here too, however, opinion is divided. For artistic quality does not necessarily depend on this new ability to manipulate the image offered by digital technology. In short, patching something together is not necessarily creative. To its champions, celluloid film and the "culture" inherent in it certainly brought with them constraints, but these in no way limited creativity. On the contrary. In any event, today the widespread use of special effects is no longer the result of a performance whose sources are often hidden, as in Méliès' day; these effects are now incorporated and part and parcel, so to speak, of the film medium itself.

We see, in the same vein, how for certain filmmakers with a perfectionist bent this potential control offered by digital technology

can be particularly reassuring, because the control it gives them is over the entire creative process. One of the things digital technology makes possible is to neutralize the semiotic fracture between the script and the film and to reduce the chance elements of filming, as this latter is at the mercy of human and material factors that can never be brought under complete control. Think of Alfred Hitchcock, for example, for whom the putting on film was always a rather disagreeable trial. A trial *of* the real and a trial *through* the real, in a sense, because it involved managing a cast of flesh-and-blood characters, and thus a coming to terms with the referential resistance of the profilmic. It is in this sense that the "drawing" aspect of cinema evoked by Aumont took a peculiar and literal sense in Hitchcock through that drawn object the storyboard.[49] As one of the two authors of the present volume has written elsewhere, "The storyboard may offer the illusion that one can put off, limit or even avoid the great fracture separating the script from the film shoot and production by inventing an intense contiguity for them. This manner of smothering the media fracture is found in exemplary form in the work of Hitchcock."[50]

The master of suspense did not conceal the fact that for him the entire film played out in the text preceding the film, and more specifically in the graphic preparation of the storyboard, on which he collaborated closely. He describes this work in one of his famous interviews with Claude Chabrol and François Truffaut: "I always do my films on paper And when I start to shoot a film, for me it's over. So much so that I would prefer not to have to shoot it. I have the whole thing inside my head: subject, framing, dialogues, everything."[51]

Hitchcock was thus a "complete" *auteur* in the sense that he did not enjoy, we can imagine, the reduction in narcissistic pleasure brought about by the fracture of the film shoot and production, when the demiurge is obligated to a lesser or greater extent to share his power. His ideal would have been to move his creation along without incidents within a single fictional "isolation tank," like Hergé bringing to life his drawn stories in a homogeneous graphic space under his control alone.[52]

Where does the digital fit into all this? In the fact, precisely, that we might suppose without too much risk of error that the control it provides the artist, who can direct every aspect of the images and the visual narrative, would have been ideally suited to the author of *Psycho*. With it he could have retained the same demiurgic grip on the film that he exercised over the storyboard.[53] We would not be unjustified in thinking, moreover, that the manipulation and second thoughts encouraged by digitalization play the role of a digital storyboard today. And that is not simply a metaphor. In 2008, Steven Spielberg used a digital storyboard capable of simulating with great precision his film *Indiana Jones and the Kingdom of the Crystal Skull*. This "digital storyboard" is a previsualization (a "previz," in Hollywood jargon) with 3D modeling that makes it possible to preview most of a film's action scenes.[54] We could almost say that today the putting-into-film-with-actors need only slip into the digital mold prepared for it. We can imagine how much Hitchcock would have appreciated the comfortable control of such a programmatic storyboard. Another consequence for the film profession: these new activities give rise to new specializations in keeping with the spirit of hybridization proper to the digital mutation. In the case of the Indiana Jones film, for example, the storyboard was supervised by a "previz coordinator" (Daniel D. Gregoire), who came out of the video game industry. Convergence in its pure state!

Many other filmmakers today extol in their own fashion the almost demiurgic freedom, and sometimes the financial autonomy, offered by the digital as a creative tool. Philippe Katerine, for example, in answer to the question "Is your film project tied to the existence of digital cameras?" replied:

> Yes. The equipment gave rise to the film. The original idea was to make a film which, economically, would owe nothing to anyone. That meant no development, no crew, just two microphones and me holding the camera. At the same time, I wanted to use fairly long takes, and thus not be limited by the length of reels of film. Then, because there was no crew, I wanted the sharpness of the image to be done by the camera itself. In this sense, it's also a film by Sony's engineers. They're the technical crew.[55]

Special Effects for All

Although this creative control and malleability enabled by digital technology is a major plus for filmmaking professionals, they also provide disarming accessibility to any amateur with a bit of equipment. High-performance video cameras can be bought at low cost in a market full of multifunctional devices, from the iPhone to the webcam by way of camcorders of every description. An increasing number of software programs can be used, not only for retouching images, such as the famous Photoshop, but also literally to create images and for editing. An amateur sitting in front of a computer can quite quickly take advantage of a software program such as iMovie or Final Cut Pro. In this respect it is interesting to note that, since the 1990s, the software program Avid held a monopoly for much of that time in professional digital editing in the film industry. After Adobe launched the software program Premiere in 1992, Apple developed the editing software program Final Cut for home use in 1999. This program met with great success, to the point of becoming a major competitor for Avid, even in professional circles. To respond to this competition, Avid launched its home version (Avid Xpress) with mixed success: as Olivier Asselin describes, "According to some evaluations, today Final Cut Pro has 40% of the market (against 25% for Avid)."[56] In any event, all this indirectly confirms the fact that there is growing interpenetration in the digital era of the domestic and professional spheres in the production of film images.

From the point of view of an anthropology of film practice, we might salute (or dread, depending on one's perspective) the reduction and even elimination of the distance between the professional and amateur worlds, in particular because of the proliferation of smart phones. Today anyone with a cheap digital camera can present themselves as an artist and filmmaker. These shifts in customs and the need to understand the new forms of intermedial elasticity are quite evident in this comment found in the Parisian newspaper *Libération* on the occasion of the 2011 edition of the Cannes film festival (with a cover page bearing the emblematic title "The Last Cannes Film Festival?"):

Truffaut's famous phrase, "Everyone has two jobs, their own and film critic," has continued to be borne out, as the profusion of

> film commentary on the Internet demonstrates, but we can say we
> are quickly coming upon a state of affairs when a new Truffaut
> could say with a knowing look: "Everyone has one job, their own
> and filmmaker." For the act of filming—with a smart phone, a
> webcam or using cheap equipment but technically of professional
> quality, such as the Canon 5D camera—has multiplied. We can
> speak romantically about the death of cinema or become infatu-
> ated with its extraordinary plasticity.[57]

Note the striking remark in the final sentence of this quotation. Didier
Péron raises the specter of the "death of cinema" but, like Arnoux
in 1924 (and like us today), a "death" such as this can be seen as
a disappearance or as a new birth. Or as both at the same time.
Cinema's extreme malleability enables it to survive, in another form,
all the jolts that history has in store for it. Clearly, in some instances,
there is something that dies, but cinema never does, because it is
made of a "fabric" that is so elastic that it is possible to take new
form after being stretched one way or the other. This, in essence, is
what Stefan Jovanovic remarks in a well-documented article whose
main subject overlaps with some of the aims of the present volume:

> It is evident in my estimation that the discourses I have been
> discussing herein resist the notion of a final closure to the medium
> within [which] they are inextricably bound; hence the propensity of
> death-of-cinema discourses toward a possible "revitalization" of the
> cinema, or postulations of a "post-cinema" moving-image regime,
> rather than toward the cinema's pure and absolute negation.[58]

Do-It-Yourself Cinema

Cinema's malleability is also its ability to curl up and find a niche
in any apparatus that can "play" moving images. A film on a smart
phone may not be "the" cinema, but the very fact that we feel a
need to make this distinction (which has the appearance of denial)
shows that, no matter what happens to it, *there always remains
something of cinema* in the supposedly degraded images of every
very-small-screen device.

Cinema's malleability is also the ability of any smart phone to be used today as a video camera. A good number of events in the world today, moreover, are visually communicated in this manner. The "Arab Spring" upheavals of recent years provide an illuminating example. It is possible, moreover, to draw an eloquent parallel with what is happening in the music world. A multitude of powerful composition software programs has enabled the motivated amateur to become a little Mozart. This democratic access to creating has an incontestably revolutionary quality to it, if it is not revolutionarily democratic.

At the same time, on the side of the reception and consumption of films this time, digital technology (but also, before it, television, the television remote control, the video camera, etc.) has transformed the "traditional" film viewer, who in a sense had to agree to read a film in a passive manner according to predetermined modes of consumption, into a "user" with a certain degree of "control" over these modes. We know that the invitation to *viewers'* reactivity and their intervention in their film "program," begun with the remote control, has considerably broadened under the digital. This of course is not, as Laurent Le Forestier points out, a decisive "transfer of control" conferring absolute (and in part illusory) control on a supreme user, but rather a kind of shared control over the way we consume our moving images. This idea is similar to that of "highly controlled freedom" suggested by Le Forestier, who backs the idea up with a remark by Deleuze (concerning the passage from a disciplinary society to a control society).[59]

This rather optimistic conception of shared control could be related to the distinction made by the French historian Michel de Certeau between two kinds of use.[60] What de Certeau invites us to do is to take into account strategic uses on the one hand (the modes of consumption "imposed" on viewers) and tactical uses on the other, meaning the means by which we each get around or twist the strategies tied up with institutional norms. We might add to this the remarks made to the authors by Simon Thibodeau:

According to this point of view, "traditional" viewers (meaning: [those from] before digital, before the remote control, etc.) were

not necessarily more bound or passive when watching a film (there are all kinds of ways of keeping one's distance, for example by using the movie theater in a singular manner—group outings, sneaking into a second screening without paying, etc.). Nevertheless, they didn't have the means (or even a potential means) to make "direct" use of the film image, whether in their way of consuming it or by producing it. This is something that digital technology makes possible in a [completely] new fashion.[61]

With respect, precisely, to the movie theater, the *locus classicus* of the cinematic spectacle, the installation of a DCP projector (Digital Cinema Package—the digital era's "reels" of film)[62] modifies the exhibition setup in only a marginal manner. For many viewers who watch films in a movie theater, digital and even 3D projection do not seem to have changed much the way in which they participate in the entertainment. Yes, there are a few signs of marvel at the novelty attraction of the system, but we also find reticence, around the great reputation of digital images for coldness, for example, a reputation willingly spread by some people, especially cinephiles.

One thing is certain: at this point in our book what we need in our tool box is a *brief phenomenology of "digitalized" cinema.*

Chapter Three

A Brief Phenomenology of "Digitalized" Cinema

On what is kinematography based? On celluloid alone.
FRANÇOIS VALLEIRY, "LA NOUVELLE PELLICULE," 1907

Films have become files.
DAVID BORDWELL, *PANDORA'S DIGITAL BOX: FILMS, FILES, AND THE FUTURE OF MOVIES,* 2012

Images today are not merely *digital* images; they are also *multiple* and *migrating*. The authors of this volume call this the "DiMuMi syndrome" (for *di*gital, *mu*ltiple, and *mi*grating), behind which we find, on the reception level, one of the most explicitly "revolutionary" dimensions of the digital mutation we are a part of and a witness to. What our "media modernity" offers us are numerous "on ramps"—most often by way of a touch of our finger—to a phenomenal quantity of images, both moving and not. At the same time, the number of screens in our lives is increasing at breakneck speed and they are becoming increasingly adaptable, accessible, and diverse. A terminal as widespread as the smart phone has thus been transformed, to borrow Pierre Musso's expression, into "a kind of multi-purpose electronic Swiss army knife" capable of handling film.[1] We could also adopt the media triad proposed by Thierry Lancien, for whom the rise in the number of screens is part and parcel with "migrating, hybrid and evolving media."[2]

While the qualitative difference seen by viewers when they watch a "digitalized" film compared to a celluloid film may be minimal, what has changed profoundly is the way information has been made universally accessible.[3] We have plunged head first into what Jeremy Rifkin calls "the age of access."[4] This *revolution in access* to an

exponentially growing mass of images is affecting an ever-increasing multitude of users. This deep undercurrent is making its effects felt on various levels and is influencing the different actors in the virtual world, including mega film distributors such as YouTube, Dailymotion, and Vimeo.

Others, however, also profit from this new access to multiple data: teachers, for example, and cinephiles, who can dive into their favorite films however they like (on the condition that they give up the movie theater and celluloid). The cumulative accessibility of films seems limitless and their *digitalized* format lends itself to the most rigorous analysis. Michel Marie remarks:

> I am in favor of the digital revolution, which is causing an upheaval in and expanding the way we make and view films. To be able to see on DVD every film by Capellani, André Sauvage or J. B. Brunius is tremendous. This was unthinkable twenty years ago. It is throwing the way we consume films into upheaval. . . . It does not hinder the enjoyment of seeing a film in a movie theater. The two things are complementary. And it's an exceptional way to study film.[5]

Is this a different kind of sensorial stimulation? A different mode of participation? Is unbounded digitalization modifying the quality of the film image as it is perceived and received by the user? These are big questions and give rise to passionate debates in which it is not always easy to discern nostalgic rearguard battles or in-your-face provocations by militant technophiles. Without pretending to exhaust the matter, we have chosen here to approach it through a brief ontology of the film image resulting from digitized capturing and restoring. Or, more precisely, through an examination of the pragmatic consequences of such an ontology. We will focus in particular on the still/animated dialectic and its corollary with respect to managing the time of the image.

An Essentially Discursive Image?

A theoretical description of digitally recorded images finds itself right at home in some of the fundamental concepts proposed by

Charles S. Peirce. The indexical nature of traditional photo-realist images is often a topic of study, as it is the very principle of photography: passing through a lens, light leaves its trace, is preserved, and then restored. With digital encoding, this essential imprinting, this strong contiguity with captured reality, is lost. It is no longer a case of catching hold of and restoring a slice of profilmic reality, but rather of encoding the "data" seized by the device. With the digital, to record reality is already, and simultaneously, to reconstruct it. We know of course that any representation, however slavishly recorded it may be, is always-already a (re)construction. We even know, since the work of Philippe Dubois in particular, that "with photography, it is no longer possible to consider the image apart from the act that brought it into existence."[6] But a more radical system is activated with digital capturing-encoding, such that it is possible to speak of "literalizing" and "essentializing" this act at the very heart of the photographic medium's digital technology. Laurent Le Forestier's comparison of the DVD with optical toys is quite in keeping with these ideas:

> The loss of belief in the image is, in a sense, compensated by an increase in illusion—and this illusion is once again connected to the viewer's manipulation of the device. But here too the nature of this illusion points up the gap separating the DVD from the optical toy. For, clearly, what is illusory is the interactivity itself: the illusion no longer resides in the object being viewed (as it does with cinema), or in the viewing itself (as it does with optical toys), but rather, now, in the mode of viewing. Interactivity, meaning the freedom to act on an object, is most often limited to giving order to the object, to giving it form out of pre-existing elements. This is a kind of supervised freedom, or more precisely a highly controlled freedom.[7]

More broadly, and at the risk of offending purist Peircians or semioticians who are sticklers for principles, what digitalization provides access to here is the analogical system. In the sense that the image produced by digital capturing loses its indexical status to become part of the iconic system (a sign not integrated into reality through metonymic contiguity but rather a sign added to this reality,

maintaining with it a relation of imitation and resemblance, a metaphorical bond). In this respect it is not by chance that an author such as W. J. T. Mitchell sees in the digital recording and manipulation of images a form of cloning.[8]

Note that the adjective *indexical*, applied to the silver gelatin photographic image, can itself be disputed, given that it is, precisely, a photo-realist image.[9] Photo-realism is a form of imitation of reality by analogy and has a metaphorical relation with it. It must be admitted, however, that a photo-realist silver gelatin print has a much higher degree of indexicality than does digital encoding and translation. As D. N. Rodowick remarks, "What appears to be photographic, and therefore causal, is simulated and therefore intentional."[10] The photo-realist image, or rather the *photo-realist effect*—the way Roland Barthes spoke of a *reality effect*—arising from digital capturing and restoring is, for its part, taken over by the system of the Peircian "symbol." This kind of sign, as we know, is characterized by conventional abstraction and the arbitrary quality of the code, hence the fracture between this kind of digital image and the indexical image found in photography. Rodowick explains: "What looks photographically 'real' has actually shed its indexical or causal qualities. Our previous perceptual criteria for realism have now ceded fully to imagination, fantasy, and the counterfactual powers of possible worlds. When photography becomes simulation it yields to a new imaginary that is unconstrained by causal processes."[11]

As a result, the very notion of the shot finds itself contested. Rather than a traditional shot, the digital mutation provides filmmakers with modifiable units, indefinitely transformable by "interactive manipulations." Thus cinema, for Rodowick, "has become more like language than image."[12] Cinematic shots, scenes, and sequences are thus more language than image, as if they were the pure products of discourse marked from the outset of their—digitally encoded—genesis by intentionality. This in fact is Rodowick's argument: "Digital synthesis produces an image of what never occurred in reality; it is a fully imaginative and intentional artifact."[13]

The digital thus disturbs the mimetic system of the photo-realist image. Its iconic representation of reality loses some of its indexical proximity and credibility when its capturing of this reality is

joined with its synthesis within the new images. The indexical status of photo-realist images of captured reality (the profilmic) is thus in the process of slipping toward the ambiguity of metaphor, the simulacrum, simulation. Digital images thus oblige us to reconsider the relations between the indexical and the iconic.

Do Users "Believe In" Their Images?

Let us take a break from this ontological discussion. Now would be a good time to examine the pragmatic effect these new digitalized images have, or not. We need only look at the everyday habits of a good many users. All amateur photographers experience the same pleasure of photogenic recognition when they select the family scene that they believe they best captured among the flow of pictures taken on the fly. Someone taking a picture today of a baby eating, like Lumière more than one hundred years ago, seemingly also experiences the feeling that the scene will go down in the family's history. Just think, they grow up so quickly! Have things really changed so much with respect to this feeling of having produced a recording that matches reality, of having used a camera lens to catch a scene in the family anthology? The photographic apparatus is still obsessed with capturing and restoring the world, and its reputation remains that of bearing witness to a recorded reality. Despite Photoshop and the like, we still tenaciously attach this "documentary" notoriety to it today. On this score we need only think of the extent to which we still put our faith in this documentary quality of the photo-realist image: Roland Barthes' famous "what has been."[14] Think of the colossal number of things we are aware of in the world and how up-to-date our knowledge is of current events, and of culture in general, without ever having been in their presence, thanks to images. Who among us, upon seeing a news photograph of Barack Obama, even if we have never met the American president in the flesh, would dare say: "That is not Obama in the picture"? A large proportion of scientific and medical imagery remains in the realm of this guarantee of authenticity that photographic capturing and restoring has bestowed since the nineteenth century.

What does the digital change in the very deep-rooted "referential faith" we persist in placing in images created under the photo-realist

system? The answer to this question deserves a long discussion that is impossible to undertake in the present context. We can, however, draw out a few major lines of such a response. To return to the example of the family photograph we gave above, what has changed is the importance of the flow itself. Amateur photographers or video makers can shoot without counting their shots or takes, without paying the price. The expression "wasting film" no longer holds, and a single limit now remains (even as it is constantly being pushed back): digital memory. The more qualitative concept of the "pose" is now also out of date: when it comes to the human profilmic, it is pointless to "act," to fashion one's posture; in the end, the camera will always capture a satisfying image or a sequence. In a certain sense, this potential overabundance of images produced by users is in tune with the overabundance of images offered up by the immense inter-iconic cultural market. This leads us to ask another, more qualitative question with respect to our visual culture—that of saturation, of the overly full and, perhaps, of widespread indifference: one image always follows another in perpetual fluidity. We know, moreover, that in this respect the Internet, that great image reservoir and colossal image distributor, has remained to date a cumulative medium much more than it has become an integrative medium.

These remarks lead us to the question of addiction that is sometimes raised with respect to the digital and new media. Here the word *addiction* should also be understood in the quantitative sense of its paronym *addition*. In a sometimes shrewd manner, the digital world incites users to accumulate objects, media, technologies, and services to the point of saturation. The consequence of this addiction/addition is that one easily passes from an *activity* one carries out to a kind of *reactivity* that carries us along. The addition *of* diverse solicitations and the addiction *to* diverse solicitations (if only via the e-mails we receive) thus oblige us to be constantly in reactive mode: read, save, put in the recycle bin, reply, find links, follow a website's suggestions, etc.

In our digital universe there is thus a plethora of images, each of which is often as good as the next. This kind of generalized equivalence of images ties in with another equivalence of a more ontological nature. The capturing-encoding of digital media tends to erase the

difference between images, particularly in the documentary system and with respect to photo-realism's "testimonial" value. Rodowick remarks in this respect that "in its numerical basis, digitally acquired information has no ontological distinctiveness from digitally synthesized outputs that construct virtual worlds mathematically through the manipulation of a Cartesian coordinate space."[15]

As we remarked earlier with respect to intrinsic editing effects, the cross-media, universal aspect of encoding takes precedence over image recording. Put another way, the traditional traces created by capturing and restoring no longer guarantee the reality of that capturing. The numerical basis of the image being the same, this capturing can very well pertain to the virtual and to the work of synthesizing. It doesn't matter, digital logic appears to say. Images of the real world can now blend in with fiction's images of possible worlds because they are constructed and perceived in the same way. And this point surely touches on the ethics of our faith in images, particularly with respect to the documentary contract and journalistic coverage of the world's factual events. How can users tell the difference? Is the difference even relevant? If the photo-realist aspect of an image fools me once, who can assure me that it is not capable of fooling me every time? This too is a huge topic and brings in the question of the caesura and the radical fiction effect proper to any representation of reality, but it is a question that undoubtedly becomes especially stiffened in the digital era. It is also tied up with the opposition between representation and simulation that has been studied by scholars such as Lev Manovich.[16]

Persistent Rumors of Coldness . . .

This generalized equivalence of the digital can also be seen, let us repeat, in the multiplicity of devices across which our images travel. Users consume films on a multitude of screens and receptacles. We might even wonder, with respect to the ontological discussion above, whether this variety of consumption sites is not in the end more decisive than the loss of the invaluable indexicality that gives celluloid film and recordings by analogue moving picture cameras their singular quality.

The same could be said of the recurring reproach of clinical cold-ness and excessive perfection leveled against digital "film." To the extent that such coldness exists, is it perceived in the same way when one consumes a film on a tablet, a telephone, a television, or when one looks at an IMAX screen? Jacques Aumont describes an Inter-national Federation of Film Archives gathering in 2006, when film preservation professionals from around the world were unable to tell a film projection and a digital projection apart: "On that date it became clear for everyone—not without a few shivers of horror or melancholy among those further on in years—that high-resolution digital projection was equal in quality to film projection." Aumont hastens to add, in parentheses: "(This, I admit, astounds me, because even if the image definition is as good, or better, digital projection can be identified, precisely, by this cold perfection.)."[17] Here he is following in the footsteps of Jean-Philippe Tessé's remark on the loss of the indexical warmth found in film grain: "This grain has now been replaced by an electronic simulacrum ("image noise") whereas before it was evidence of an element of reality being deposited on the film by means of a chemical reaction, like the effect of the sun on the skin."[18]

With respect to how the digital is perceived qualitatively, its reputation for "cold perfection" appears to haunt the entire digital image circuit. To try to better understand what we must indeed call a reproach, let us take the example of the reception of the new tech-nique known as the "high frame rate" (HFR) used in films such as *The Hobbit: An Unexpected Journey* (Peter Jackson, 2012).

One of the fundamental features of the digital universe is that it makes it possible to develop rapidly an increased number of many new techniques. High frame rate is one such technique. Here is a catchy introduction to the technique that gives a good idea of the novelty effect it is striving for (attraction, you are always in our hearts . . .) as it fearlessly bandies about the word *revolutionary*:

> The Gaumont cinemas in Toulouse invite you to share a unique cinema experience thanks to High Frame Rate projection tech-nology. This major new digital-era revolution doubles the speed of usual film projection, leaving 24 frames per second behind to

pass directly to 48 frames per second. Twice as many images for a heightened sensation of ultra-realism and fluidity. The Gaumont and Pathé cinemas invite you to its movie theaters to discover this major development in the history of cinema.[19]

The journalist Michael Oliveira's comments about the use of 3D in *The Hobbit* strike a similar note: "This technology should create a more persuasive effect and add realism to the aesthetic of a film's scenes."[20] Here we can pose an initial question: why speak of a *more persuasive* 3D effect? To persuade *whom*, and persuade them of *what*? Is this because the realism of 3D, the brightest jewel in the digital crown,[21] has been deemed insufficiently persuasive until now?

With HFR we are thus in the presence of an ultra-realism that Bazin, with his idea of total cinema, would not have repudiated, because this technology provides hitherto unseen precision of movement. Just as motion capture has been doing for some time now, in its own way and using different technology: what motion capture is after is not so much *high definition* as it is *high animation*. The fluidity of HFR, however, creates a greater sense of transparency and a more realistic image (or at least the illusion of greater realism).

Nevertheless, this new advance in "media comfort" has a few drawbacks.[22] This at least is what we can infer from the remarks of Hans-Nikolas Locher, head of research and development at France's Commission supérieure technique (CST):

We are heading towards an increasingly precise and almost clinical image. Before the arrival of HFR, 4k digital images caused problems, because they tend to make the background too sharp, distracting the viewer from the action. The argument of those in favor of HFR is that the number of images per second must be increased to capture their attention once again.[23]

There you have the word of a specialist: we are headed toward increasingly "clinical" images. *Clinical* asepticizing, *clinical* coldness. This, we are told, is the essential quality of digital images, which neutralizes the effects of depth of field and places everything (the set and the characters) on the same level of visual intensity—here we find the

syndrome that runs through the digital, that of nondifferentiation—thereby creating the danger of interfering with the film's monstration and narration. Note, however, that here our specialist gives this a positive connotation, unlike the critics of the digital discussed above.

Digital and the Magic of Cinema

Beyond the novelty effect to which this new digital (r)evolution gives rise (and which soon dims) by means of the ultra-realism of HFR's high-definition image, criticism has been leveled against it that could be applied to all digital images. In an article entitled, significantly, "*The Hobbit*: Does the new video format ruin the magic of cinema?" the journalist Philippe Berry describes a number of reproaches leveled against the new technology that we would do well to unpack here.[24] One such reproach is that the heightened sharpness of movement and increased fluidity promised by Peter Jackson are only promises "on paper." While Jackson swears that it helps avoid headache, Berry maintains that "too much sharpness kills the dream" and that "those who own a recent HD TV know this feeling." Other criticisms in the article are in the same vein. This one, for example: "There is no magic because the images are too realistic. In the indoor scenes, there is too much of a sense that we're in a film studio." At the same time, the acting seems "closer to the theater."[25]

Grasp at too much, lose all, the saying goes, and HFR 3D gives poorer results than the "classical" 3D of a film such as Ang Lee's *Life of Pi* (2012). To back up his "digital skeptical" point of view, Berry does not hesitate to call on the opinion of experts:

> "We don't understand this effect 100%," the neuroscientist Paul King remarks. He explains: "Some people believe that a lower number of images per second captures the imagination" and activates the state of "willing suspension of disbelief" in the viewer. With sharper and more realistic images, on the contrary, we see the stage tricks behind the magic act we call cinema.[26]

This comment surely merits an in-depth discussion because it touches on the complex and fascinating phenomenon of how we

enter into fiction, as Coleridge's famous expression used here by King describes. Coleridge's "willing suspension of disbelief" is not dissimilar from Octave Mannoni's equally famous "I know very well, but all the same." To participate in the illusion of fiction, to play at make believe, we have to be perfectly willing and activate that part of ourselves that agrees to believe. In the context of cinema's moving images, this "liberation" or willing activation is said to be facilitated by the relative slowness of the flow of images. Or, viewed from a technological perspective, by the low level of performance of the apparatus responsible for that flow—by its relative "shortcomings." Because a lower number of images per second is better, "some people believe" (as Paul King remarks), at inviting our imaginary participation, the high-speed flow of high definition is paradoxically less effective—not in terms of realism but in terms of the quality of our imaginary involvement. The most direct explanation, albeit the most difficult to demonstrate, consists in accounting for the quality of this involvement through the fact that "users" of fiction must, in the case of lower definition images, contribute more to fill in the gaps of the monstration, for which they must "compensate." And this compensation is effective only if viewers truly play the game by *really* entering the work. This is the measure of their emotional participation. And thus the circle is complete.

Echoes of this degree of participation in inverse relation to the shortcomings or performance of the representational apparatus can be found in an article on the graphic novel that one of the authors of the present volume published in 1993:

> With respect to the imaginative power of the fiction constructed, the graphic novel's seeming lack does not equal qualitative shortcoming. On the contrary, we might imagine that the effort it must expend to create its referential illusion is naturally in keeping with fiction, at least if we take the latter as an imaginary assemblage. . . . The "weak realism" of the graphic novel is a sign of its fictional purity. The resistance of the code and the entirely fabricated graphic consistency paradoxically make possible a "truer" fiction, all the more credible for being admitted by the active consensus of a complicit reader-viewer.[27]

We might also mention, on the topic of the graphic novel, the comments of a filmmaker—and not just any filmmaker: Federico Fellini—who described his scriptwriting collaboration with the cartoonist Milo Manara in the following manner:[28] "Graphic novels, more than films, benefit from readers' input: you tell them a story that they tell themselves, at their own pace and using their own imaginations. . . . The graphic novel is a purer form of expression than cinema because it is less realistic and more allusive."[29]

Many other authors, philosophers, educators, and cartoonists have also underscored this fictional dynamic, in which the caricatured and roughly sketched figures found in comic books,[30] for example, show themselves to be capable, despite their "rough sketch" quality, to bring about intense emotional involvement on the part of the reader. One thinks of E. H. Gombrich's hobbyhorse: this hobbyhorse resembles a horse only schematically, yet for the child riding it, it is a steed truer to nature than nature itself. In this respect, Gombrich remarks that "the common factor [is] function rather than form. Or, more precisely, the formal aspect which fulfilled the minimum requirement for the performance of the function."[31] As early as 1827, the cartoonist and professor Rodolphe Töpffer described in the following manner the "little people" that children draw:

> I have seen some . . . which, as gauche and badly drawn as they are, vividly reflect a striving to imitate, a striving to present thought, to such an extent that the latter is always . . . infinitely more marked and successful than the former. Indeed, although we see only barely recognizable limbs taken one by one, a fabulous face, a poorly constructed belly and two sticks for legs, there is from the outset a striving to depict an attitude, unequivocal traces of life, signs of moral expression, and symptoms of ordering and unity: marks above all of the creative freedom that prevails high above the servitude of imitation.[32]

This detour through the vitality of our experience of fiction is thus one way of understanding the impression of hyperrealist coldness left by a technique such as HFR in its present state of development. The difficulty lies not on the level of content, but in the too

high definition to which film audiences are not yet accustomed. These images deemed too sharp and too clean have been compared, in an astonishingly consistent manner, by many viewers in online discussion forums to watching a television soap opera. Consider this comment on *The Hobbit*, for example, published in the online newspaper the *Atlanta Blackstar* in 2012:

> Early reviewers have compared the higher frame rate versions to high definition television shows, and have accused the format of making the special effects and scenery appear to be fake due to the sharpness. "This wildly expensive visual technology paradoxically conspires to make everything else in the film look cheap," said *Slate*'s Dana Stevens. "It's hard to overstate the degree to which the 48fps format interfered with my ability to get lost in this movie's story."[33]

Thus some people worry: what good is improving the quality of the relief in a 3D film if one pays a high price by rendering the work aseptic, even sterile?

In Search of Lost Duration

What emerges out of the above is that the descriptive *digital* is a far from neutral term. It carries with it a connotative network that attributes to it an aseptic coldness that makes it appear hyperrealist, to be a truer-than-life, more-than-sound depiction. But the term has in addition a deprecatory side, because it also suggests inhumanity, death, the absence of warmth and vitality. Exactly, precisely, like the adjective *sterile*, used to indicate security, protection, and the preservation of life—and the contrary: a void, the absence of life. Jean-Philippe Tessé has summed up the entire connotative network associated with digital media's cold sterility, suggesting that the quest for perfection is confronted with "dogmas whose symbolic meaning we run up against: extreme fixity; smoothness; compression; ridding the medium of imperfections, the unexpected and roughness; the eternal juvenility of the images which will never age, never have any history. Scrubbed, hygienic, disinfected images."[34]

In the case of the film image, this sense of mortiferous asepticizing is not unrelated to a kind of collapse of time that occurs with digital capturing and encoding. This is yet another ontological dimension. The captured light is not transformed into computer code without collateral damage! Recording reality digitally thus fractures duration, rendering the living time of the profilmic sclerotic. This, as we have seen, is Rodowick's position, as he argues that "the spatial unity of the image . . . is broken."[35] For those who think like him, digital encoding fractures or at the very least alters the spatio-temporal unity of the profilmic captured by the moving picture camera. The imprint of light on celluloid, on the other hand, preserves this duration, which merges with the act of photographing the event in almost tactile contiguity with this act. According to Rodowick, this accounts for why the video maker Babette Mangolte poses the following question, which to his eyes is crucial: "Why is it difficult for the digital image to communicate duration?"[36] Rodowick takes up this question in his own manner: "Can digital cinema express duration and past-relatedness with the same force as film?"[37] The digitalization of film may animate the image and give it back movement, but it would appear that the duration of the photo-realist image has been broken up. A comparison with sound recording can help us here: the champions of vinyl record albums as opposed to CD and other digital media argue that the "indexical" sound produced by the contact between the grooves and the turntable needle has irreplaceable depth, proximity, and warmth.[38]

Beyond these questions, however, there is an aspect of digitalized film that overlaps at one and the same time the user's everyday experience, ontological issues, and the institutionalized division of images into territories. This aspect is the boundary, for a long time seen as stable, between still images and animated images, something that digital capturing and encoding tends to eradicate.

Let us begin, once again, with the user. Any device on the market today lets amateurs pass quickly from taking still images to video images. Better yet, this video mode is one of the basic optical options of these devices, along with the portrait and landscape formats, etc. Between the video and the still image mode, the burst mode lets

anyone play at being a "chronophotographer." The same is true for viewing images on the screen, which can bring a still image to life with a simple click or tactile contact. No one today, with all the screens about, is astonished at these screens' hypersensitive skin. The opposite is true: people are perplexed by a fixed image that resists being brought to life, especially when this image is part of a screen environment in which animation is everywhere.

With hybridization and cross-fertilization constituting something of digital technology's signature, we find them in the way the digital has of bringing about the (relative) obsolescence of the still/animated dichotomy behind so many university programs, in which it was one of the principles used to categorize a work. As Laurent Guido and Olivier Lugon explain,

> Among the many unexpected consequences of the passage to digital technologies, one of the most profound is incontestably the sudden convergence of the categories still image and animated image. While until this passage they had been seen as mutually exclusive, occurring in distinct institutional spaces and requiring the use of different media . . . and making up the cultural and intellectual economy of independent university disciplines, today they appear to be simply two variants of the same entity, without a stable boundary between them.[39]

In this sense, let us repeat: within the flow of digital visual media and through the widespread animation of these media, the "moveable" image has become almost the norm and the still image the exception.[40] Put another way, today it appears as if the still image has now sworn allegiance to the superior principle of movement: as if the still image was never more than an initial state of lethargy that could be reversed with just one click of the mouse at any moment. It is as if its stillness was *virtually* movement.

Naturally, before the digital era the still/animated caesura was not always as rigid as one might think. In particular, the nature of this caesura varied according to the institutional framework in which it was situated (the academic tradition of classifying image studies, for example). In addition, an increasing amount of historical research

demonstrates that these two registers, *still* and *animated*, often inter-penetrate and that their seeming opposition turns out to be without basis in more than one respect, as the work of Maria Tortajada[41] and Caroline Chik,[42] for example, has demonstrated.

Nevertheless, it is clear that the porosity of the boundary between the animated and the still—one might even say the fusion of these two modes—is more than ever a contemporary concern, if only in the way we capture and consume images on screens on an everyday basis. We might even formulate the hypothesis that in the digital era the *animated image* is the dominant cultural series. We could undoubtedly even raise it up as a *meta-series*, justifying the use of a capital *A*: Animation. Indeed the "dispositif" animation seems to us to subsume the still and animated image and, on that basis, to neutralize what formerly made them incompatible.[43] Here too the users themselves, when they are before a screen configuration involving Animation, can choose a still "contemplation" mode (by hitting the pause button or by choosing not to activate the animation) or an "animated" participation mode (by hitting the play button or by activating the animation). True, this was already possible with the video recording machine. But in the new digital screen systems, contemplation and animation have become almost indiscriminately accessible. By *not* clicking by an image programmed to come to life on demand, one can decide *not* to set the image in motion. Conversely, one can interrupt any image flow and decide to stop on a fixed image. Here we see certain fundamental features of the world of video games and how they have taken playability and interactivity to new heights. In this sense, we might say that the digital puts within reach of every viewer the singular prosody and rhythm of Chris Marker's *La Jetée* (1962).

The recent digital mutation thus forces us to reconsider a conceptual dichotomy that one of the authors of the present volume once proposed we distinguish through two neologisms: that between *homochrone* media and *heterochrone* media.[44] In the former, the time in which messages are received is programmed by the medium. In the latter, the time of reception is not determined by the medium, nor incorporated in its utterances. In a homochrone situation, therefore, media products are designed to be consumed in an intrinsically

programmed duration. The reception time is absorbed and integrated into it; it is determined by the media utterance itself:

> A film screening and television and radio broadcasts are designed so that the message matches the duration. If receivers remove themselves from the duration programmed by the medium, they run the risk of breaking the temporal interpretive cooperation programmed by the homochrone medium. . . . To receive and enjoy the message is to accept the temporal broadcast directives. This is surely what gives a degree of legitimacy to the academic distinction that places specialists of the still image and those of the moving image into two quite separate camps.[45]

In a heterochrone situation, on the other hand, the time it takes to consume the message is not incorporated into the medium, is not a part of the time of the broadcast. This broadcast time, separated from the medium, does not seek to regulate the reception time. With graphic novels, for example, readers remain in control of the speed at which they read and where they stop and look at an image.

Controlling the Time of Images

In the digital era, the boundary between heterochrone and homochrone appears to have been effaced, or at the very least become porous. More precisely, our new screens and media are unusual in that they mix up the heterochrone and homochrone, making each system only provisional in a sense. Better yet—and here we see emerging one of the major features of the digital era, interactivity—it is *spectactors* (and not spectators) who increasingly hold the keys to activate a reception system and posture by turns heterochrone and homochrone. This porosity, this hybridization of the time of reception, moreover, is an essential feature of hypermedia today. In a sense, and to express the matter in a somewhat dialectical manner, they have moved beyond the "heterochrone *thesis*" and the "homochrone *antithesis*" to reach a *synthesis* we might describe as polychrone. That said, there still exist of course exclusively homochrone or heterochrone media. It is hard to picture, or rather it would sound funny to our ears, to speak of the radio as something

that could one day be anything but homochrone. Just like the radical example of music, because to stop playing music is to annul it.[46]

Here is an opportunity to return to cinema. Some champions of the medium's last redoubt of identity, even though they do not use the same terms as we do, see homochrony as irreducible and invariable. Jacques Aumont, as we noted above, is one of these guardians of cinema's untouchable base identity. He asks what remains of the "more or less solitary viewing of a large moving image in the dark, commanding our attention without us being able to act on it."[47] His categorical response maintains the homochrone as cinema's inalienable identity principle, because there the film imposes a "modeled and modulated" time:

> To look at a work of art "analytically" in painting means to focus in turn on different parts or different aspects of a work; in cinema it necessarily means breaking the work up, fundamentally altering our experience of it and not seeing it in its correct and vital unfolding but in bits and pieces. . . . I would be the last to say that viewing a film analytically in this way cannot be satisfying, but it is quite simply a different viewing, one that is not what the cinematic apparatus calls for. If one must spell it out: it is not cinema.[48]

This "unfolding," experienced by the viewer in real time, is a "correct and vital" cinematic principle, a necessary condition to what we might describe as an *epiphany*.[49] For Aumont, the homochrone is thus well and truly essential, a necessary condition of cinema's identity. It is an indispensable feature if we wish to describe the *cinematic* on an ontological level. At the same time, this statutory homochrone epiphany is, for Aumont, a source of magical fascination and an incitement to cinephilia.

Today a similar debate is also taking place around the heterochrone world of the graphic novel, in which the homochrone and the heterochrone occupy opposite positions. Does the graphic novel lose its "epiphany-like soul" when the possibilities introduced by the digital enable it to open up to movement and animation, and thus to the homochrone? On this topic, Magali Boudissa remarks that "with digital technology it is now impossible for authors to be certain that

each reader will read their graphic novel in the format in which it was created."[50]

Thus when readers read a graphic novel on a screen (whether the work was designed for the Internet or not), they must deal with the fleeting visibility of screen pages—an element of the screen amnesia phenomenon[51]—which "contrasts with the immutable materiality of paper images."[52] With the digital and the possibility of scrolling through screen pages, for example, the spatio-narrative layout of the graphic novel becomes temporal. The crystallization of vignettes in space, the "epiphany-like" heterochrone quality of the graphic novel, is no longer intangible. In short, the heterochrone employs what Boudissa calls a "flipped-through quality" to enter the realm of the homochrone: "The way the vignettes appear in sequence in the plate creates a flipped-through quality in the sense that the vignettes break down into successive strata in the plate."[53] We know to what extent this "flipped-though" quality can be found on our screens, which operate by means of superimposition or the presence of more than one "layer," as Lev Manovich has pointed out.

This new instability in the boundary between the still and the animated is growing today. In numerous webcomics read digitally it is possible to animate some of the boxes and still images, and in some cases all of them. Often it is the reader who sets this programmed animation in motion, thereby retaining the heterochrone initiative of setting in motion, so to speak, while at the same time taking advantage of the animation, also in a heterochrone mode.

Curiously, the reduced imperviousness of still and animated visual media makes cinema more accessible, as each user can take apart the previously hidden mechanism that created its magic. On this topic, Laurent Guido and Olivier Lugon remark:

Paradoxically, the conception of film as a juxtaposition of isolated images has never before been so close, through the pause feature on any DVD player, to the common experience of the average user of cinema in the digital era—against the material conditions of the traditional film screening, which made it impossible to perceive concretely the still images on the film strip being projected onto the screen.[54]

A situation such as this is not without effect, at least on the ontological and narratological levels. Guido, in his comments on an article by the American scholar Tom Gunning published in his coedited volume, notes that Gunning demonstrates how instant photography has made it possible to perceive movements that hitherto had been completely invisible, at the same time as they contribute to "reveal[ing] the transitory, the fleeting, the ephemeral, the commonplace, whereas the classical aesthetic of someone like Lessing demanded the selected, emblematic, vital moment."[55] Cinema projected images in a continuum, using a flow founded on duration—"those frozen moments produced out of the arbitrary," Guido calls it: the fleeting, secondary, everyday moments of life.[56] In a word, *nonvital moments*. In a sense, digital media and new technological devices enable us to recover, by stopping on the image, the "secret" of editing (or what goes on behind the scenes). Here too, then, viewers can subvert the homochrone vocation of the medium's flow and manipulate it in a heterochrone manner. They can stop on any film frame or any image in the flow of moving pictures. In almost narratological terms this means that users, looking at their domestic screen, can give any fleeting moment back its vital quality. In doing so, through this simple interaction, they can go so far as to reorganize the program of narrative tensions built into the work, relying instead on an ensemble of vital moments.

Given that these rather minimal forms of interaction have such consequences, one understands the importance of those that derive from the accelerated evolution of other forms of interactivity in combination with media hybridity of every description. We are thus in the presence today, among many possible examples, of a convergence of television series, video games, social media, the smart phone, and mobile platforms equipped with cameras and screens and even voice recognition and geographical-positioning technologies. In *Last Call* (Milo, 2010, produced by Deluxe Films and the advertising agency Jung von Matt), for example, a "fictional" character can make a real phone call to a viewer in the movie theater telling him or her what to do.[57] This viewer can then lead the film in a direction of his or her choice, with the attendant effect on the

unfolding of the story. Olivier Asselin puts this into perspective with the following comments:

> On the one hand, real-world information is now often located on the Internet, notably through mapping software and interfaces, producing a kind of augmented virtuality; on the other hand, virtual information is now often located in real space, notably through augmented reality applications. In this expanded field, new forms of cinema and games have emerged that deploy pervasive transmedial narratives.[58]

This brief phenomenology of digitalization, as partial as it may be, has led us in multiple directions, given the rapidly changing reality that we have had to examine in order to produce it. In this chapter we have paid special attention to the phenomenon that lies at the very basis of kinematography: capturing an image. Beyond questions around the digital operation par excellence that we have called *capturing-encoding*, there looms capturing-restoring, which is not *encoding* properly speaking, even though in the end it corresponds to a number of codes—in particular in the way it passes from a fairly limited *procedure* on the *semiotic* level (recording images with a moving picture camera on celluloid film) to a more complex *process* (*filming*, which "sublimates" in a sense the mere act of shooting). In the passage from *shooting* to *filming*, cinema thus reaped the fruit of what we will call in the next chapter the *Aufhebung* effect.

From Shooting to Filming:
The *Aufhebung* Effect

Whenever I hear the word "cinema" I can't help thinking "movie theater" rather than film.

ROLAND BARTHES, "LEAVING THE MOVIE THEATER," 1975

No amount of mourning will revive the vanished rituals—erotic, ruminative—of the darkened theater.

SUSAN SONTAG, "THE DECAY OF CINEMA," 1996

We know that for Roland Barthes, as the first epigraph to this chapter demonstrates, the movie theater was a special, unchanging place. Today, however, the movie theater, the jewel case of filmic attractions, appears threatened by the *digital revolution* that is turning our traditions upside down and putting our habits topsy-turvy and that just a short time ago precipitated a crisis. Yet the movie theater and celluloid, let us repeat, are the two major principles on which most definitions of cinema bequeathed to us by the twentieth century are based. For the champions of the cinephile tradition, it is hard to conceive of cinema *without the movie theater*. And it is hardly any easier to conceive of it *without celluloid*. And yet this is the exercise in spectatorial gymnastics to which the passage to the digital invites us. Say goodbye to the cumbersome projector! Say goodbye to the cumbersome reels of film! And say goodbye to the equally cumbersome projectionist! Projection, which at one time was the *sine qua non* of film reception, has become, as we described above, merely one mode of consuming a film among others. This is inescapable, irreducible. The gig is up. Cinema (or the film?) has been irreparably knocked off its pedestal.

Chain reactions: because the movie theater (the theater primarily intended for film screenings in a form we might describe as

"classical") does not want to die, it is seeking out other, complementary, functions. Today the movie theater is used to serve the viewer in a way quite different from that at the time, say, of the golden age of institutional cinema. This is true today and will be even truer tomorrow. The movie theater is in the process of becoming (or re-becoming, in fact) a crossroads of cultural series foreign to cinema: opera, ballet, and other stage performances, along with sporting events, television programs, etc. Thus New York's Metropolitan Opera has, for some time now, been transmitting its productions live via satellite (an example of those "harmful" things known in France as "not-film") in movie theaters that previously had shown only films on celluloid.

The situation has become so entangled that the following question, as astonishing and seemingly contradictory as it is, now appears to make perfect sense: are the images we see at "the cinema" still "cinema"? It is almost as if the digital revolution has reversed the underlying premise of institutional cinema and that of what we might call institutional television: on the one hand, a "cinema film" (let us call it that, because nothing is self-evident any longer in cinema's new digitalized world) was something you saw (1) in *public*, (2) on a *big screen*, and (3) in a *movie theater*. On the other hand, the live broadcast of an opera or televised gala was seen (1) in *private*, (2) on a *small screen*, and (3) in a *living room*.

Now that digital technology has made possible the proliferation of alternative practices out of all proportion to anything seen before it, and *ordinary viewers* can choose to watch films in the comfort of their home, whenever they like, rather than according to a restrictive schedule set by someone else, we can say hello to the oxymoron *home theater*.[1] Now that digital technology has made possible the proliferation of alternative practices, and movie theaters are looking high and low for new vocations, we can also say hello to the equally oxymoronic *tele-agora*![2]

From the Movie Theater to Home Theater

Years after the new practice *home theater* brought "movie theater cinema" (let's call it that) into our homes, we are now seeing the pendulum swing the other way, in the movie theater this time: productions

normally intended for the small screen are now being shown on the big screen.

We must face facts: your neighborhood movie theater is no longer what it once was. It has become something other than a *movie* theater, is no longer a mere *movie* theater. What was once the domain of the screens in *public* movie theaters is now "projected" onto a screen lording over our *private* living rooms; what was once the domain of the screen lording over our *private* living rooms is now increasingly projected onto the screen of *public* movie theaters. Our movie theaters are no longer truly movie theaters. This, at least, is what a daily newspaper in Montreal intoned a few years ago in an article, entitled "Your Movie Theater Is Not a Movie Theater," about live New York Metropolitan Opera broadcasts in movie theaters. As the subheading of the article remarks, in promoting these broadcasts, "The director [of the Met] has brought the Met into a new era."[3]

We must also face the fact that these new phenomena—showing digital "films" (strictly speaking, the expression *digital film* is a contradiction in terms) in movie theaters and showing live or prerecorded operas, professional boxing matches, ballets, plays, sporting events, and major interviews (thereby putting the movie theater at the service of a different cultural series than movies for a few hours)—are an essential feature of our *cinematic* modernity. What this modernity draws us in to see in movie theaters is no longer just films but also, in a sense, television events (works produced for the *tele*-agora) that retain something of the immediacy and spontaneity of shooting for the small screen. It is as if the "recording" function of the moving picture camera was being put back into service. The posters and promotional texts for prerecorded performances being shown in movie theaters sometimes specify that the opera or ballet was "recorded" on such and such a date in such and such a concert hall. This is the case, for example, with Rudolf Nureyev's ballet *Cinderella*, which was shown in September 2008 in a movie theater in Montreal's Ex-Centris complex. The promotional poster for the event indicated that the original ballet was "recorded at the Palais Garnier, Paris, for cinema."[4] We can say without hesitation that those who came up with this poster viewed the work they were promoting and showing, in movie theaters "classically" devoted to cinema, as a

filmed representation, a *recording*—or should we say an interception, a capturing, a replica?—of an Opéra de Paris ballet. What this seemingly innocuous remark leaves unsaid, as we shall see in a moment, is that this version of the ballet *Cinderella* is anything but a simple, ordinary recording of a stage performance.

Nevertheless, this remark indicates that the recording was carried out specifically *for cinema*, without our knowing exactly what is meant by this. One thing is certain: the remark surely doesn't mean recorded-for-cinema-as-an-art-form, given the emphasis that is placed on the *pure recording* status of the finished product. Here one has to imagine that the publicist took a short cut and meant instead to say "recorded for the cinema"—for the movie theater.

At the same time, our poster doesn't breathe a word about who was responsible for the recording or, to give this term a literal sense, the putting on record. The only individual named on the poster is the person who staged, directed, and choreographed Charles Perrault's tale, Rudolph Nureyev. This version of *Cinderella*, which we go to watch in a movie theater even if it isn't a movie, is thus the product of a seemingly obsolete process, at least in our cinematic culture, because it appears to be the result not of the work of directing a film, of "cinematic creation," but quite simply that of merely *capturing* the work by placing a camera before it. And yet this is not the case. As the reader can see by viewing clips of the work on the website of the French public television network, the finished product, the film version of this ballet, is, contrary to all expectations, the work of multiple cameras that retain traces of the active presence of a production crew that was in no way limited to passively and neutrally capturing the event.[5] The result is a collision between two cultural series hitherto believed to be autonomous: the cultural series "ballet" and the cultural series "cinema."

Canned Profilmic

Let us look at one of the essential questions around the base technology at work in kinematography. As we know, the kinematograph was initially seen as a *capturing* device—as an instrument, above all else, for recording what took place in front of it. What was important

about this device was, first of all, its ability to relay on a strip of film a visible and tangible trace of the shifting reality in front of which it was placed (a tangible and visible trace of what, since Étienne Souriau, has been called the profilmic).[6] These reproductive abilities of the base apparatus were what the Lumière brothers themselves highlighted in the patent application for their invention, as well as on the invitation notices for the first public, paying screenings of their Cinématographe. There we can read that their device "makes it possible to catch . . . all the movements which . . . pass before the lens, and then to reproduce these movements."[7] Georges Méliès was not far behind when he wrote, in a text signed with the presumably fictive name "Georges Ménard" (note the way in which the two sets of initials are quite opportunely identical), that "the Cinématographe, the latest improvement to the art of photography, has today become a fixture in every theater in the Universe. This marvelous device, which flawlessly *reproduces* life, has completely superseded the magic lantern of a previous generation and the so-called Polyorama fixed-projection lanterns."[8]

For Lumière, as for Méliès-alias-Ménard, "kinematographers" (as they were known until the 1910s) could thus, first of all, limit themselves to reproducing, purely and simply, so-called natural scenes. We could say of them that they were *reproducers of life*. Erwin Panofsky would agree, having said outright: "At the very beginning of things we find the simple *recording of movements*: galloping horses, railroad trains, fire engines, sporting events, street scenes."[9] From this we can conclude that, like every recording apparatus, the moving picture camera is capable of creating and recreating a document with a degree of archival value. We could even go so far as to generalize the principle and postulate that, as the moving picture camera is first and foremost a *recording* device, every film image can be seen as archiving an "event" of some description. As long, of course, as this image is the product of photographic impression.

Allow us to illustrate this generalization. To *document* a silent film actress, Mary Pickford, for example, we could turn to the documentary images *recorded* during her triumphant tour of the Soviet Union with Douglas Fairbanks in 1926. We could also, still with the sole goal of documenting the actress, turn to shots taken from

fiction films in which she starred. Through close observation, the shots recording various parts of the action of a film such as *Sparrows* (William Beaudine, 1926), for example, would provide documentation of Pickford's style, presence, and performance as an actress. In this case, the viewer would be led to deactivate what Roger Odin calls the "fictionalizing reading" (for which the film in question had been made) and use in its place another mode of reading, what he calls a "documentizing reading,"[10] one form of which, for us, is the "archiving reading."[11]

There are thus at least two kinds of *recorded images* that make possible an *archiving reading*. They correspond to the dichotomy documentary/fiction, a longstanding cliché of film theory, as nontheoretical as it may be. On the one hand are images recorded by camera operator-reporters working for the major news organizations. They took pictures of the quite real world around us, a world that silent movie stars triumphantly crisscrossed, as vast as it is. On the other hand we find images shot for fiction by cinematographers working for the big studios. We can inflect the meaning of these fictional images because nothing prevents us from reading them for their value as *documents*, for their *documentary* value; by nature they document the performance of such-and-such an actor or actress who, in the quite real world of a film studio, acted to create an "as if" situation. For it remains that the simple fact of acting in or filming a film, even a fiction film, is an activity fully a part of this world we call real, the same way activities such as visiting a foreign country or getting ready to go to work in the morning are real.

Naturally, things are not as simple as the documentary/fiction dichotomy can lead us to believe, and it is possible to use a more complex nomenclature—not by imagining things branching out from each of these two poles, documentary and fiction, but by taking a step to the side and shifting our perspective in order to take into account the cinematic apparatus's important peculiarity of always-already archiving.

To do so, we will look at the official discourse of the agents responsible for bringing to market tele-agora products for movie theaters. These agents have no qualms about using denial and disinformation to reveal nothing in their publicity material that would indicate that

these performances are the "work" of an *agent of some description responsible for the putting into images*. This was the case, as we have seen, of the publicity poster for Nureyev's *Cinderella* in 2008. It was also the case of the cast sheet distributed in movie theaters in late 2009 for the Metropolitan Opera's presentation of *Turandot*, which made no mention of the "putter into images" of the performance.[12,13] This might lead one to believe that the performance would be presented in the movie theater in such a way that the integrity of the original stage version would be scrupulously respected by means of a truly elementary technique close to that of a surveillance camera.

And yet this was not the case, any more than it was for *Cinderella*. Not only has the cultural series "opera" met the cultural series "cinema" (with the latter inviting the former into its home), but cinema has also "contaminated" it: viewers were treated to anything but a passive and neutral capturing. It is as if the Met were trying to increase the number of followers of cinema rather than of opera.

Plastic Interpretation as the Recording's Added Value

Critics in the camp of the cultural series "opera" are not wide of the mark when they raise a hue and cry at regular intervals to demand greater respect for the original stage performance when these are broadcast in movie theaters. This is the case of the music critic Christophe Huss, for example, who in a symptomatic and highly revelatory manner came to take a disliking to the director Gary Halvorson, one of the most important personalities involved in *putting into images* New York Met performances (among them Wagner's Ring cycle in 2012). According to Huss, this kind of exhibition, filmed opera, should only be a mere *broadcast/retransmission* of an already formed work (already *pre*-formed, we might say, within *another* cultural series *that is not cinema*). Otherwise, this opera critic writes, we run the risk of having to put up with "interference with the performance by means of hysterical editing sequences . . . nervous tracking shots and unrealistic low-angle shots."[14] Opera broadcasts in movie theaters, he adds, have "no need of a virtuoso and fidgety film director."[15] What they need, on the contrary, is a "mere *witness* to a theatrical activity."[16] To respect the original

performance, the broad view of a witness observing with a kind of bird's eye objectivity must be taken: "The poetry of the performance in a theater is predicated on an overall view, the exact opposite of the broadcast aesthetic of the movie theater, which uses and abuses magnifying-glass effects."[17]

Raising himself up as the defender of the expressive singularity of opera in a description of how Barbara Willis Sweete (another specialist in putting Metropolitan operas into images) commits the same kinds of errors in *The Damnation of Faust* that Gary Halvorson commits with practically every outing, Huss is of the opinion that, because she goes beyond the boundaries of a mere capturing, she is not performing her job properly:

> Unfortunately, the Met assigned the directing of the video recording of its most important performance of the year to the underequipped Barbara Willis Sweete, whose main claim to fame to date was last year's massacre of Wagner's *Tristan*. Her wandering, aimless direction, her grotesque manner of turning in circles with the camera while looking for something to film and her probing of the minutiae of the stage production, when a broad vision is what was needed, butchered the performance.[18]

The putter into images thus refused to be a simple operator-relay, a mere recorder. Huss implicitly reproaches her for placing the cinema center stage and, in a sense, for encumbering the performance with a misplaced and illegitimate opacity. What he is calling for in the end is more modesty on the part of the live filmer-broadcaster, who should stand aside from the source work. In sum, one should only *film the opera* and reject any kind of contamination of one cultural series, in this case opera, by another, cinema. A filmed opera should remain a *filmed* opera, precisely, and should not become a *filmic* opera. One should limit oneself to producing a *copy*, a mere copy, as photographic reproduction once did so well or as the kinematograph once did so well, if we accept what Riciotto Canudo had to say about the matter in 1908: "The kinematograph is not *yet* an art. It is missing the elements typical of plastic *interpretation* as opposed to *copying* a subject, thereby ensuring that photography will never be an art."[19]

What these fidgety and virtuosic putters into images of filmed operas propose is neither more nor less than a plastic interpretation of So-and-So's opera, directed by Someone Else. What they propose is thus their filmic *interpretation* of the stage *interpretation* of the libretto author's opera—a *plastic interpretation* to the power of three. This is why some people insist that filmed operas must only be the mere capturing of a stage performance (the mere capturing of an "attractional package," to adopt the expression we have proposed to describe the way Edison imported to his West Orange film studio performances already predetermined, predefined, and preformatted in and by an extracinematic cultural series).[20] This was the case with Eugene Sandow, the famous body builder from the turn of the twentieth century who performed on stages around the world and who was the subject of a "kinetographic" capturing in Edison's studio on March 6, 1894, for a filmstrip marketed under the title *Sandow* (see fig. 4.1).[21]

Figure 4.1 Film frame taken from the Kinetoscope filmstrip *Sandow*, shot at the Edison studio on March 6, 1894.

Critics of operas presented in movie theaters, adopting the perspective of the world of opera and its artistic legitimacy, tend to try to show the impact filming has on the essence of opera itself. In so doing, critics spontaneously highlight, as in a negative image, what they believe to be cinema's potential identity. According to Huss, *filmographic* virtuosity (intricate camera movements, elaborate editing, variations in shot scale and angles, etc.), a virtuosity that is a strong and legitimate aspect of cinema's identity, is completely misplaced when it comes to simply capturing-restoring a live opera, or more simply to transforming opera into a form of media by way of cinema. Even the use of the expression "broadcast" by movie theaters is indicative of the desire to preserve the original medium in its entirety. What is required in this view is to broadcast an already "formatted" work, not to create a new work which, of a filmographic or cinematic nature, would superimpose itself on the initial layer of meaning, the properly operatic layer, by swallowing it whole.

From a "mediacentric" perspective such as this, opera is only "cine-compatible" on the condition that one limit use of the camera to its original mission: filming, capturing-restoring, and recording! In short, when putters into images of an operatic attractional package become wrapped up in plastic interpretation, they risk causing affront to the original work of opera by superimposing a new level of discourse on that of the specifically operatic *mise en scène*. To purists, filmed operas must therefore not be subjected to any form of cinematic creation. They must be the result only of a mere recording.

A mere recording, which could—if preserved—enable these performances to achieve the status of archival documents. On the one hand, then, we have a "live performance," and on the other a "recorded performance," to adopt a dichotomy found in French law and dear to members of the profession described, in France, as *intermittents du spectacle* (casual workers in the entertainment industry).

This dichotomy enables us, precisely, to advance our argument, because we can use it to show how cinema is the dichotomy's blind spot. The question thus arises: alongside a live opera performance in an *opera* hall and the same performance recorded and shown in a *movie* theater, what is the status of a cinema film? Is a cinematic work a live show? No, of course not. *But is it then a recorded show?*

Neither is it that, whatever one may think at first sight. Naturally a film, like a recorded performance, is made up of acted presentations recorded in a medium that makes it possible to preserve the work and show it at a later time. *But a film is not*, we can agree, *a recorded show.* Just the same, a film is produced with a moving picture camera, which in the beginning was merely a recording device. We are thus faced with an apparent paradox: how to explain the fact that one and the same device makes it possible, on the one hand (that of opera, say), to transform a *live* show into a *recorded* show, and, on the other (that of a cinematic work, say), can bring into being something quite other than a *recorded* show (which is to say, those shows that are *neither* recorded *nor* live that we call films).

Shooting as the Recording's *Aufhebung*

Normally a recorder does only one thing: record.[22] And it records a "show" that, originally, was always-already and of necessity in the realm of the living. This produces, always-already and of equal necessity, something recorded. How is it then that the kinematograph gives rise to something other than the purely and simply recorded? *What happened*, in the historical continuum, for such a thing to happen? *What happened*, within the apparatus, for such a possibility to arise? What happened, "quite simply," is that the *recording device* ended up losing its supposedly permanent status as a mere recording machine. What simply happened is that over time, as cinema became institutionalized, the moving picture camera became something other than a mere machine for capturing and reproducing. And it simply happened that artists of a new category, the cineaste, inter*posed* themselves and began to superim*pose* onto the world recorded by the camera's crank turners a new layer of meaning by means of their plastic interpretation. And this layer of meaning, in order, precisely, to mean anything, denies in a sense the initial nature of the images on which it, this layer of meaning, is nevertheless laid.

Take a classic film such as *Casablanca*: the reading we are called upon to make while a film such as this is being projected neutralizes the "archival" aspect of the mere shooting of the actors' performances, which are time-stamped, or time-stampable, but which lose

their time-stamp moorings. It is somewhat as if the filmic material was *transfigured* and there remained the effects of a procedure of surpassing, of transcending, of *Aufhebung*. The filmic material thus undergoes something like a procedure of sublimation (and even profits from it, we might say), given that the living "show" constituted by any acted performance passes immediately from its "recorded show" state to that of a "sublimated" show.

If we were to combine two famous formulas, one by Barthes and the other by Octave Mannoni, we could say: "I know that such a thing happened (that it was recorded, that it was taken from reality), but just the same I'd like to forget it in order to enter the world of the film." It thus appears to us that it would be beneficial to distinguish two kinds of archiving: *reproductive archiving* and *expressive archiving*. Reproductive archiving, first of all, has a direct connection to the reproductive capabilities of the base apparatus. In calling this kind of archiving "reproductive" we are taking our inspiration from Malraux and his description of cinema's photographic dimension: "As long as cinema was merely a means of *reproducing* characters in motion, it was neither more nor less an art than phonograph records or photographs that reproduce nature. Actors moved about in an enclosed space, generally a real or imaginary theater stage, performing a play or a comic sketch which the camera simply *recorded*."[23]

This is the ability to archive that is proper to the medium cinema, which is based on the recording capabilities of the film stock (the silver gelatin base that gathers or collects what will *make* the document) and defines the *allographic*[24] quality of the kind of *ontological archiving* involved in capturing-restoring what Souriau called the *afilmic*.[25]

Historically, the representative agent of this aspect was the *crank turner*.

Along with reproductive archiving there is also expressive archiving, which occurs when one has pushed the medium beyond its recording capacity alone. The medium then develops an expressiveness of its own by way of the style and expressive opacity of an author, or at least of an enunciative agent within the medium that explicitly assumes this role. What is archived on this second level is the style of the creator who added soul to the film medium (it is this

additional soul that Canudo was implicitly yet earnestly calling for when he deplored the kinematograph's lack of artistic interpretation). Here we are in the presence of the autographical quality of archiving: what is being archived is no longer simply what happens *in front of* the camera, but also, in a sense, what happens *behind* it. This kind of archiving documents the creation of a properly profilmic world. Let's not forget that for Souriau, a film makes it possible to generate an ethereal world located somewhere above inscriptions of reality and to inscribe this world on a medium. For Souriau, cinema invites us on "immobile journeys through [this] filmic universe."[26]

We should note that this expressive archiving does not belong to the same system of evidence as reproductive archiving. It remains in the realm of the virtual, whereas the other has an almost ontological dimension: there the archival effect occurs the moment there is capturing-restoring, the moment something is recorded. We might say that the archival effect goes part and parcel with this *reproduction* apparatus, the moving picture camera. *Expression*, on the contrary, requires an outside will, an external desire to negotiate with a medium's expressive potentialities in a given time and place.

The agent representing this aspect is no longer the prosaic crank turner but rather the *cineaste*, a true "creator of a filmic world."

The distinctive feature of reproductive archiving is the moment of "shooting," when the *crank turner* reigns supreme, whereas the distinctive feature of expressive archiving is the moment of the "filming," when the *cineaste* reigns supreme. For *shooting is not filming*, and *filming is not shooting*. They are two different operations for capturing images with a moving picture camera.

In the case of *shooting*, or "archival" recording (what we, taking our cue from Malraux, have called here "reproductive archiving"), we could almost say that we are dealing with a *preformed* reality, meaning a reality preconfigured in the way Paul Ricoeur articulates in his description of his "threefold mimesis" system.[27] It is thus an autonomous and "time-stamped" reality that one merely *sections off*, films, and *records*. To continue to use Souriau's concepts, we would say that shooting captures and records the afilmic, transforming it into a virtual archive. Becoming part of a *shooting* procedure thus means that one places oneself under an implicit principle, that of

respecting (or *attempting* to respect) the reality being captured.[28] The important thing here is being able to capture this reality and, consequently, to preserve it as best one can and in all its depth. The *preformed* quality is respected: the shooter does not let himself or herself manipulate or transform what is being shot. *Shooting* is, literally, *recording*; it is not *filming*.

If one observed the principles championed by the Montreal newspaper critic, the putter into images would be content to limit himself or herself to simply *shooting* and avoid shifting to that higher stage, *filming*. Those who record attractional packages must not take themselves for cineastes; in the end they must be nothing more than a mere *steward of the images* whose motto should be: "I record, therefore I archive!":[29] "The Met's (old) production [by Manon Lescaut] did the job. . . . The whole thing worked very well, with the tenor Marcello Giordani, Levine conducting and Brian Large's elegant *visual stewardship*."[30]

The putter into images should thus be content with his or her simple role as a visual steward in charge of the *putting on record*— like Brian Large, who goes so far as to demonstrate elegance! Brian Large, unlike Gary Halvorson and Barbara Willis Sweete, doesn't play at being a hyper-putter-into-images: Brian Large, a man with a predestined name, because he takes the "wide" (*large* in French) view and doesn't let himself "scrutinize" from up close the "minutiae of the stage production," in the words of the Montreal critic.

There is of course nothing new in this often implicit debate between those who privilege reproductive archiving and those who privilege expressive archiving. For example, we can see a few points in common between it and the debate that took place when television began to broadcast live concerts and plays in the 1950s.

Going back further in time, we can see analogies with the legal arguments made during the first court cases around copyright (which Alain Carou discusses in detail in his book *Le Cinéma français et les écrivains*).[31] The question that presented itself at the time was: Does returning to a work of literature in cinema (let's not call it adapting) pertain to staged performance or to illustrated publication? In 1909, the French publisher Calmann-Lévy brought action against the heirs to Alexandre Dumas, who wanted to profit from his work.

That same year, the court's judgment described this revelatory claim made by the publisher in the following terms: "The publication of a script in cinematographic form and drawn from a literary work does not constitute a theatrical use of the work but only an illustrated publication of a special kind."[32] In other words, while "theatrical use" would seem here to constitute an adaptation in the strong sense of the term (one takes the "script" of a novel and intentionally transposes it onto another expressive media system), putting it into film amounts to no more than a slight editorial variation and thus an adaptation in the weak sense of the term.[33]

Let us now attempt to sum up our view of the matter. While, in the case of reproductive archiving, we are dealing with a *pre*formed reality, in the case of expressive archiving we are dealing with a *per*formed reality, performed by the very act of filming (in our view, it is this element of performance that differentiates the *filmic* from the *filmed*). In this paradigm, the filmer can take the liberty of arranging the profilmic, of manipulating it, doctoring it, etc. Reality is thus *performed* in the sense that it is added to or amplified for the purpose either of monstration, understood as a deliberate and intentional action to produce a visual depiction, or of narration, understood as an equally deliberate action to reconfigure, to *plot* a series of events in a more or less elaborate diegetic framework. *Shooting* (capturing, recording) becomes *filming*, and the work of the filmer adds a certain *je ne sais quoi* to the recorded images. This is what we termed above *Aufhebung*.

The "Cinematographiation" of the Recording

Filming, unlike mere shooting, introduces a new agent's expression; it allows the point of view of a camera operator-subject, who injects the images with a something extra that transcends mere recording and brings out new possibilities for the means of expression. This is cinematographiation.[34] The archiving that results from this is of another order: it no longer merely preserves a time-stamped space-time but is the trace of an expressive and filmic reappropriation. It is from this level of expressive performance that the world of the film issues forth: *in its release from historical contingency, whereupon*

an actor's deeds and gestures are not preserved for themselves, but are an integral part of the film world into which they have been incorporated.

With filming, there is an "as if" aspect to the actor (who acts "as if" he or she were a particular character), but there is also an "as if" aspect to the camera. The camera acts *as if* it were recording the referential, whereas it is doing more than that: it gives rise to a *process*, the filming, which transcends the *procedure* of merely recording (*shooting*) and enables the film world to come into being. But before this coming into being is possible, before *expressive* archiving can be set in motion, the film must unavoidably carry out a phase of *reproductive* archiving, a phase we might describe as involuntary and statutory.

This is the paradox mentioned earlier: one must first put on record in order to transcend this record and open the door to the film world. An archival effect is unavoidable in the making of a film based on capturing-restoring (so-called real images). Without archiving the captured reality it is impossible to edit or construct the film. The archive effect is just as unavoidable when one makes a film seeking admittance to the filmic world (and thus seeking a form of separation from the afilmic world). This archiving is not the goal of the film. Its goal, rather, is to *connect* with the filmic world to which the *filming process* gives admittance and to neutralize the simple world of capturing-restoring to which the *shooting procedure* gives admittance. In a word, one must neutralize and make the viewer forget reproductive archiving and give oneself over entirely to expressive archiving. The *filming performance* must take precedence over the *shooting performance* and subsume it.

Confirmation of the approach we are developing here can be found in the peculiar and emblematic form of archiving found in "making of" films, which have a different status depending on whether they were made around a filmed opera or around a film that generates some sort of filmic world. In most cases, "making of" films on filmed operas only strengthen, without realizing it, the "respectful putting on record of the shooting" dimension: the performance is filmed on tiptoe to show how it was archived, meaning how an imprint of the original performance was modestly caught using the

putting-on-record apparatus (such and such a number of presumably faithful cameras placed here and there to capture as best as possible the attractional package, the ceremony, the operatic *High Mass*).

The situation is quite different with "making of" films included with DVDs of cinema films on the market today. In most cases, the goal of these "making of" films is to attest that there truly was, before the film, before *Aufhebung* is brought into play, and before the epiphany of the filmic world, performance labor that was duly recorded, duly captured—at times laboriously, dangerously, or playfully. What these "making ofs" offer us is the possibility of *disengaging* from the cruising speed of the filmic world. What they offer us, in the end, is a return to *reproductive archiving*, that indispensable compost of any filmic epiphany. But this ontological "archival" dimension is not a mere bonus. The force of the *reproductive archiving* effect enables it to attest that there truly was a series of performances that were recorded—captured—to comfort better the viewer's make-believe.

Apart from its anecdotal value, the phenomenon of opera or ballet retransmission (live or prerecorded) is important in the sense, which we have endeavored to demonstrate in our previous work, that the kinematograph, for kinematographers working under the kine-attractography paradigm, was nothing more, precisely, than a *capturing* and *reproduction* device.[35] Why should anyone be interested in this mere technological curiosity beyond its sole quality as a novelty gadget, its sole ability to capture and restore space and time? As André Bazin remarked many years ago,

> Perhaps it was only through a trick of the mind, an optical illusion of history, fleeting like the pattern of a shadow cast by the sun, that we have been able to believe for the past fifty years in the existence of cinema. Perhaps "cinema" was just a stage in the vast evolution of the means for mechanical reproduction whose source lies in the nineteenth century with the photograph and the phonograph, and of which television is the most recent form. . . . Lumière was right when he refused to sell his moving picture camera to Méliès on the pretext that it was just a technological curiosity of interest at best to doctors.[36]

Thus the kinematograph was nothing more in the end than a device for *recording* the "world" that was "paraded" before it, or in front of which it was placed before the crank was turned. A new category of artists, the *cineastes*, had to begin to superimpose on the world recorded by kinematographers a new layer of meaning for film art to be born. In short, the stage of mere recording had to be surpassed for a new art to be created. A minimum value had to be added to the "recorded substrate," using techniques capable of transcending the mere putting on record carried out by the moving picture camera—a value capable of bringing us into a new realm. A good recording (aural or visual, or both at once) can certainly impart soul to the thing being captured, but it does not necessarily impart art, which can only happen when one scrapes the "recorded substrate" in such a way that it comes to say something other than—something other than in addition to—what the original event said (or what its mere capturing would say). We can say that art is imparted when the "recorded substrate" serves as raw material for another, higher level agent that offers a plastic interpretation such that there arises out of this material another world than the mere world of the recorded event—by adding a layer of discourse, a new thread of "language," which this agent "affixes" onto the recorded world.

And this is what happened in the case of *Cinderella*, and all of the Met's operas broadcast in movie theaters, despite the apparent denial: the finished product of the *filmed* version of this ballet (as well as that of the operas by Puccini, Wagner, Bizet, and Rossini) is, contrary to every expectation, the result of multiple camerawork, the sign of the active presence of a production crew that was in no way limited to a passive, neutral, or transparent capturing.[37] Contrary to what the poster for *Cinderella* suggests, the ballet was not "captured" with a single "recording" device content, like a surveillance camera, to capture passively everything that passed before it, hence the numerous shot changes and variations in scale and the occasional camera movement.

All this, we believe, presents considerable food for thought for anyone wishing to define the transition from *kinematographic practice* (prevalent during the kine-attractography era) to *cinematic art*. The issues raised are the same ones we are faced with today with

respect, no longer to cinema, but to that new, evolving art of capturing and broadcasting—live or prerecorded—noncinematic shows in movie theaters.

Using our model, the cinematographiation of opera can be understood in different ways. To simplify a little, we can see that opera specialists view "digital cinema" merely as a new way to disseminate their art form. Because it is essential for them to preserve the expressive identity of the opera performance, they tend to take the view that the agent filming the work should limit itself to simply putting it on record. Filmmakers ("filmers"), on the other hand, take the opposite view: for them, it is tempting to use the potential of their medium and to surpass, or even sublimate, a mere everyday putting on record.

What emerges here is the repressed "Lumière" conception of the kinematograph. The adherents of this conception have no interest in going beyond the functional "zero degree" of that "technological curiosity," the moving picture camera—beyond its simple and amusing vocation of capturing and restoring. Here again is Christophe Huss, the Montreal critic we quoted above:

> *Le Comte Ory* also confirmed the flair of director Bartlett Sher, who came to the Met from Broadway and who has just created a third success for them, after *The Barber of Seville* and *The Tales of Hoffmann*. Sher, who resituates the action in the eighteenth century, found the perfect theatrical tempo, unlike the video maker Gary Halvorson, who takes a stand by impressing a style of editing that overloads the work with a frantic rhythm, out of time with Rossini's work. In addition, because most of Halvorson's shots are done quite close up, the video clip aesthetic cultivated in the vocal ensembles is tiring for the viewer.[38]

Are we not in the presence here of a music critic who is manifestly on the side of those who fear that opera will lose its soul by entering the movie theater? Especially, we might add, when the putter into images charged with transmitting the opera inopportunely sets out to "overly cinematographiate," we might say, the singular performance of the opera on view.

What is going on here is curiously reminiscent of the kinematograph's monstrational inclinations, going beyond mere capturing-restoring to impose a higher level discursive performance. What this new "cultural series" of filmed operas is perhaps foretelling is the "birth" of a new art, one that will add a supplementary layer of meaning, a new *plastic interpretation*, to a preexisting art, to a cultural series already in place. A new "speaker" thus imposes himself or herself between the viewer-listener and the opera director (who also imposed himself or herself between the viewer-listener and the creator of the opera).

The movie theaters in which films are shown today are thus recovering a kind of diversity or *plurality*, a phenomenon that is not unlike the tradition based on polyvalence that the reign of the all-powerful cinematic institution tended to neutralize. This tradition made it possible to show films in a space that wasn't exclusively reserved for them and that could be used for other kinds of entertainment or, to express this in terms closer to our own, in venues where there was a hybridization or aggregation of diverse *cultural series*.

In this way the movie theater, one of the last redoubts of institutional cinema's identity, *has become today,* in this era of the digital's dominance, *the site of a polyvalence that threatens this very identity,* forged at the time of what might best be described as "cinema's second birth." "Second" because, as we now know, *a medium is always born* (at least) *twice*.

A Medium Is Always Born Twice . . .

> Today film authors can no longer make silent films. Tomorrow they will no longer be able to make dull films, and the day after tomorrow shabby ones.
>
> RENÉ BARJAVEL, *CINÉMA TOTAL: ESSAI SUR LES FORMES FUTURES DU CINÉMA*, 1944

> Far from killing cinema, television will, on the contrary, encourage its necessary metamorphosis.
>
> ROGER BOUSSINOT, *LE CINÉMA EST MORT. VIVE LE CINÉMA!*, 1967

The passage to digital media has thrown the habits of every film user into upheaval. A situation such as this encourages people to take extreme positions. Between those who announce cinema's dissolution or implosion and the champions of its new vitality there exists a spectrum of intermediate attitudes. Among these there is taking shape an alternative route that foregrounds the ways in which cinema and other forms of moving images are associating and hybridizing. Before going into detail in the next chapter on the various manifestations of this new spectrum across which cinema's identity is spread, we believe it necessary to return to the fundamental question of the genealogy of media. In the present chapter we thus propose to revisit and redeploy our model of the "double birth of media."

Where then does our theory of the double birth, which we proposed in 1999, stand with respect to the present-day turmoil accompanying the digital mutation?[1]

We explained in our original proposal that our use of a biological metaphor was intended to deride the hagiographic mythology that has the "infant medium" being delivered to our doorstep one fine morning by some turn-of-the-century stork. We even suggested that, instead of talking about the birth of a medium, we should be talking

about its emergence. Nevertheless, playing along with the biological metaphor, we proposed to use the expression "the double birth of cinema" to define, on the one hand, the invention between 1890 and 1895, not of cinema but of a *simple device for capturing-restoring* moving images (of which the Lumière Cinématographe was the most successful example) and, on the other hand, the establishment about 1910–1915 of an *institution for producing and exhibiting* moving pictures. Our goal at the time was to call attention to the fact that, in our view, it was a little too facile to date what is commonly called "the invention of cinema" to the year (about 1895) of the invention of a mere technological procedure that made it possible for cinema to emerge at a later date (about 1910). Cinema is a complex sociocultural phenomenon that cannot be reduced to merely projecting photographic images to give the illusion of movement. Cinema, quite simply, is not something one "invents": there is no cinema patent because cinema is not a technique but rather a social, cultural, and economic system. Cinema had to be *constituted* and had therefore to be *instituted*, and had in the end to be *institutionalized*.

The basis of and justification for our double birth model is the refusal it implies of any simplistic and one-dimensional conception of a phenomenon as complex as the emergence of a new medium. We must argue for a pluralistic view of its birth (or rather its emergence), one that will enable people to see the history of cinema as a succession of beginnings and a succession of deaths. But we should first perhaps sum up what we mean by the double birth of a medium and how it applies to cinema.

Another Look at the Double Birth Model

Looking closely at the so-called "birth" of cinema, one can see that its singular media identity was far from evident from the outset. What we still call today "early cinema" was in fact a kind of hodgepodge of other expressive forms. Before *cinema* succeeded in establishing itself as a medium with clearly defined boundaries, the *kinematograph* had merged into an existing media and cultural environment: the new device was more or less explicitly seen as a means for recording and reproducing already existing entertainments and

live attractions, whether natural or staged. The first ambition the new machine gave rise to was to exploit its ability to reproduce and amplify already well-established cultural practices and sometimes to make them more forceful. In short, it was used for its simple status as a recording machine, some of whose qualities we have mentioned with respect to operas and other filmed performances or events. The situation's ambiguity arises from the abrupt qualitative leap that the arrival of the Edison Kinetograph and the Lumière Cinématographe supposedly brought about. Many long-dominant discourses around the invention of cinema infer the existence of a rupture about the time of the invention of the technique that made possible the recording of moving photographic images (about 1890 for those who back Edison and about 1895 for those who back Lumière). Still today essayists such as Jacques Aumont seem to persevere along this path, remarking that "when the first moving image technologies appeared between 1890 and 1895, no one had ever seen anything like it. No one had ever seen *large format, strongly analogical images in movement*. The technological inventions of the past twenty years have in no way contributed a novelty as essential as this in terms of the sensation it provided."[2]

The invention of the "base apparatus" was certainly a turning point in the evolution of photographic recording technologies, at the same time as it was a moment of fascination, but such an invention did not give rise to a new *paradigm*, to a new order.[3] In other words, the appearance of the Kinetograph and the Cinématographe was not a true moment of rupture. Changes of paradigm do not necessarily occur at the same time as the invention of new techniques, and the sudden availability of a new technology does not necessarily revolutionize the surrounding culture or the behavior and activities of the various cultural agents who latch onto it. Nor does it make it possible to accede immediately to a new cultural, artistic, or media order. Nascent media take their first steps by reproducing in a rather servile manner the other media from which they are to greater or lesser degrees derived. This was the case with cinema.

In our view, the case of cinema is exemplary because of the scorn elicited by the appearance of its technological procedure of *capturing and restoring* reality, a fascinating novelty that has mistakenly been

seen as constituting the medium's sole identity. On the contrary, cinema's quest for singularity as a recognized medium is part of a long development process and can in no way be confused with its "first birth," which was the product of mere technological progress. We must wait for kinematographers to acquire a reflexive understanding of their means of expression and for the cultural practice of cinema to attain a certain level of institutionalization for the medium to achieve a degree of autonomy. This is the sense in which we mean that a medium *is always born twice.* Its first birth takes place when a technological innovation is used to give new life to existing cultural practices and series, under whose authority this technology places itself. A second birth occurs when the expressive resources made possible by a medium, or more precisely those of a technological apparatus that has *become* a medium, achieve institutional legitimacy and work toward establishing the specificity of these resources as the norm.

In fact this model took place in three stages: three processes we have identified by three terms located in the same semantic field but to which we have assigned a specific connotation. These three terms are *appearance, emergence,* and *advent.* Early film history thus leads us from the *appearance of a technological apparatus* (a technology), the moving picture camera, to the *emergence of a socio-cultural apparatus*, perhaps even a new cultural series, that of animated pictures, to the *advent of a socio-cultural institution*, that of cinema.

After the appearance of the recording device, the production of films *defined itself as a practice* that must make possible the passage to another stage: the emergence of animated pictures. This was the first example of "film culture," whose institutionalization, however, was yet to be carried out. This culture, although it remained resolutely and necessarily intermedial, was marked by its status as being in the process of institutionalization, in that it came out of a patchwork of neighboring institutions that did not yet share a common definition of what cinema should be. It was out of this unstable cultural broth that the kinematograph set out on the path that would transform it into an autonomous expressive medium and raise it up as a singular and well-established medium. Cinema could then plunge head-first

Table 5.1
The Three Phases of Cinema's Double Birth

	Expressive Intentionality	Identity Status	Visual Apparatus
Appearance of a Technological Process	Capturing-Restoring	Novelty Effect	Moving Picture Camera
Emergence of a Media Apparatus	Monstration	Specification/Codification	Animated Picture Shows
Advent of a Media Institution	Narration	Legitimacy	Cinema

into its second culture, that of its second "birth," into a culture that, this time, was truly "media-centric." Three phases and two "cultures" thus marked cinema's quest for institutionalization. The first phase, typified by its subordination to the surrounding institutions, was followed by a second phase in which it broke off from the preexisting institutional environment before finally, in its third phase, entering a period of insubordination, the necessary condition for cinema to be institutionalized and become autonomous. This process is summed up in table 5.1.

On the Y axis are three paradigms of the double birth. On the X axis, the first column is devoted to the expressive intentionality associated with each of the three paradigms. The second column indicates the consequences of the process whereby the medium's identity is made singular. Finally, the third column shows the visual apparatuses corresponding to each paradigm. Each of these various elements will be explained below.

Narrative Concerns Are Secondary

Cinema and narrative! For many years, a good proportion of film research focused on this strong relation, this magic connection. Does cinema not have "narrativity built into it," as Christian Metz once wrote? The idea prospered. And the medium's coalescence with narrative became practically a commonplace, to the point that narrative

seems to be a part of the very definition of cinema. We are obviously not about to contest the decisive role of narrative in film history, nor the importance of cinema's "intrinsic narrativity,"[4] but our approach does make it possible to add an important qualification, in the same way that our slightly polemical "double birth" formulation is a way of exposing that other commonplace to the effect that cinema had an abrupt birth, out of nothing so to speak, resulting in a cinema with a ready-to-use media specificity.

In fact our first phase, that of the appearance of the new technology, the "animated pictures machine," did not give rise to a precedence of narrative. What was dominant at the time was the novelty aspect of the apparatus. It was novelty that appeared to man the command post when animated pictures were fabricated. In particular, novelty was what attracted the public's attention. The capturing-restoring paradigm prevailed during the kinematograph's early years, roughly until about 1898. The capturing-restoring phenomenon by no means disappeared after that date, because it is part of the essence of the medium's technology, hence the importance, in our view, of a concept such as the *paradigm,* which, unlike the concept *period,* does not suggest the rigidity of a linear succession, something that would expose us to the many traps set by teleology. Paradigms are the high points of a diachrony, but they are not necessarily mutually exclusive. The way they succeed one another makes possible certain kinds of overlapping.[5]

The sway of the novelty aspect represents this moment when fascination for the capturing-restoring abilities of the new technique were of prime importance. What mattered was its intriguing faculty for showing duration and for presenting moving images on a screen, no matter what they were. This then was the initial moment: mechanically capturing natural scenes in whose composition the human "machinist" had only a small role to play (documentary films are directed by God, Alfred Hitchcock said).[6] In those years, the kinematograph used its underlying technique to draw out its intrinsic narrativity, that of a simple mechanical unfolding. In such cases the kinematograph thus disregarded extrinsic narrativity, which is the product of a human concern to configure events in a narrative, something to which cinema would subscribe fully at a later date.

This paradigm of capturing-restoring supposes a minimal degree of intervention—nearly none—on the part of the "filming agent," on the level of both the profilmic (what is captured by the camera) and the filmographic (all cinematic techniques combined).[7] This was the case, for example, of the reportage films produced by the earliest camera operators, which involved practically no intervention on the part of the filming agent with respect to the filmed agent. In a case such as this, when kinematographers ventured into narrative, it was by means of a kind of "passive" capturing of an event itself given over, in the profilmic, to narrative. This was neither more nor less than a "ready-to-film" narrative, but it was not *filmic*. It was a *filmed* narrative, or rather a narrative sequence of filmed actions using the cinematic apparatus, whose sole filmographic element resides in the mere transfer of an event onto light-sensitive film. On an intrinsic level, this narrative possessed only a first-level narrativity, one inherent to an apparatus that orders images in sequence and imposes a duration in keeping with the homochrone system.

In short, we are in the presence of a series of narrative actions whose *disposition* owes little to the *apparatus*. The equipment served first of all to render reality in media form, then in communicating the performance, which consists in re-presenting this reality, of "presentifying" it in its temporality. In sum, we are in the presence here of a kind of constrained *narrative package*, to employ one of our fetish expressions. The same sort of narrative that can be captured by a surveillance camera, a medical camera, a GoPro fastened to the helmet of an athlete in action, or a photocomposition device used to record a plate in a graphic novel. Within this paradigm, the filming agent thus tends to preserve the autonomy of the object shown by respecting its temporal integrity. It does not submit the capturing-restoring to the intentionality and discursive ambition found in narrative. We should recall how the digital image is different in this respect: there, this discursive effect is consubstantial with the encoding-reconstruction intrinsically tied to digital capturing. This fascination for the kinematograph as a mere—yet spectacular in its day—"recording-recreating" device is somewhat similar, for example, to the IMAX system. This system's organic integration of extrinsic narrative was initially obscured behind the attractional resources of the spectacle

itself, which were enough to motivate the viewer. The same could be said for most novelties recently announced in the field of film technology.

In the medium's early days, narrative was not a true concern. Narrative motivation came well behind the fascination that the capturing instrument wielded. Naturally, this situation did not last forever, and once the novelty effect had passed, the program supplement that extrinsic narrativity hitherto had been began to become a sure bet, leading to the establishment of a new cinematic element. In the industry manufacturing animated pictures, increasing attention was thus paid to the profilmic's narrative potential. Narrative intermediality came to play a greater role and the exterior pool of *fabulas*, which is to say extrinsic narrativity, attracted more and more interest on the part of people working in the field. The concern for profilmic monstration thus interacted with that of incorporating extrinsic narrativity, as we can see, for example, in the emergence at this time of scriptwriting as an activity. The kinematograph thus put its singular ability to tell a story to the test, finding its cruising speed in the "narrative paradigm" that came to dominate the film world in the 1910s. In the case of kinematography, the advent of the institution thus grew out of the medium's coming into narrative plenitude. Cinema, for institutional reasons, must put its singularities in the service of the production of singular narratives—hence the beginning of the screenplay's grip on cinema. The potential for interaction between intrinsic narrativity and extrinsic narrativity for telling-showing stories in their temporal *énonciation* must be put to use, and this is something that cinema knows very well how to do (as later film history clearly demonstrated).

The institutionalization at issue in the present volume, however, is no happy ending for the model, for the digital era coincides with a period in which institutional media are becoming fragmented and scattered. In the case of cinema, classical fictional narrative is yielding increasingly to other registers of visual consumption. Roger Odin signaled this phenomenon when he remarked that, alongside what he calls fictionalizing reading (the dominant form in hegemonic narrative cinema), other readings often associated with other cinematic forms have taken on added importance, such as this one, which

privileges the energetic mode as he has defined it: "Whereas in the fiction film all the work carried out on energy is mobilized to . . . put [the viewer] in synch with the rhythm of the events being told . . . in these productions energy is disconnected to varying degrees from its narrative function."[8]

Odin remarks that Laurent Jullier expresses a similar idea with his "fireworks cinema" concept, pointing out that many films today are based on a "non-causal minimal narrative" and employ means that seek to "short-circuit the viewer's intellect in order to 'directly' affect their sensorial system."[9] In this case, narrative appears to have become a kind of troublesome supplement one must put out of mind quickly in order to concentrate on the energy and attraction of the spectacular. As Jullier goes on to remark, "The path is clear then for the transmission of pure stimulus."[10] This return to attraction at the expense of narrative appears to us to be a sign of the complex process at work in the postinstitutionalization of cinema and its possible *third birth*—and this is a fundamental hypothesis underlying the present volume—to which the digital mutation has given rise.

Here an important point needs to be made when speaking of a medium's identity. In our view, identity should be understood in the sense suggested by Paul Ricoeur;[11] that is, it should adopt a resolutely genealogical perspective rooted in that state of permanent transformation found in the heart of Ricoeur's principle of ipseity and providing the possibility of almost dialectically overcoming the antithesis of the *same* and the *different*. This dimension of "ipseity" means that a medium's identity is in part made up of permanent features, but that all media are inevitably engaged in a process of constant evolution. Their identity must as a result always be adjusted and at times redefined. In sum, a medium's identity hinges on a sheaf of complex questions. We should emphasize that specificity in no way means separation or isolation. A good way to approach a medium, especially in the digital age, is to seek to understand how this medium is related to other media: the way a medium should be understood is through its intermedial dimension—the way it opens its borders and enters into necessarily intermedial relations with other *prisms of media identities*. Put another way, using terminology in keeping with

that of our times, a medium becomes singular in the way it manages the convergence taking place in the *intermedia*.

The medium's first birth is in a sense its *integrative birth* and its second birth its *differential birth*. At the moment of its appearance (in French we say its *apparition*, and the "epiphany-like" or "medium-like" connotation of this term is undoubtedly not without significance), a new technology is limited to the status of a *crypto-medium*. Its singularity as a medium is not clearly apparent. Or rather, what is *too* clearly apparent is all the attraction exerted by a new technology that appears to have the ability to revolutionize the way in which dominant cultural series are made available. The novelty aspect of the new medium, however, renders the new medium's acquisition of an identity difficult—or, in a sense, opaque. In other words, its identity cannot yet appear clearly.

The new technology thus finds itself engaged in the context formed by preexisting media, genres, cultural series, and cultural practices that have already achieved a degree of visibility and legitimacy with respect to their identity. This technology then adapts to the social and cultural uses associated, at a certain historical moment and in a certain society, with the other—recognized and accepted—cultural series. The idea of making this technology autonomous, of making use of its medium-specific possibilities, has not yet appeared. The new possibilities offered up by the medium thus remain complementary to, dependent on, or in continuity with older and more established genre and media practices. By inheriting an apparatus located at the crossroads of various preexisting intermedial combinations, the *crypto-medium* becomes a *proto-medium*. Nevertheless, at this stage it remains a mere assistant to existing series and genres. And its task as an assistant consists in facilitating access to these established cultural fields by broadening their dissemination. The proto-medium has not yet obtained recognition of its identity, something enjoyed by any legitimately constituted medium. An air of indecision, a kind of hesitation, surrounds it, something seen in the way it attempts, awkwardly, to assert the features of its identity. At times this can mask what will become its institutionalized singularity.

After having served for a time as a mimetic relay for the series and media around it, a medium will set out upon the path of crystallizing

its identity. This is our emergence phase. The *possibility of autonomy* is thus closely tied up with the medium's evolution and potential. Its second birth, our advent phase, comes about when the medium's "quest" for identity and autonomy coincide with institutional recognition.

Logically enough, once it acquires its own identity (or at least the identity that the prevailing institutional powers recognize in it in the end), the medium loses its initial intermediality—that necessary intermediality that characterized the period of its first birth. Nevertheless, alongside the loss of this initial intermediality, it gains another, one that is compatible this time with the assertion of its identity, which is regulated by its institutional framework. This is a form of intermediality that will be negotiated according to the degree of the medium's singularity and notoriety, both of which are guaranteed by the institution that emerges from it. This contingent and in a sense *deliberate* late intermediality resembles those forms of intermediality present in every cultural production process. And yet, in the context of today's digital culture, operating under the sign of flux, contamination, generalized interfaces, and the global Web, such intermediality, negotiated from an institutionalized identity, takes on a shifting, complex, and particularly unstable form.

Precursors of the Double Birth

Before looking at the future of the "double birth," we should mention a few authors who, although we were unaware of it at the time we conceived our model, also once suggested the idea of cinema's second or new birth.[12] Although the terms they use resemble our own, these authors do not, however, address the same intermedial context and do not take up the question from the same perspective of viewing cinema as a site where other media meet. We might begin with the comments of someone such as Alexandre Arnoux—who, as we wrote above, "foreshadowed" our model as early as 1928—on the question of the upheaval brought about by the arrival of the talking film: "*Second birth or death?* This is the question facing cinema."[13]

In 1946, Jean-Pierre Chartier developed the idea—one we have already encountered—that cinema did not have a double birth, but

was "invented twice over." Fifty years before us, and nearly forty years after François Valleiry, Chartier called into question the validity of the monolithic concept "the invention of cinema," which, in his view, "papers over an extremely serious confusion."[14] What he identifies as the first invention was technology (just as Valleiry had in 1907), which fits well with our own first birth: "The first [invention of cinema] was technological and was limited to perfecting a machine capable of recording and reproducing movement, the way the phonograph records and reproduces sounds."[15]

On the other hand, Chartier's *second invention* is quite radically different from our own *second birth* (as it is from that of Valleiry). Rather than identifying this second birth with institutionalization, Chartier locates it in the camp of aesthetics:

> Cinema's second invention was not technological but rather aesthetic. Like its first invention, we cannot attribute a date or author to this invention; it is the result of the fantasies and explorations and aesthetic discoveries of those who, for twenty years, made films with the sole goal of expressing themselves better through images and of varying their effects to please their audiences.[16]

Here we sense, between the lines, the hodgepodge quality we have associated with the phase of a film culture's emergence. But we should note in particular that this second invention is similar to another dimension we discussed in the previous chapter, that of the plastic interpretation so dear to Canudo and thereby to our *Aufhebung* effect. According to Chartier, "The state of marvel into which movement on the screen plunged us" obscured this second artistic invention: "The marvel of cinema is not the movement of images; it is that with these images artists are able to create a world."[17]

Finally, we can also see in the work of Bazin another author who anticipated our model of the double birth. In 1953, the famous French critic put the matter in the following terms:

> Perhaps it was only through the happy coming together of technological, economic and sociological elements that what we call cinema had the time to evolve into indubitable aesthetic forms.

Lumière was right when he refused to sell his moving picture camera to Méliès on the pretext that it was just a technological curiosity of interest at best to doctors. It was cinema's *second birth* that made it the form of entertainment it is today.[18]

In the beginning then, at the time of the first birth, the Lumière Cinématographe was just a "technological curiosity," good only for recording. Later, through its *second birth*, the new invention was able to become something else and accede to another dimension by taking a path that enabled it to "evolve into indubitable aesthetic forms."

This recurrence of the theme of cinema's *double birth* or *double invention* is not the product of chance. There is something in the formulation that gives it an archetypal quality: with a little effort one could find a large number of texts in which the question is posed in similar or related terms. (We have seen, for example, that Pierre Leprohon and Edgar Morin, each in their own way, set out the idea of two succeeding periods: first that of the *kinematograph* and second that of *cinema*.)[19–21]

Extending and Employing the Model

To what extent have other important media, from the oldest to the most recent, also taken the double birth path?

In order to test our model outside the case of cinema, we first sketched out an application to photography and the graphic novel. With respect to photography, we identified the path it took from the invention (the appearance phase) of heliography by Nicéphore Niépce to the public emergence and institutional growth of the daguerreotype to the initial advent of the medium under the influence of practitioners such as Nadar, who expressed their faith in the singularity of this new means of expression whose identity by that time had become well established in society and culture.

The graphic novel also lends itself, albeit with certain important qualifications tied to its historical, geographical, and cultural singularities, to a genealogical reading in keeping with the dynamic of an evolving double birth. In Francophone Europe, for example, we can thus see a course stretching from its invention (appearance)

by Rodolphe Töpffer to the "autographic" album (using a kind of lithography) to the advent of the medium as a genre, in various editorial and generic configurations, at the turn of the twentieth century. Since we first proposed this model, several writers have critically appropriated it as a framework for their own genealogical exploration of the media on which they carry out research. These include, to mention just these few, François Jost and Doron Galili for television, Christophe Gauthier for the Internet, James Lastra for the cell phone, and Gyula Maksa for the graphic novel.[22-26] In the case of websites operated by media and new technology analysts, someone such as the communication researcher Julien Lecomte has popularized our model in the following manner on his blog:

> We might thus explore the so-called "double birth" model (Marion and Gaudreault, "Cinéma et généalogie des médias," 2006). . . . To simplify the model, in reality a medium is born initially in a technological form. Here it becomes a part of the society that preceded it. Then comes it social appropriation according to previous usages, a context, etc. It may be simply rejected or put aside, or end up not being used in the manner envisioned when it was created. One shouldn't think that a medium turns current practices upside down from one day to the next.[27]

As we can see, here Lecomte emphasizes the integrative dimension of a new medium's emergence.[28]

With respect to the application of our model to different media, we will mention just two cases: first, the cellular phone, and second, television. James Lastra, in a text in which he proposes a "friendly amendment" to our article "A Medium Is Always Born Twice," removes the word "twice" and replaces it with the word "repeatedly" in an attempt to apply the model to the cellular phone: "the cell phone as a very contemporary example of a technology/medium in whose misapprehension we are currently participating. The name is telling: cellular *phone*. Born 'first' in 1973, its second birth occurred in the 1990s as cell phones penetrated all levels of society and the market."[29]

Lastra speaks of the *misapprehension* of this "data terminal" that the portable telephone has become. He is quite right when one considers that the telephone, which people describe wrongly as smart, is constantly used as an unexpected support or relay for other media: television, radio, the Internet, etc.[30] Is it not significant in this respect, moreover, that in many parts of the world the customary term used to describe this "medium" does not include the word *telephone?* (In France it's a *portable*, in Quebec a *cellulaire*, in Belgium a *GSM*, and in England a *mobile*.) It's as if this omission of the word *telephone* was a subliminal way of concealing the original purpose of the device: to enable telephonic communication.

There is in fact a kind of misunderstanding in our relation with the portable phone since it experienced its second birth. While some people use it strictly for telephoning, others rarely or in some cases never use it to telephone. This much more radical second birth than what cinema experienced when it was institutionalized in the 1910s has led this little pocket gadget to become a kind of multipurpose electronic Swiss Army knife, to return to Pierre Musso's wonderful metaphor we quoted above.[31]

Doron Galili, for his part, applies the double birth model to television in a doctoral dissertation defended at the University of Chicago in 2011. Galili rightly points out that applying the model to other media must of necessity demonstrate flexibility and be adapted to the specificity of the medium in question. In his view, television experienced a particularly slow period of emergence compared with cinema. Here is how the young scholar sees the emergence of the two media:

I find that Gaudreault and Marion's model is useful for early television historiography, for it draws attention to the important period during which the medium established its norms, its distinction from other media, and its public recognition. In examining this period, it is clear that the emergence of television was qualitatively different from that of cinema since a great deal of the articulation of television's autonomy occurred before and around television productions and programming *per se* and existed on a discursive and experimental level rather than a practical one.[32]

The model of cinema's "double birth" rests on a metaphor whose aim is to minimize any kind of narrow chronological account. As Galili implies, this model, in its application to the history of television, provides an epistemological framework whose earlier application to cinema constitutes a kind of prototype. Our metaphorical model should thus not be taken literally. Especially as, in our view, it exposes itself to criticism on several levels.

Criticisms of the Double Birth Model

Because of its biological connotation, the metaphor of the double birth may be unfortunate in the sense that it projects onto a techno-semiotic world a semantic field proper to life on Earth. But why not take up this biological metaphor fully, given that a bio-mimetic quality more or less haunts those odd machines that are our media. On the one hand, we humans have a metonymic relationship with our media; they extend the human body, whose functions they exteriorize, reinforce, multiply, etc. They are thus a logical continuity of our skeleton, our muscles, our senses, and our brain (as the anthropologist of technologies André Leroi-Gourhan has described in detail).[33] On the other hand, however, they also have a metaphorical dimension: they are made in our image, even if this image is sometimes deforming or deformed. *We possess the media, which possess us,* media scholars justifiably claim. Our media devices and technologies resemble us, and we end up resembling them. Could we not legitimately apply to them, even if it were only for a moment in our discussion, the cycles of human life: birth, development, crisis, death, etc.? Let us thus adopt this biological metaphor without false shame, especially if it can help us to understand!

There is a second possible element on which we could carry out a self-criticism. In asserting that "cinema" was born twice we have slightly abused the meaning of the term, because, as we have already demonstrated, what was born with the first birth was not yet truly "cinema." It was, rather, the kinematograph. This is a subtle distinction, but an important one.

There is a third element of our model that lends itself to criticism: today it appears to us to be much too closed, because it ends, without

any other proceeding, with the second birth, which dates back a hundred years now. This second birth is like the finishing point of a phenomenon that is nevertheless in a state of constant transformation. Here we could compare our closed model to certain canonical narrative schema proposed in earlier times by structural semiotics, such as initial equilibrium, suspension of equilibrium, and new equilibrium. At the same time, for those with an optimistic outlook on the medium's future, the present-day effervescence of the digital has put on the agenda a kind of cinematic renaissance (rebirth): a new, third birth. It is as if cinema, in the sense in which it was understood institutionally, reached the point where it experienced a kind of death, to play out our biological metaphor.

Let us reassert here our definition of a medium's identity, understood as a provisional federation of diverse cultural series. Or, to be more precise, a provisional and *consensual* (meaning in synch with social uses) federation of diverse cultural series. Each of the cultural series that converge to give rise to cinema has its own historical trajectory, its own genealogy. This approach to identity introduces some nuance into the abrupt "life or death of a medium" opposition and is compatible with the current work of other scholars. Charles Acland, for example, has proposed the idea of "residual media," drawing on the work of the British cultural historian Raymond Williams, considered one of the founders of cultural studies.[34] For Williams, three strata of culture exist: dominant culture, emergent culture, and residual culture. Acland adapts this triptych, highlighting the continuity at play in media that are not dead but residual. This conception of residual media is an effective counterargument to the idea of a rupture, a sudden break between a "before" and an "after," between medium X that had to annihilate medium Y, or between a "this" replacing "that." It would be a mistake to believe that a new media configuration radically and completely replaces what came before it. In any event, the appearance of a new technology is far from an irremediable indication that previous technologies in the same field will disappear or be eradicated. Printed books may have become residual in the face of digital tablets, but there is little chance they will disappear. Many people believe that paper, the printed page, and the reading habits associated with them are immortal.

Such ideas are not that dissimilar from those we have developed elsewhere, to the effect that new media, apart from their novelty effect, are often content, initially, to serve as a relay for preexisting cultural series by borrowing their established form and content.

The advent of certain technologies nevertheless profoundly changes the rules of the game and forces us to reshuffle the cards. This is the case with the digital, which, unlike what occurred with the arrival of talking cinema, is spilling in unprecedented fashion beyond the boundaries of cinema alone (to take just this one example). Thus the new forms of entertainment on offer in venues we still call *movie* theaters (this is the tele-agora phenomenon) not only call into question the identity and status of these theaters themselves, but they also bring about identity crises within the other media that invite themselves to "the cinema," occupying a part of the theater's screen time.

Toward a Third Birth: Fragmented Cinema

Let us return to our second birth, which we qualified as "differential" and which occurred at the time of cinema's institutional crystallization. What was born at the time of this birth thus corresponds to what we have suggested be called "institutional cinema." This is the cinema, precisely, that today is threatened with extinction or a relative death. This death, it appears, would open the door to a kind of new birth, one associated with a "restoration" or a bringing back to life of the integrative and intermedial nature of the medium's first birth when the apparatus was invented. Let us repeat: what we have just explained with respect to cinema's deaths and crises demonstrates that the institutional "difference" or singularity of a medium such as cinema is not as stable as one might think at first glance. It also shows that the life of a medium is made up of both continuities and discontinuities, and equally of thresholds and ruptures. At every crisis moment the institution splits and must react on the level of its identity to confront the nondifferentiation, the intermedial porosity that besets the singular identity of institutional media such as cinema.

We believe our double birth model errs in particular in the way it presents the second birth, that of the advent of *cinema* ("real" cinema, we might say) and institutional regulation, as an end point

leading to its definitive and immutable stabilization. Cinema is seen, at this point, as having taken on a state of peaceful homeostasis in the shadow of the institution. Systems theory tells us that such a state can be fatal to any system, whether organizational, biological, or medial. In truth, in order to survive, a system must combine entropy and "neguentropy," permanence and change.

Although our second birth consisted in fixing this federation of parameters and cultural series that make up a medium such as cinema, the frenzied degree of hybrid forms and cross-border porosities seen today in the field of the moving image makes it possible to extend our model. Indeed everything that is taking place suggests that today's upheavals in cinema's identity brought about by the digital revolution have led cinema to return to the intermedial effervescence that was in full swing before its institutionalization. Is this not the sign that we are, at this very moment, in the midst of a *third birth of cinema* (a *second* second birth, in a sense)? The *new* birth of a *new* medium, whose *new* identity is the process of being defined in response to the questions around its identity that are around every corner in these times of crisis and that, especially, every inhabitant of planet cinema continues to ask himself or herself.

James Lastra, who was unaware when he wrote the text we have quoted from here that we had already declared our double birth model to be too limiting, will be pleased to hear this.[35] For Lastra is in favor of a "proliferation of births":

> Cinema may well have a "first" and a "second" birth, but it is a historiographical mistake to believe that any representational or communication technology ever achieves a stable or "autonomous" form. Indeed, it is these technological/aesthetic media's perpetual need to produce and reproduce a kind of "constitutive exteriority," that serves as its engine for change and transformation.[36]

For Lastra (and for us, moreover), the definition of a medium's identity is not riveted solely to the machines that make it possible, and it is impossible to reduce the range of its identity to the institutional rules to which it is subjected at any given moment in its history: as Lastra points out, "Technologies are in a constant and necessary state

of self-definition."[37] Everything except, in the final analysis, stability. What Lastra is expressing, in a sense, is the idea of a second birth that is multiplied and indefinitely repeated throughout the medium's genealogy. Lastra calls this the medium's constantly transient autonomy: "History shows us again and again that what we have taken as 'specific' to a medium inevitably withers in importance to be replaced by more vital concerns, and aesthetic autonomy evaporates along with it. Media constantly produce their transient 'autonomies' by producing and policing the boundaries of what they are 'not.'"[38]

It is thus essential to recognize that the second birth experienced by cinema in the early 1910s, its *institutional* birth, must also be seen as evolving and dynamic—so evolving and dynamic that it is capable of giving rise to a new birth. Hence cinema's *third birth*, which we are witnessing today: an integrative and intermedial birth involving a degree of return to porosity, to a hodgepodge, to hybridity, to cross-fertilization—all of which imbued the medium's very first birth. To be more systematic, we might even propose the idea that this third birth metaphorically puts into concrete form the idea of cinema's constant rebirth, given the recurring, inevitable, and cyclical dimension of its identity crises, which oblige the institution to adapt or die.

This third birth is thus not differential, unlike the second, and is the result of a neo-institutionalization or postinstitutionalization. It derives not from cinema's unimedial singularity but from the way it negotiates with the other media around it. We might even argue that cinema, in the present-day context, has once again become a kind of cultural series in a weak sense, enabling it to link up more easily with other media. A cultural series in a weak sense because it is more or less preinstitutional and thus less rigid, more open to hybridization, etc. This partial return to the spirit of the cross-fertilization of its beginnings, even if today's cross-fertilization is different in nature and extent, takes on uncommon strength in this era of media convergence. We should note that the spirit of cross-fertilization in force at the time of the emergence of the kinematograph, about 1900, was unique in that it was both *intrinsic* and *extrinsic*. It was extrinsic in the sense that, to accompany the projectionist's "performance," the *exhibitioners* of animated pictures and others who showed kinematograph pictures often called on a variety of "performers": musicians,

stage artistes, and behind-the-scenes technicians. The cross-fertilization was also intrinsic in the sense that, as has been demonstrated on many occasions, the kinematograph was part magic lantern, part stage show, part photography, and so on. Today's cross-fertilization, powered by changes in the technology of audiovisual recording and the new uses these give rise to, is of course of a different order than the hybridization in force in the medium's early years. Nevertheless, the breaking down of cinema's boundaries that today's digital revolution is carrying out is in a sense the equivalent of a return to the spirit of nondifferentiation in the medium's identity associated with the hodgepodge of kine-attractography, before institutionalization came along and put some order into this muddle by promoting and ranking the kinematograph's various identity values.

The identity crisis to which the digital tsunami has given rise and the crumbling of the institution's control thus go hand in hand. Seen with a degree of hindsight, the crises that a medium such as cinema has undergone in its genealogy are excellent for demonstrating the implicit hybridity that shapes every media identity, which is never anything other than a developing federation of media from various cultural series.[39] Seen in this light, we might almost say that media are always in a sense hypermedia that are unaware of the fact. One might even argue that contemporary hypermedia, when they regroup and incorporate various other media, are "imitating" on a different scale those classical media that also established their identity by federating preexisting cultural series.

The Cinematic, the Kinematic, and Postinstitutionalization

In order to continue our discussion correctly, we must now open up the field of study. This is why we propose to take into account not only the "cinematic" but everything pertaining to what we have described elsewhere as the "kinematic," in reference to the shift from the medium cinema to a convergence of moving-image media.[40] The blurring of the boundaries between media (cinema, television, and media arts, say) that now use one and the same "recording system" for their base "signals" (where before at the very least there was celluloid on the one hand and videotape on the other) appears to

us to call for and justify the use of the term "kinematic." To buttress our argument for this terminological and conceptual need, let us look briefly at what is happening in universities, particularly in the names of recently created programs. One of the strategies used to broaden these programs' horizons and show that they are not limited to cinema alone is to follow the word "cinema" (or "film") with the expression "moving image"—which could on its own, strictly speaking, suffice to describe what is taught, because cinema is "moving images." This is the case, for example, of the PhD program launched in 2008 at the Mel Hoppenheim School of Cinema (Concordia University, Montreal), which was given the name "Ph.D. in Film *and Moving Image* Studies."[41]

To show that one is casting a wide net, it is also possible to use expressions such as cinematic arts or cinematic media in the name of the program or department itself, thereby proclaiming to the world that the learning offered is not limited to cinema alone while at the same time indicating that cinema retains special status just the same (or, even better, that it remains the ultimate reference for other media!).[42] Such expressions are highly contestable, however, and the blurring of boundaries is not sufficient to justify them, in our view. To maintain that television, for example, is a "cinematic medium" will not win the favor of everyone working in television, to say the least. The difficulty of labels such as these is the territorial "annexation" that cinema might be suspected of carrying out in trying to be a home to television, video art, etc., under an umbrella term bound up with cinema. Hence our proposal to introduce the word "kinematic," which makes possible an additional level of distance or, more precisely, of being run through with a variety of elements. For us the kinematic is what remains of the cinematic in the vast culture of moving images. This is the case, to take just one example, with "films" on DVD, which are no longer on film and in which highly cinematic silver salts no longer have a role to play.

This addition to our vocabulary will prove useful to us in carrying out our project of establishing a dynamic genealogy with a view to understanding cinema through its evolving identities. In order to do so, we must first attempt to understand, "from first to last," the hybridization phenomena that have affected it. First, in the

late nineteenth and early twentieth centuries, characterized by inter-medial mixing, is the media culture broth of what we have called the kinematograph's integrative birth. This is matched, lastly, by the late twentieth and early twenty-first centuries, marked for its part by the intermedial mixing of what we call the "kinematic" in the polyphony of contemporary hypermedia.

Lifting the protections around cinema's identity—the dissolving of singularities we are witnessing today—is a kind of "de-institutionalization" or, at the very least, the institution's need to update its way of concentrating and regulating the kinetic energy of the medium whose fate it governs. We propose to call this cinema's "postinsitutionalization," which corresponds to the sort of intermedial reviving that characterizes our third birth.

In today's all-digital age, cinema is thus condemned to find a place, to find its place, among the new and many variants of the moving image.

New Variants of the Moving Image

We are not in the civilization of the image but rather that of the screen.

SERGE DANEY, "BEAUTÉ DU TÉLÉPHONE," 1991

There will be a final screening attended by a final audience, perhaps indeed a lonely spectator.

PAOLO CHERCHI USAI, *THE DEATH OF CINEMA: HISTORY, CULTURAL MEMORY, AND THE DIGITAL DARK AGE*, 2001

When it comes to cinema, things were once simpler than they are today. There is no need to belabor the fact that since sounds and images became relatively dematerialized and transformed into *cathode* or *numerical* signals, the paradigm that we call the "classical model of cinematic proceedings" has been smashed to bits. Nor is there any need to belabor the fact that the *commercial* relation between the *ordinary film viewer* and cinema is no longer what it was. Things are not as simple as they were before, starting with the fact that buying a ticket to a movie theater is no longer the only way to see the films on offer in the marketplace. Worse yet, buying a ticket to a movie theater is now only one means among *several others* to see these films.

The "classical model" ruled unopposed (but not necessarily in a manner as monolithic as we are suggesting, something some people might view as relatively lapidary)[1] between, roughly speaking, the 1910s and the 1950s, or in other words until the massive arrival of television. Laurent Gervereau, in his book *Histoire du visuel au XXe siècle*, maintains that "the nature [of cinema] is *public projection in an auditorium*, as *inaugurated by the Lumière brothers* (and not the individual viewing in a box launched by Edison)."[2] This *topos* of the

public hall equipped with a screen where viewers gather—generally recognized as the concentrated expression of what we might call "cinematicness"—is the myth par excellence of "cinema's origins." In order to decree, retrospectively, that the birth of cinema had taken place with the famous inaugural, public, and paid projection of the Lumière Cinématographe on December 28, 1895, at the Grand Café in Paris, there had to be brought together, necessarily and in a concomitant manner, an *auditorium*, a *screen*, *paid admission*, *assembled viewers*, and the *projection of moving images on celluloid*. We might call this the PPPP system: the *p*rimordial *p*aid *p*ublic *p*rojection.

With the arrival of television, the "spell" of the "classical model of cinematic proceedings" was broken. The access to films made possible by television put an end to the exclusivity of this model (a relative exclusivity, of course, because there were also educational films, amateur films, home movies, etc.). Television thus brought about the end of this model's exclusive reign, but not of its hegemony, because it remained clearly dominant just the same until the digital tsunami washed ashore in the 1990s.

Beginning in the mid-twentieth century, therefore, television offered a radical new way of watching films. Viewers now had a real choice between two distinct social practices: "going to the movies," a practice that had become established in people's habits in the 1910s, and "watching a film on TV," a practice that became a part of people's lifestyles in the 1950s—and which, it was thought at the time, threatened the very survival of the movie theater, if not of cinema itself! Viewers could now *choose from a menu*, but could not *choose their menu*: despite the two avenues that the "television revolution" opened up, selecting what was shown (everything that was shown) on screen (both the *small* screen in the living room and the *big* screen in the movie theater) was something decided by agents (*commercial* agents, say) over which the "ordinary viewer" had no power. In any given city in the world, on any given day in the late 1950s, at any given time of day, a certain number of films were being shown in the six or seven movie theaters of a typical town and perhaps one film was being presented on the town's sole television channel. Viewers clearly had a choice (between the film on TV on the one hand and the six or seven films in movie theaters on the other), but this was a *limited* and *restricted* choice.

The reason the hegemonic model was smashed to bits is because, for more than sixty years, one has been able to pay an annual fee (in a country such as France at least—many other countries have a different system, where people pay no fee to receive the basic hertz signal) and watch films without any other formality (and free of charge, in a sense, because the price is the same whether one consumes hundreds of films per year or none). For almost forty years now it has also been possible to obtain films in a domestic format: first with videocassettes and then with the digital versatile disc (DVD). And for almost the past ten years ordinary viewers have also had access to video on demand (VOD, on television or by Internet) and to films offered directly on the Internet (through streaming or downloading).

The Autonomous Viewer

The threshold following that of television's arrival was thus crossed with another major event, the appearance of the video playback machine (the most important change in cinema since 1895 according to Boussinot, as we saw above). From that time on viewers were able not just to record any given film shown on TV (or any television program, for that matter) but also—and this was the great revolution—watch it *whenever they wanted, as much as they wanted, and according to a schedule that they, alone, decided*. The dictatorship of the socially determined programming lineup was over! Home theater could take flight. Once it became historically possible to *possess a copy of a film on a videocassette*, home theater had what it needed to become a true institution. A new avenue now opened up for viewers: on any given night, they could watch a film showing in a movie theater not far from their home (avenue A), or stay at home and watch another film being shown on television (avenue B), or watch on their TV set (whenever they want!) a film they obtained on videocassette (avenue C).

Now that cassette tapes have been replaced by DVDs (which, it would appear, will be replaced by digital files stored on a remote server—the cloud—accessible by Internet),[3] now that new portable devices such as the multifunction telephone and the walkman are available to the viewer, make room for *nomadic consumption*, which makes it possible to audio-view films not only on the *big screen* in a

movie theater or on the *small screen* of our television set, but on a series of screens (which we will call "secondary").

The arrival of home theater and, in particular, its expansion, and the place it has found in our everyday lives, have tolled the bell for the heretofore dominant model, which required of the viewer to be "constrained" by and "subjected" to the film. Francesco Casetti explains:

> The filmic experience has changed profoundly since the 1960s. Looking at what is happening in cinema—and to cinema—if anything is clear, it is that we have reached the end of a model which has been dominant for a long time: the model which thought of the spectator as attending a film. To attend means to place ourselves in front of something which does not necessarily depend on us, but of which we find ourselves to be the witnesses. What is important is to be present at an event, and to open our eyes to it.[4]

Viewers have become proactive and can, indeed must, get involved in the act of audio-viewing a film (watching a film has now become an *act*). To quench their thirst for films, they must now carry out a certain number of actions: choose the device on which the "film" will be shown (the "big screen," the "little screen," or a series of "secondary screens"); they must determine the environment in which the film will be "read"; they must determine whether the reading will take place all at once or in several segments, in bits and pieces even, by choosing their mode of audio-viewing (do they intend, for example, to organize an evening devoted to viewing the film, or to *consume* it—the term is well-suited to the following example—in *passing*, such as a traveler in possession of a nomadic screen: first in an airport, say, then in an airplane, and then, to conclude, having arrived at their destination, in a hotel room?). On this topic, Casetti remarks:

> The presence of options where once there was standard practice, the necessity of establishing the rules of the game where once they were implicit, the strong connection with one's own world where once there was a separation, the widening of perspective where once the field was bounded—these are all elements that testify to how much the framework has changed.[5]

In other words, one of the current models, which we suggest be called the "contemporary model of cinematic proceedings," results in "ordinary film viewers" being able to *possess* films. In other words, they can *purchase* them. Before the massive introduction of the video-cassette onto the market in the late 1970s, *buying a film* was an expression very few ordinary viewers would find themselves uttering. Yet it was an expression that was a part of the everyday vocabulary of the first people to show animated pictures, back in the days of kine-attractography, and it was of course part of the everyday vocabulary of film distributors under institutional cinema. Except that there are two senses to the expression: when a distributor or a television network "buys a film" (at the Cannes film festival, for example) for a particular market, it is understood that "copies" of the film are not the main element of the transaction. Something quite different happens when an ordinary viewer goes to a DVD store to "buy a film": normally, they leave the store with one or two copies of films (we might say that these are "empirical" copies).

To take up Charles S. Peirce's distinction between type and token, we might say that what distributors or TV networks purchase for their market is the "title" of the work itself (this is the type, or the film-type), whereas what the ordinary viewer of today and the person who showed animated pictures buys is an "avatar" of the title in question (one of its tokens, or a film-token).[6]

It was these film-tokens, and not film-types, that exhibitors in the days of kine-attractography purchased. In those days, *buying a film* was one of the obligatory tasks of "ordinary" showmen, who emerged from the sales office of animated picture merchants with their arms full of newly purchased film reels, which were now theirs alone. Indeed for the very earliest generation of showmen, the basic transaction, the first essential step, was to *buy* copies of films. In those days, the pictures offered to audiences by exhibitioners were their own property: every film they showed was a token that they had procured through purchase. Until 1905–1910 (depending on the country) there was no intermediary between those who *manufactured* the film and those who *exhibited* it. What the former sold the latter was not a type, a film-type, a "title," but rather "film stock": a copy of the film, a film-token. And with this transaction, the *manufacturer*

ceded all rights to the *exhibitioner*—even the right to determine the final form the film would take on screen. Indeed animated picture manufacturers quite consciously encouraged the idea that the films they sold to showmen, the "exhibitioners," were, to borrow Thomas Elsaesser's expression, "semi-finished" products.[7]

Animated picture exhibitioners ran their businesses as they saw fit, showing *what they wanted* and *how they wanted*. The manufacturer did not have any word about how these shows unfolded. What is more, exhibitioners took on the task of refining the products they had just purchased from the manufacturer, in their *own style* and according to their *own tastes*, completing the task just before projecting the images onto their canvas screens and determining the context of their presentation, for they were the ones who decided whether an animated picture would be accompanied by music, spoken commentary, or both.[8]

Buy or Rent: The Lost Paradigm

The emergence of the nickelodeon in the United States between 1905 and 1907 was in this respect an event of capital importance for the development of cinema, because it brought about a complete reversal in the relationship between animated picture manufacturers and exhibitioners. It was also a capital event because the establishment of dedicated movie theaters brought about a radical reversal between viewers and exhibitors. The new paradigm required exhibitors to turn over their supply of films on a regular basis, which was a quite new development. As John Collier remarked at the time in an extremely clairvoyant manner, the nickelodeon "became a neighborhood institution."[9] This is why film exhibitors needed to bring back, over and over, week after week (if not more frequently), the *same* viewers to their establishment.

This passage from sale to rental made possible the passage from *nomadic* to *sedentary* exhibition, and the arrival of that very special agent, the distributor, the film renter (who owned the great film exchanges, as these companies serving as an intermediary between manufacturers and exhibitors were known in the United States). The proliferation of theaters devoted exclusively to cinema and the very

concept of "movie theater" are tied directly to the establishment of the film rental system and the emergence of the exchanges. If manufacturers had continued to sell films to those who showed them, cinema would not have developed in the same way.

It was thus necessary to pass from the sale to the rental of film-tokens for the exhibitor's user rights to be limited in time, for the balance of power between the producer and the exhibitor to swing toward the producer, and for the producer to have a say in what would be shown on screen.

In our view, the passage from the sales system to the rental system must be seen as a threshold, a break, in the film history continuum.

Naturally, other thresholds were crossed in the course of this history and other ruptures occurred, such as that, for example, of the arrival of the "not-celluloid film." Once ordinary film viewers, back in the 1950s, could see not-celluloid films on television, their relations with the *res cinematografica*, it seems to us, were literally turned topsy-turvy. We must also see as a threshold and rupture the point at which the ordinary film viewer could begin to buy copies of films—copies of not-celluloid films, of course—in the 1980s.

We must view these two shifts as changes of paradigm. They take us to the other side of the mirror and create historical ruptures and breaks, like the first radical transformation brought about by the passage from the sale of films to their rental. We might even argue that this passage from sale to rental was *the* inaugural gesture of cinema's classical era, even its date of "birth." As we have explained in detail in this volume, cinema's date of birth does not correspond to the invention of its "base apparatus." We might even go so far as to say, by returning *ab ovo*, so to speak—to use a biological metaphor that is not necessarily adequate if taken literally—that cinema was able to begin to be born, was thus born, the day films were made available for rental, because this made possible the emergence of the permanent movie theater. It also reined in the exhibitors in favor of those who, by virtue of this fact, became the knights of the nascent film industry by taking all editorial power away from the *local exhibitioner* and granting the *central producer* the right to dictate and regulate the industry as a whole, setting in motion the institutionalization process.

There can be no institution if everyone does what they want; there can be no institution if power resides with each individual, who sees his role as showing animated pictures how best he sees fit. Institutionalization implies the concentration of power. And all that may be the result of an act that may appear banal and insignificant, but is in fact *huge*: putting an end to the model of the *kinematograph proceedings* that held sway before the second birth we described above.

The importance of the emergence of the permanent venue for film exhibition is abundantly clear: with it, viewers were able to seek out films in theaters whose raison d'être was the projection of moving pictures. Before taking up residence in these new theaters dedicated to it, cinema had always been *without a fixed address*: it traveled around, hither and yon, in various places that were not its own (vaudeville theaters, community halls, fairground tents, cafés, theaters, etc.). "Going to the movies" was not yet part of the everyday routine of the average person (instead, the kinematograph came to them). Cinema could not yet reign over the entertainment world because it was without a kingdom. The construction of this kingdom was not long in coming, however, with the building of movie palaces in the 1910s,[10] complete with chandeliers, red carpets, and marquees. The movie theater, despite having been born into humble circumstances, soon became worthy of King Cinema (or should we say worthy of King Viewer?).[11]

Finally a kingdom, cinema went on to see a great expansion of its domain in the early 1950s, because at that time, thanks to the hertz signal, it was able to get outside the walls of its palaces and take up residence in our residences, and more precisely in our living rooms, and take over our humble hearths, thereby reversing the basic proposition: not only could people continue going to the movies, but cinema could now come to us, inviting itself into our homes. As we mentioned above, this brought about an *irreducible* and *irreversible* transformation of the relation between viewers and the *res cinematografica*. This process of "expelling" film from the movie theater would continue thanks to the growth of domestic or individual supports for viewing films, to the gradual dematerialization of the base "signal," or in any event to its weakening, and to the miniaturization of devices and their proliferation.

The "Hyperviewer" as Living Room "Manager"

Unlike *ordinary* viewers of *ordinary* cinema, today hyperviewers who want to see a film can naturally buy a ticket to a movie theater, but can also buy a film *outright*. Once this transaction has been completed, these viewers can return home (home sweet home) and soon be transformed, not into "theater managers," but into "living room managers," creating in the process their very own little home theater.

We have seen that only those people who used this verb *on a regular basis* (buying films, buying a film) over the seventy years or so separating the establishment of institutional cinema (in the early 1910s) and the massive introduction of the videocassette (in the late 1970s) were, with a few rare exceptions, active members of the sector of the film business located between the film producer on the one hand and the viewer in the movie theater on the other: *film distributors, film renters, theater managers,* intermediaries inclined in principle to cast their lot with newly released films.

Purchasing a film, or "appropriating" it in one form or another, could also, albeit in a more marginal manner, be carried out by a *collector* or *archivist*. These types were more interested in old films. Even more marginally, a purchaser could be a well-off amateur filmmaker with access, at various points in film history, to the various kinds of "small-gauge home movie" that began to appear as early as the 1910s (from the Pathé Kok system introduced in 1912, to the Pathé Baby appearing in 1922, to the Kodascope Libraries in the mid-1920s).[12,13]

The essential difference between the film showman, collector, archivist, and well-off amateur filmmaker on the one hand and the film distributor, film renter, and theater manager on the other was the purpose of the transaction they entered into. For the former group, this was to obtain the physical film itself, as we described above, something that was not exactly the case for the latter group. For a distributor, purchasing a film was a virtual act, at least at the moment of the transaction. Although such a transaction necessarily involved the acquisition of quite real copies of a film (for a film screening to take place it was indeed necessary, not so long ago, for a "real" print of the film to physically land in the projection booth and reign there for

a while!), what distributors purchased was, in essence, immaterial in nature. What they purchased was not celluloid in and of itself (a token) but rather a *right*: the right to distribute a particular film (in fact the right to distribute *various copies* of a particular film) and to rent it to various theater managers (who purchased the right to show it in their theaters in turn) for a defined (and predetermined) period of time.

When ordinary film viewers purchase film-tokens for a given film-type, this purchase carries with it a number of restrictions and constraints. For by purchasing a film one also purchases a right, but this is a *limited* and *restricted* right. As the warnings on videocassettes and video discs remind us constantly, ordinary viewers who purchase a particular film are not authorized to show it outside the family circle and certainly not to a paying audience.

At one time, there were not a million ways to see a film: you had to leave your home and go to a movie theater according to predetermined schedules over which you had absolutely no control. There was a time (not so long ago!) when viewers had *no control* over the unfolding before their eyes of the *luminous object of their desire*. To "consume" the object in question, viewers had to wait patiently for it to be shown on a neighborhood movie screen, at a time decided by someone else. As this model applied of necessity to all ordinary film viewers wishing to see a film that had not appeared on the program of their local movie theater, there arose a pattern that was predictable, linear, and not at all interactive: resign yourself and wait.

In that bygone era, many movie theaters were used exclusively to screen "film-films." Today we can audio-view films in our living room or office and even in the subway. After a film is released in theaters, where it normally stays for a very short period of time, a film today can be shown not only on television but also can be downloaded online, made publically available on VOD, recorded on a DVD or Blu-Ray disc, etc. As Édouard Arnoldy remarks, "Thanks to the DVD, the true life of cinema is now somewhere other than in movie theaters."[14]

ATAWAD: A Major Syndrome in the Advent of the Digital

The difference today between the cinema we knew and the cinema we are in the process of discovering is the great syndrome ATAWAD,

which accompanies the "break" brought about by the digital revolution, as Bruno Icher explains:

ATAWAD: "Anytime, anywhere, any device." When I want, where I want, on any device. The old prophesy of entertainment always within our field of vision, popularized by that wily Bill Gates, is gradually leaving the realm of fantasy. When? Now, there, right away. Where? At home, on a train, at your cousin's place in Brittany or in the middle of the Gobi Desert. Using what kinds of devices? All of them: my (wi-fi) computer, (plasma) TV, (traveling) game console, (mobile) phone or video playback machine (as thin as a credit card).[15]

The ATAWAD syndrome, the ability to transport media anywhere, makes all the difference, because we now no longer watch films in the public sphere (in a movie theater, for example), and no longer even in our living rooms, but *everywhere we want, how we want, if we want.*

Hence the following crucial question that returns like an obsession: *Is a film watched on a telephone* (to take just this example) *still cinema?*

A close relative of the DiMuMi syndrome (for *di*gital, *mu*ltiple, and *mi*grating), the ATAWAD syndrome grows out of *media convergence,* a convergence leading to another kind of convergence, the *convergence of interfaces* (of devices and apparatuses), a major phenomenon in the digitalization of media (of *all* media). The ATAWAD syndrome is thus changing the nature of the relation between the film and the individual. The film's dictatorship over me is over! Film programmers no longer call the shots! This "work" is no longer as inaccessible as it once was: I rent it, transport it in my car on the way home from the video store, take it out of its case, hold it in my hands, and put it in my playback machine, letting me watch it on my TV or on my home theater screen, whenever I want.[16] What the heck? Have I become an exhibitor (meaning someone who, normally, rents films, ships them, and projects them according to a predetermined schedule)? The ATAWAD syndrome has thus brought about a break in the continuum of media development, resulting in the presyndrome and the postsyndrome. This syndrome has made it possible for a

particular airline, Air France, to maintain (in a light-hearted sense) that it is the largest movie theater in Europe:

> The new seat's large individual screen . . . lets you screen eighty-five films, in some cases translated into nine languages. *Air France is the largest movie theater in Europe* (in terms of the number of films). . . . Nearly 500 hours of programming are added each month . . . : films, TV series, French and international television news and talk shows, games, languages [*sic*] courses and even a jukebox with 200 CDs.[17]

In the turbulence we are now going through (passengers please attach your seat belts!) because of the digital revolution, what is needed is a degree of tolerance around the vocabulary used on planet cinema. This is what makes it possible to argue that passengers' individual screens on a few airplanes in flight constitute something like *one* movie theater.

If it is true, as Camus remarked, that "the misuse of language is . . . harmful to the soul,"[18] then today there are a lot of damaged souls on planet cinema. The "films" we see on this planet are no longer on *film*—on celluloid—and in addition the movie theaters where we see them are no longer *movie* theaters exactly (or at the very least they are no longer *only* movie theaters) because, in particular, of the invasion of what is known in France as the "not-film" (*hors-film*): opera, ballet, plays, and sporting events are often shown there live and sometimes prerecorded.

Our movie theaters are no longer truly movie theaters, as the Montreal newspaper we quoted earlier proclaimed loud and clear about the operas of New York's Metropolitan Opera. According to the newspaper, the Met's director, by encouraging live retransmissions of the company's performances, has put things topsy-turvy: "'Your movie theater is not a movie theater,' Peter Gelb, the director of the Met who has brought the company into a new era, began by saying."[19] Yes, but this new practice, an essential feature of our "*cinematic* modernity," is also bringing the *movie theater* into *a new era,* a new era in which we will go to see not-celluloid films in not-only-cinema-movie-theaters, but which we don't mind seeing

in movie-theaters-that-are-not-at-all-movie-theaters, in a multiplex-in-the-sky-that-is-not-really-a-multiplex. Help us, Camus!

It is thus clear that the many shocks planet cinema has suffered lately have produced upheavals and mutations in the established order, with the result that the vocabulary we use on an everyday basis is struggling to keep up with the new order. This is not to take into account that, in our home theaters, the device on which I show the *film-not-on-film* is equipped with a smart switch called the remote, whose invention, according to Peter Greenaway, tolled the bell for cinema, or at least for a certain kind of cinema. Film viewers' legendary state of submotility, drinking in the images on a screen that nourishes and dominates them, is no longer as absolute as it was.

When you think about it, you realize that the very principle of the tele-agora is in flagrant contradiction with the ATAWAD syndrome! In the left corner, home theater, and in the right corner, tele-agora! The advent of the digital has produced everything—and its opposite! For when we go to see a not-film in a movie-theater-that-is-not-only-for-movies and this not-film is broadcast live by satellite, it is not "anytime, anywhere, and any device," on the contrary! Say goodbye to the virtues of the ATAWAD syndrome! The not-film is shown in movie theaters *now*, according to a schedule decided on and imposed by a "superior" and "higher" agent! *Here, in this movie theater*, and not in that one over there! And it's *on this movie screen* and *none other*, and *no other kind of screen*. Even worse than the classic case of cinema, in the case of live tele-agora, it is no longer even the theater manager who decides the schedule. A higher agent makes this decision, because the screening time is clearly dictated by the place where the performance originates and is produced. It's as if the freedom that viewers had just won in their living rooms thanks to the digital were, at the same time, lost in the "movie" theater—or rather, in the "tele-agora auditorium."

Thus it is not only films that aren't what they used to be, but movie theaters also! They have become *tele-broadcasting theaters*.

In light of the above, one might wonder not only *what has become of the boundaries of cinema*, but also *what has become of the movie theater*.

We have also seen that what we describe as the tele-agora appears to be here to stay. Giving a name to the phenomenon helps us, we believe, to distinguish this new "cultural paradigm,"[20] the tele-agora, from the rest of the performing arts (live or prerecorded) on offer in contemporary culture. As scholars, it is in our interest to group together all "not-film" productions shown in movie theaters in order to be able to establish what gives them their specificity and determine what differentiates them. That said, although the expression *tele-agora* is new, the phenomenon it describes is not entirely so. In fact it was not written in stone initially that television would become a medium that would take over the private space of our living rooms. Indeed the earliest television receivers were found in public spaces.[21]

No one keeps track, moreover, of the number of social experiences involving television viewing in public (sporting events in cafés and bars, for example, or open-air giant screens to present an event). Nor does anyone keep track of the number of times a television program is rebroadcast in a movie theater to a paying audience—sometimes, as in Berlin in the late 1930s, numbering hundreds of people. New York's Metropolitan Opera did its part in this field as early as 1952, with a production of Bizet's *Carmen* shown on thirty-seven movie theater screens (in twenty-seven cities in the United States and to an audience totaling 67,000 viewers) using the Eidophor. One can appreciate the difference between these experiences and the resurgence of the tele-agora since 2007–2008: a recent televised broadcast of a Met opera, Verdi's *Traviata* in April 2012, took place in 1,500 theaters (compared to thirty-seven in 1952) in forty countries (compared to twenty-seven cities in just one country), and was seen by some 250,000 viewers (against 67,000).

Cinema Events That Are Not Really Cinema Events!

Changes to the cultural products on offer not long ago have given rise in North America to a new concept, the cinema event, to describe the category that in France is known, with a touch of disdain, as the not-film. For the past few years viewers have been urged to go to the movie theater to audio-view not only films but also ballet, opera, theater, and classical music. To pull all that together into a cogent

expression, the concept "cinema event" was launched to describe any kind of projection of moving images onto a movie theater screen normally reserved for cinema—whether what is screened is a "film-film" or some other kind of audiovisual "entertainment" (live or prerecorded). This concept of the cinema event was what Canada's Cineplex movie theater chain had in mind when it announced its holiday programming in December 2011:[22]

> The holiday season has arrived at Cineplex!
>
> We would like to share a few dates with you for your winter calendars. The upcoming *cinema events* are excellent family activities and an opportunity to share the holiday classics. Here is our special holiday programming at Cineplex theatres.
>
> Film
> > *White Christmas*—December 7
> > *Top Gun*—December 12
> Ballet
> > *The Nutcracker Suite*—December 18–19 (in our Bolshoi ballets series)
> Opera
> > *The Magic Flute*—Wednesday January 4
> > *Hansel and Gretel*—Thursday January 5
>
> The series The Metropolitan Opera: Live in High Definition continues with:
> > Wagner's *Götterdämmerung*–February 11, 2012 (directed *live* by Robert Lepage in participating Cineplex theatres).[23,24]

Note how the films themselves (the "cinema-films" to be more precise: *White Christmas* and *Top Gun*) are just an astonishingly thin part of this list of presentations that are nevertheless described as "cinema events." Ever since the development of home theater, which lets ordinary viewers consume films whenever they want in the comfort of their living room on a regular basis rather than according to a restrictive timetable set by someone else, movie theaters have feared the worst. By making it possible to present not-film entertainment in movie theaters, exhibitors in fact prepared themselves for the worst, to avoid bankruptcy in case people began deserting movie theaters

en masse. It is as if they resigned themselves to using their theaters for other "cinema events" than the cinema event par excellence that a simple and classical film screening must be in their eyes: a good old movie in a good old movie theater!

The range of products on offer in the not-film genre is far from having reached its peak. Promoters are coming up with more and more imaginative ideas! You can now visit museum exhibitions in a movie theater near you. This was the case with the great Leonardo da Vinci exhibition at the National Gallery in London in November 2011, for which a guided tour was rebroadcast in several movie theaters.[25]

In our future research we will examine the particularities of the arrival of the not-film in Europe, and in France in particular, where what we call the tele-agora is very popular. In May 2011, for example, the company Pathé Live replaced the structure initially known as CielEcran ("SkyScreen"):

> CielEcran, the leader in France in the distribution of entertainment and sporting events in digital movie theaters, announces an important change. The group will now be called Pathé Live. It is established in more than 88 departments and every region of France. The group is present in more than 200 Gaumont and Pathé movie theaters in France and in more than 420 movie theaters abroad. Upcoming presentations include the closing ceremonies of the Marrakesh comedy festival, presented by Jamel Debbouze. This event will be retranscribed [*sic*] live in a number of theaters on Saturday, June 11, 2011 at 10:00 p.m. Pathé Live uses a satellite video transmission system that is HD, 3D and 5.1 digital audio compatible.[26]

We speak here of this phenomenon as the *arrival* of the not-film, but we should perhaps speak instead of the *invasion* of the not-film, so great has been the commotion among a number of (relatively corporatist) interest groups in the face of what they see as unfair competition. Unfair and, in particular, *intrusive* competition. The not-film, which is viewed as a lifesaver by theater managers, is seen by producers and directors of "cinema-films" as a veritable "occupying power." This occupying power, by means of these not-film productions, seen as aliens, has invaded cinema's territory (the movie theater screen).

Figure 6.1 Title card from one of the animated short films in the series "Digitizing movie theaters should serve the cinema." © Société des réalisateurs de films (SRF), 2010. Directed by Romain Blanc-Tailleur.

The French film directors' association, the Société des réalisateurs de films (SRF), is one of the most activist groups to denounce the new power relations in movie theaters between the *film* and the *not-film*. In 2010 the SRF produced a series of animated shorts by Romain Blanc-Tailleur for the sixty-third Cannes film festival to denounce this "barbaric invasion" of movie theaters by the not-film. The title of this series of three films, "Digitizing Movie Theaters Should Serve the Cinema" (see fig. 6.1) is a real program in itself! Each film has a different title, each more hard-hitting and charged than the previous one:

> *The not-film causes serious harm to cinema.*
> *The rapid turnover of copies causes serious harm to cinema.*
> *The lack of diversity causes serious harm to cinema.*[27]

Less Glamorous Names

As we can see once again, since the advent of the digital, our media world is going through a turbulent patch of unprecedented

proportions. When you consider that an organization such as Montreal's Cinémathèque québécoise, known at one time for its almost excessive and in any event *exclusive* love of cinema, has surreptitiously changed its "museum" image, going from the "Musée du cinéma," a name it proudly displayed and to which it was fully devoted, to the less glamorous and less specific appellation "Musée de l'image en mouvement,"[28] you know that big changes are taking place in people's mentalities, rocking the institution's foundation. The people who run the world's film archives are social users of cinema, and like other social users of media they have lost many of their bearings. At the Cinémathèque over the past few years no one has been quite sure what position to take, as one of the curators of the institution himself describes: "Over the years we have often discussed various names to describe the Cinémathèque. . . . To the extent that I am all at sea. . . . The expression 'Musée de l'image en mouvement' was first used back in the 1990s, then we returned to 'Musée du cinéma,' and now we're back to 'Musée de l'image en mouvement.'"[29]

In an e-mail addressed to one of the two authors of the present volume, and thus like the previous communication semi-private, the executive director of the Cinématheque went even further and said the following with respect to the name that would give the most accurate indication of the institution and its mandate: "This week I heard the expression 'Museum of Cinematic Varieties.' A little *politically correct*, don't you think? For my part, I sometimes speak of variants of cinema, but I'll never say 'Museum of Cinematic Variants'!"[30]

A large part of this opinion and this attitude could be found later in a communication circulated, this time, in the public sphere. In a press release dated October 11, 2011, the Cinémathèque announced the acquisition of a collection from the Daniel Langlois Foundation of Montreal, whose documentation center had recently been closed. The Langlois Foundation is primarily interested in the encounter between technology and art, artistic creation in digital 2D and 3D, video art, and the artistic uses of interactivity and networks. Its documentation center, we might say, was devoted to what we might call "new images," whereas the Cinémathèque's is devoted to "old images": "'This is undoubtedly the year's most significant acquisition since it's a very concrete way for us to express our interest in

the many new types of moving images and to reflect the importance of new media in our collections. We thank Daniel Langlois for his generosity and trust,' said Yolande Racine, Executive Director of the Cinémathèque."[31]

The implicit contract is clear, if we may put it that way: cinema must henceforth negotiate and find its place among these "new types of moving images." This recalls cinema's first birth, when the new medium on the block had to find its place amongst already well-institutionalized cultural series such as the magic lantern, photography, stage entertainment, and fairy plays. To our mind, it is highly revealing that some institutions are dancing around this question and are stripping cinema of its exclusivity, something that a short time ago they proudly proclaimed. It is as if focusing exclusively on cinema is now an out-of-date model, perhaps even suspect. In this sense the example of the Cinémathèque québécoise is particularly symptomatic.

Quebecers are not the only ones feeling their way. The French too have the same cinematic ailment and present the same symptoms. Evidence of this can be seen in the decision to rename the leading film institution in the land, the Centre National de la Cinématographie, which gave itself a makeover in late 2010 to become the Centre National du Cinéma et de l'Image Animée. And in 2002, in the United States, the Society for Cinema Studies also changed its name to the Society for Cinema and Media Studies, thereby bringing together in a rather savage way two disciplines, simply by juxtaposing the field of film studies with that of media studies, which are not always buddy-buddy:

> The late 1990s saw the debut of digital media as a growing field of study. During the last decade the number of Scholarly Interest Groups (SIGs) has expanded, reflecting the growth of sub-fields in Cinema and Media Studies, many intermedial and interdisciplinary. In 2002 the "M" for Media was added to SCS to reflect these changes and create the Society for Cinema and Media Studies.[32]

The case appears to have been made: back in 2002, the blame for all this confusion was laid at the feet of digital media! It was because

of the emergence of the digital that there spontaneously arose new fields of interest, intermedial in nature and founded on an interdisciplinary approach, and that people in film studies were led to embrace a wider field of study, to be more inclusive, and to stop playing the card of the specificity of their discipline.

We can also measure this against the convulsions of planet cinema's satellite, "film studies." But it is not just cinema and not just the media that are changing and transforming. *We too are in the midst of a process of change.* We, as *film viewers*, but also as active members of the small community of *film studies researchers*. It is not just the boundaries of cinema-as-medium that are constantly shifting; the boundaries of the discipline known as film studies are also shifting. The past few years we have thus witnessed the proliferation of expressions such as "moving images." This relatively recent phenomenon, which holds that the use of the word *cinema* alone is inadequate to describe the discipline's field of activity and field of interest, is thus not anecdotal and is in keeping with an "epochal shift," we might say. Since the turn of the century we have been witnessing a change in our everyday vocabulary, to the extent that film instructors have come to wonder how much longer they are going to teach "cinema" (or at least *only cinema and nothing but cinema*).

This is the conclusion one can reach following a cursory survey of new university programs. The people behind them have demonstrated tremendous imagination to avoid giving the impression that they are restricting themselves to cinema alone while at the same time indicating that their program's topic is indeed cinema. Hello, schizophrenia! Indeed it is becoming increasingly awkward in institutional settings to speak in a hegemonic manner of cinema without taking into account such other "applications" of the moving image as television, video, mobilography, and installations.[33]

The Three Ds of Digitalization

Cinema thus no longer occupies the hegemonic position it once had, not so long ago, in the world of cultural practices involving the moving image. *Its encounter with the digital brought about a real*

weakening of its being-in-the-world. In truth, digital technology is not the sole "guilty party," and it is by no means the first to have battered cinema enough to topple it from the pedestal from which it reigned over the world of moving images. The initial tipping point was, as we mentioned above, the emergence of television as a mass medium in the 1950s. Television was the first technological innovation in the history of cinema to threaten the hegemony of the photochemical. Its advent was *the beginning of the end of the "celluloid era."* And on what precisely was "cinema" based, François Valleiry (a pseudonym of Edmond Benoît-Lévy) asked in 1907?[34] "On *celluloid* alone," he replied in answer to his own question.[35] Valleiry would never have believed how truthfully he spoke, the two authors of the present volume sing in unison! Television threatened the supremacy of the photo-chemical simply because it opened a breach: it enabled the film to come to the viewer along another path than the telling, one by one by a mechanical-luminous-projection-apparatus located a stone's throw from the viewer (and normally behind their backs, literally), of a long rosary made up of a film's thousands of single images. With the arrival of television, celluloid lost its exclusivity (until then absolute) and cinema lost its haughtiness. At first, films shown on TV were still on celluloid (there was thus a telling of individual images, but with a telecine apparatus, miles from the viewer). Soon, however, it was possible to record images (and make films) directly onto videotape, without having to unspool miles of celluloid. Celluloid thereby lost another chunk, a rather large chunk, of what had been exclusive to it.

And what had to happen happened: one day digital media arrived and celluloid was gone. This is where we are today. The deed is done. Celluloid is dead (or almost). But with celluloid dead, can the same be said of cinema? There is no doubt that Valleiry, if he were faced with the eradication of celluloid from the surface of planet cinema, would see cinema as being clinically dead. And he would not really be wrong. But this is a relative death, because as we have said many times here, there is always something that is reborn when a medium dies, or when something in it dies. It is hard to say that the digital caused the death of cinema when it is the digital that lets us see films and cinematic masterpieces to our heart's content. It is hard to say

that the digital caused the death of cinema because, as we remarked above, the digital has not yet chucked out the classical apparatus (projection, screen, movie theater, etc.).

Perhaps in the end we should see the passage to digital a little like the passage to the talking film and thus examine these two moments of identity crisis, which are comparable despite their singularities, with the same critical eye. *Silent* cinema is dead? Long live the *talkies*! *Photo-chemical* cinema is dead? Long live *digital* cinema! One kills the other.

We can say that this digital cinema took flight with the appearance of television, whose technology, like that of digital media, involves the decomposition of the image into points, bits, digits. Asked about this, the television historian William Uricchio concurred unequivocally with our position. One of the authors of the present volume asked him to respond to the following two statements:

1. Since its inception, TV is a digital medium.
2. The digital revolution started with TV.

This was his response:

I think the first statement is fair, though some folks will balk (they don't accept the mechanical as "digital" in contemporary parlance . . . and TV does have a long period as an analog medium from the 1940s–80s+. A formulation like, "at its start and into the 1940s, optical-mechanical television could be considered digital" would work, since the image "dissector" could indeed be argued to be based on binary visual access. Actually, the image telegraphs of the mid-19th century would also be a good (and earlier) example. The digital revolution, I'd say, is linked to computation and electrical digital systems. The mechanical digital systems go back to the 17th century (and earlier), and are especially prevalent in music recording and playback (church chimes, music boxes, pianolas and the like). But while in use, they weren't really transformative (revolutionary) in comparison to electric and computer based systems in the post-WW2 era.[36]

Cinema's encounter with the digital brought about a real weakening of its being-in-the-world, we remarked above. We should pad that declaration out a bit: the advent of television and cinema's encounter with the digital brought about a real weakening of its being-in-the-world. In fact, cinema suffered the pangs of what we might call the 3Ds (which have no connection to three-dimensional films) of digitalization: de-canonization, de-materialization, and dissemination.

De-canonization

One thing is certain: the digital revolution knocked cinema off its pedestal. It had the lasting effect of ensuring that a film would never again be "untouchable." Before digital technology, only professionals could take a film in their hands and manipulate it. For the average person, and thus for the film viewer, the film remained, paradoxically, a "virtual" object whose reflection one saw projected onto a screen but whose material form one never saw. Nowadays everyone can manipulate the film and its material form and hold a "film" in their hands. At the same time, when the film is projected, what we glimpse on the screen no longer comes from somewhere behind us, as in the model of Plato's cave, in a space-time that has been imposed on the viewer, but presents itself to us frontally on the screen of our choice, when we choose. To view a film, I push a button on a remote control I own. The film is something I tele-command (command at a distance) and tele-control (control at a distance). As Olivier Séguret remarked as early as 2007,

> What the digital revolution has changed is the perception people have of cinema: the sense that, without ceasing to love it, the people in their wisdom had removed it from its pedestal. Cinema has become one among others, has been juxtaposed and compared; it has taken its spot, albeit a prime spot, among the other objects, images, sounds and colors that the variety of digital products on offer display to the world. Cinema was once absolute; it has become relative.[37]

As has been seen in this volume, cinema is not what it used to be . . .

De-materialization

The digital revolution is in the process of reducing celluloid film to nothingness. The suppression of this tangible material support is clear and irreversible. The digital revolution even makes it possible to virtually "film" synthetic characters in equally synthetic settings. The world of the diegesis may come to be founded on the "immaterial world." Film prints have virtually ceased circulating, and soon the DCP (Digital Cinema Package) will circulate no longer either. Films may soon be screened in movie theaters by geostationary satellite. The disappearance of celluloid and its replacement by different means for preserving the cinematic "trace" are part of a movement toward atomization and fragmentation. In the digital era, everything has become a question of algorithms, equations, and binary code. It belongs to the realm of the invisible and the inaudible (we might even say to the realm of the colorless, odorless, and tasteless). It is neither prehensible nor comprehensible immediately (in the sense both of "immediacy," in the present moment, and "immedia," without a medium). To have access to it, to know its nature, one must resort to a system of restitution; it is neither prehensible nor comprehensible without, literally, a medium. This situation is not as novel as it appears, because the first step on the digital path was the appearance of television, which also requires a system of restitution: the decoder known as the television set.

Clearly, cinema no longer appears to be what it once was.

Dissemination

Before, there was only one place one could consume a film: in a movie theater (neither more nor less than a temple where one worshiped the film god). As Édouard Arnoldy remarked, "The movie theater is the sanctuary of cinematic art."[38] Then the cathode ray revolution enabled the film to enter into our living rooms. Today there are screens everywhere and one can watch a film on a computer screen, a telephone screen, a portable disc player screen, etc. There are numbers of sources and end points for a film's dissemination and propagation. Film images can be found just about anywhere.

Contemporary media have a marked penchant for intermedial dissemination.

What else is there to say, except that cinema is truly different from what it once was?

The moving pictures culture known by our grandmothers and grandfathers has been replaced by a *new visual culture* based on what we call *animage*.

"Animage" and the New Visual Culture

Cinema is not, or has not always been, a primarily special effects medium.

DUDLEY ANDREW, *WHAT CINEMA IS!*, 2010

I was shocked. A language of images was not the privilege of the cinema.

WIM WENDERS, *NOTEBOOK ON CITIES AND CLOTHES*, 1989

Among the many binary oppositions dividing planet cinema today, one as we have seen concerns the life or death of the medium. Some commentators, whom we might describe as pessimists, believe that cinema, or at least the cinema we knew in the twentieth century, has no future. They think its time has passed or at the very least that the changes to its identity that have taken place are so intense that it must be redefined. Some even believe that it is urgent that we give it a new name. This is not the first time the question what to call the medium *cinema* has been raised.

Some in this pessimist camp are out-and-out *cine-nihilists*, or rather *cinema-couldn't-care-less-ists*, in the sense that they have no interest in defending the medium's last redoubt. They are more concerned with the pragmatic search for an expressive possibility that is in no way limited to the fixed particularities of a given medium. To them it matters little what one calls an "evolving media machine"; the important thing is to create and express oneself as best as possible with existing and nonexclusive moving images and audiovisual technologies. In the corner across from the pessimists stands the camp of the enthusiasts. They are, if you will, *cine-euphorics*, *cine-diehards*, who champion the idea that the spirit of cinema has

never been louder than it is today in the great concert of present-day media. For them, every new development in cinema radiates from its "anima."

Contours of Media Identity

Here too, on the question of setting out a definition of cinema, opinion can be divided into two camps. In the first are those who believe cinema has a complex and exhaustive identity. For them, what is needed is to fix the necessary conditions and parameters to define the medium. These conditions and parameters can give rise to a kind of fundamentalism. Dictionary editors, for example, fall into this camp, because their job, precisely, is to come up with definitions. Also in this camp urging strong identities are those "in charge" of defining a new means of expression recently appearing on the market. We could also include in this group those who do not deny a degree of evolution but remain intransigent with respect to a few invariables that they deem indispensable to the medium's last redoubt with respect to its identity. This is the case, as we have seen, with Raymond Bellour and Jacques Aumont. For the latter in particular, cinema must "provide that absolutely essential result of the canonical apparatus: *the production of a way of looking over time.*"[1]

The other camp is more relativist. It sees a medium's identity as based on a small number of consensual and provisional values. The reader has surmised that this is where we hang our hat, because for us a medium is a kind of evolving patchwork of "federated" cultural series reflected through a prismatic identity whose existence is only temporary.[2] Among those found in this camp of identity in a weaker sense is someone such as Christian Metz, for whom "cinema is nothing more than the combination of messages which society calls 'cinematic'—or which it calls 'films.'"[3] Such a view thus sees a medium's identity in relative terms, as forming part of the spirit of the day: *here, at a certain time and in a certain society and culture, is what was commonly understood to be cinema.*

It might even be possible to describe a camp of complete relativists who, for fear of any essentialism, any ontological phantasm, would see any inclination to ascribe an identity to a medium as misguided.

Someone such as Francesco Casetti would seemingly fall into this camp. Casetti does not hesitate to make the claim that cinema never existed: "The eclipse of film theory reflects not only cinema's 'disappearance' but also the awareness *that it has never existed as such*."[4] He goes on to suggest that theory is a way of unifying cinema and constructing its singular identity: "Theory is where we may recognize a 'dispersed'—and likely lost—object."[5] Hence the two-fold question a wee bit cynical (even nihilist) that we should all be asking ourselves: *Isn't a medium's identity always a* constructed *phenomenon, and isn't this identity construction, more than anything else, projected by theorists precisely because they need it to erect their theories?*

Today, the widespread trend toward media hybrids is helping neutralize the very notion of a medium's identity crisis. It would appear that priority is being given to the project of expression and communication using a number of media. In a certain sense, today's hypermedia are upsetting and throwing into turmoil the last redoubts of media identity in a sort of *media animism* in which media specificities are constantly being erased and reborn. Casetti explains: "The shifts are so radical that cinema seems to be on the point of disappearance rather than transformation. On the one hand, cinema is re-articulated in several fields, too different from each other to be kept together. On the other hand, these fields are ready to be re-absorbed into broader and more encompassing domains."[6]

In the same way that Roger Odin recently welcomed the salutary reaction that a crisis can bring by entitling the special journal issue in which Casetti's article appeared "Film Theory in Crisis at Last," we can also ask ourselves whether cinema's identity crisis today is restricted to a simple calling into question, one among many, or whether it is not, rather, a source of dynamic redeployment, an epistemological opportunity, finally, to grasp the medium in all its vital bursting forth, in both its identity uncertainties and its uncertain identities.

The Secrets of "Series-Centrism"

The task at hand then is to carry out a kind of mirror-image dynamic genealogy—a program that remains to be defined in detail but whose

most important features we can describe briefly here. What appears to us to be revealed by the intermedial hybridization so much in the air today—but which, we repeat, echoes the intermedial cultural broth around kine-attractography—is the often spontaneous establishment of hierarchies in any institutional medium. We have demonstrated elsewhere the extent to which the simple act of naming a medium, of fixing its name, implicitly sanctions one cultural series forming a part of this medium at the expense of all the others.[7] It is thus far from insignificant to choose the term *film* rather than *moving pictures* to describe the object one wishes to examine. The choice of a name for a medium always betrays what we propose to call "series-centrism." This series-centrism is at work whenever the way one names a medium privileges one cultural series over another. There is always a form of series-centrism involved in the institutionalization of any medium—a powerful series-centrism that, with the help of the institution's regulation, ends up taking over and taking on a "natural" air when in fact what is at work is an incontestably cultural construction.

This concept, series-centrism, enables us to propose the idea that one always chooses one's cultural series camp to identify a medium and, perforce, interpret every moment in its evolution. This choice is solid confirmation of the construction underlying and marking every theory around media identity. Seeing through the prism of one cultural series chosen from a range of others appreciably affects the way one divvies up the media territory and identities to hand. Hence this self-explanatory maxim: "Tell me which cultural series you privilege and I'll tell you which medium you'll come up with"—or, more precisely, which media identity you will isolate.

But let us refine the argument a little: what we have just said might lead one to believe that series-centrism is a somewhat "imperialist" excess that sane criticism would endeavor to expose for what it is. This is true in a sense because any institutionalization is intimately connected to the exercise of power: that of naming, of marking out, of creating hierarchies, of legislating—and of indicating what is foreign or *alien*. But we also believe that the forms of series-centrism can be highly useful tools for understanding the genealogy of a medium or more precisely the compared genealogies of a medium. Compared

and comparable, but different: one's approach to and understanding of a medium will be quite different according to whether one is wearing the glasses of one or another cultural series. Each genealogy is thus obtained according to how well founded the choice is of a particular cultural series as the dominant point of view of one's research. The invention of the kinematograph is not seen the same way when one adopts a point of view from within the cultural series magic lantern or takes up position within chronophotography, for example. Our interest, of course, lies in comparing at a later stage the different genealogies produced by choosing different cultural series as the keys to one's comprehension. In short, what we are proposing here is nothing less than a research avenue that we might describe as *inter-genealogical*, or even *hyper-genealogical*.

The idea of an *expanded* cinema, or of a *fragmented* cinema, appears to us to be the sign not only of a kind of neo-institutionalization but also of series-centrism. In our view, this is a flexible, soft neo-institutionalization, but which we propose to call "serial-centered," even though it is not focused on a closed definition of the medium: it is as if the institution renounced the crystallization of historical "identities and specificities" while at the same time preserving the "centralizing" idea of cinema as *anima*. The idea of series-centrism seems to us to be essential on both the methodological level and the heuristic level, if only because it makes it possible to organize the discourse and to change the order of things and our view of them. Although not always clearly spelled out, this series-centrism, or if one prefers this way of interpreting a given media context by looking at it through the glasses of a dominant cultural series, or more precisely from the dominant point of view of a given cultural series, is very active, precisely, in the incorporative and intermedial phases involved in our *first* and *third* births.

Thus when one adopts the point of view of the series one privileges, it is always possible to neutralize a birth-novelty and incorporate it into one's own series. The guiding idea behind this position is media continuity combined with a will to integrate. The following example from early cinema, which is not dissimilar to the die-hard view of someone like Philippe Dubois, is an obvious case of the nascent kinematograph being taken up by an "allied" cultural

series, the magic lantern.[8] In a volume published by Roger Child Bayley at the turn of the past century we can see something like a "conceptualization" (the term is too strong in this case) of a kind of "expanded magic lantern." We should point out first of all that this volume, entitled *Modern Magic Lanterns*, was first published in 1895 and again in 1900. The first edition made no mention of "animated pictures," whereas the second edition included a new section on "Animated Lantern Pictures."

This title already tells us much about the way this magic lantern specialist saw "animated kinematograph pictures." For him, they were "animated 'lantern' pictures," if the reader will allow us this inelegant expression. And in his book Child Bayley places the invention of the kinematograph in the orbit of the magic lantern:

> In the beginning of 1896 *a novelty in lantern work* was first shown in London in the form of *Mr. Birt Acres' Kinetic Lantern*, as it was then called, by which street scenes and other moving objects were displayed on the screen in motion with a fidelity which was very remarkable. Almost immediately *afterwards* a number of *other inventors* were in the field with instruments for performing the same operation, and *animated lantern pictures* under all sorts of Greek and Latin names were quite the sensation of the moment.[9]

Could there be a finer example of such a radically series-centric attitude? Is this attitude not, all things being equal, of the same order as that of Dubois and company? *Expanded/extended magic lantern* and *expanded/extended cinema*: it's the same battle! Is this not, in addition, an obvious and clearly representative example of series-centrism, which interprets the media context in question through the prism of the dominant cultural series, in this case the magic lantern? Does not Child Bayley's remark quoted above demonstrate, in addition, that the present authors have been justified in maintaining for some time now that it is essential not to see, that we no longer see, the arrival of the Lumière Cinématographe (or of any other similar device) as having brought about some kind of rupture, at any event in those cultural series already institutionalized to the slightest extent—such as the magic lantern, precisely.[10]

We can also see series-centrism at work when Giusy Pisano, in a quite spectacular reversal, proposes that we see the interest in visual devices (cinema, television, etc.) in the late nineteenth century as an attempt to furnish images for the Théâtrophone, an exclusively audio device appearing in 1881:

> Shouldn't we thus study the conditions around the emergence of "early cinema" in light of the Théâtrophone experience? And what would happen if, for once, we agreed to invert the scale of traditional values between sounds and images and see the emergence of visual devices—the kinematograph, television, etc.—as attempts to provide images for the Théâtrophone's sounds?[11]

It is important to note that such series-centrism, although it proposes that we view media phenomena under a particular light—and thus according to a particular reconfiguration—is far from simplistic. It can even serve as an explanatory principle for a media archaeology. The same is true when one adopts a serial perspective using an interpretive key as rich as audio-viewing, as the authors of the anthology *La Télévision du Téléphonoscope à YouTube* do when they define their project in the following manner: "The present authors, carrying out an archaeology of audio-viewing, take into account as many televisual apparatuses as possible, among which television and cinema are only two possible manifestations that are neither more nor less emblematic of this audio-viewing."[12]

Animation's Anima

We spoke above of a middle path, one that tends to associate cinema with "something else." And among these possible "other things" are moving images, or what we call "images animées" in French, which appears to be a major trend. Intermedial porosity, intensified by the digital mutation, thus provides new visibility to a cultural series that, curiously enough—although not by accident—is symbolically and etymologically related to what we described above as cinema's *anima*. We might even give it the title "mega-series" or "hyper-series." We refer quite simply to *animation*, which has always had a bone to

pick with cinema despite their parallel evolution. Against all expectations, we might argue that, under certain conditions, animation in fact constitutes cinema's *anima*.

The idea of putting on our animation glasses to understand the evolution of cinema is lurking in the background of the work of several contemporary thinkers, but it has not attracted the attention that we believe it deserves. And yet a scholar such as Lev Manovich explored this topic as early as 2001, remarking that cinema, "Born from animation . . . pushed animation to its boundary, only to become one particular case of animation in the end."[13] Developing this argument, he explained the omnipresence of animation in special effects films using a famous Freudian formula:

> The privileged role played by the manual construction of images in digital cinema is one example of a larger trend: the return of pre-cinematic moving images techniques. . . . These techniques reemerge as the foundation of digital filmmaking. What was supplemental to cinema becomes its norm; what was at its boundaries comes into the center. Computer media returns to us the repressed of the cinema.[14]

The postinstitutional phase of cinema we are living through today is thus the site of a *return of the repressed*, and *animation is returning to take its place as the primary structuring principle*, as it was at the time of optical toys, from Plateau's phenakistiscope to Reynaud's Théâtre optique.

An animation studies specialist such as Alan Cholodenko, an adherent without realizing it of series-centrism, or rather what we might call "animato-centrism," goes so far as to elevate animation as cinema's founding principle (and not the reverse, as classical film theory holds). He has written a veritable manifesto on the topic, entitled "*Who Framed Roger Rabbit*, or The Framing of Animation":

> I disagree with those who think of animation as only a genre of film. . . . Indeed . . . animation arguably comprehends all of film, all of cinema, was (and is) the very condition of their possibility: the animatic apparatus. In this sense, animation would no longer be a

form of film or cinema. Film and cinema would be forms of animation. Let us not forget the notion that the motion picture camera/projector *animated* still images called "photographs."[15]

It seems to us to be highly useful to thinking about cinema that we militate in favor of a return of the cultural series animation as an essential frame of reference, while at the same time trying to understand why it was pushed to the periphery of the institution. We can advance a wee bit in this direction by saying that the capturing-restoring paradigm was sanctioned, in a relatively "dictatorial" fashion, as the primary structuring principle of this cultural series, moving pictures, to the point that it placed the cultural series animation in the shadows. An artist such as Reynaud, the great master of animating images, was one of those who paid the price.

Moreover, once one looks at the early development of the kinematograph through the lens of "moving pictures" rather than the lens of cinema alone, one becomes well aware of the relative muddle. Our first instinct is often to equate *moving pictures* and *kinematographic pictures*. Traditional history and its deep-rooted series-centrism have conditioned us to have such an instinct. The cultural series known as moving pictures, however, with which we always associate the beginnings of cinema, is not limited to kinematography, which is its culmination in a sense. The series known as moving pictures also includes Kinetoscope pictures, which came into the world before *kinematographic pictures*. It also includes Reynaud's Optical Theatre pictures, which also came into the world before kinematographic pictures, and even *before* kinetoscopic pictures. Reynaud is a truly repressed figure in film history, and we might expect him to return with force. This *repressed*, knocking repeatedly on the doors of history, unfortunately brings with him his share of blundering champions. Bernard Lonjeon, for example, who does not serve Reynaud's cause, nor any other good cause, by claiming that Reynaud was the "true inventor of cinema" and suggesting that the town from which he set forth into the world, Puy-en-Velay, is the *birthplace of the kinematograph* (yes! the kinematograph!) as early as June 1875.

The real rehabilitation of Reynaud, the legitimate return of this repressed, will necessarily come, we believe, through the return of

another repressed in the history of cinema: the cultural series animation. Of course, animation has its place in the concert of genres existing on planet cinema, but the term we use to describe it, "animated film," is already indicative of the evacuation of the cultural series and its inclusion in institutional cinema, which acts in a sense as its guardian. And it is here, precisely, that our model of three births takes on another dimension. This postinstitutional and integrating third birth marks the return of the repressed: animation comes back to take its place as a primary structuring principle. With cinema's institutionally regulated identity blurred, with the erasure of the "discriminating" quality of a cinema shaken by the assault of digital hybridization and by the general porosity of media convergence, we return to cinema's quality as *animation*, which the institution had so carefully declared outside its identity or, at most, a para-identity. Just as, similarly, cinema's "attraction" dimension is back in force, sometimes to the detriment of narrative.

Everything is taking place as if, long subjugated by the novelty effect of capturing-restoring, which the institution adopted as its founding identity, cinema had renounced an important part of its origins and its "nature." It is as if cinema had renounced the first cultural series to which it belonged. In fact, as one of us has declared elsewhere, "In some respects, animation is kinematography and kinematography is animation."[16] Today perhaps the paradigm of capturing-restoring should worry about the return of *cinema's anima*.

We should note that this series-centric point of view tied to the return of animation can include several variants and shifts depending on the series chosen. Dominique Willoughby, in a volume entitled *Le Cinéma graphique. Une Histoire des dessins animés: Des jouets d'optique au cinéma numérique*, traces a line from optical toys to digital cinema from the perspective of what he calls "graphic cinema." His approach, which in a sense provides Reynaud's ghost with another opportunity to knock at the doors of film history, is the spontaneous effort of a historian to construct a series and legitimize it by reconstructing the history of a "visual art that appeared 175 years ago: *images in movement created by a series of drawings, engravings or paintings since its invention in 1833.*"[17] Or, put more simply, by

reconstructing the history of what he calls "graphic cinema," a series within which Reynaud, of course, has a special place. Willoughby remarks, in addition, that this series was the "origin of cinema" and that its domain extends "from optical toys to Japanese *anime* by way of cartoons, experimental cinema and new forms of graphic animated feature films, all the way up to today's digital animation, image manipulation and special effects techniques."[18] One has a very clear sense here that the series to which Willoughby is referring is not far from the series described, in a more traditional manner, as animated film, which in a sense was inaugurated by Reynaud's system (even though we must keep in mind that in that system there was, strictly speaking, neither film nor cinema).

With digital technology, Willoughby perceives a return to what we might describe, using the vocabulary of the present volume, as cinema's graphic *anima*[19]:

> Image manipulation, retouching, color timing, editing and post-production operations, all now digital, have encouraged a heightened "picturization" of films, for example, by broadening the color palette and the ways it can be manipulated. All these methods contribute to the original filmed material being increasingly seen as re-interpretable and capable of being recolored, retouched, reconstituted and dynamically modified by varying its tempo and rhythm after the fact.[20]

Here we find the intrinsic plasticity of the digital image, its malleability in a sense, that we discussed in Chapter 2 of this volume. In a sense, where we proposed with a hint of provocation that the digital ontologizes trick effects, Willoughby could reply that it also ontologizes cinema's graphic fiber. This is an idea that could benefit from being placed in the context of Thomas Elsaesser's remarks on the connection between digital images and painting:

> At the same time, a radical break is posited between the photographic index and digital code. Yet arguably, at least as fundamental a break occurred in the switch from luminosity through transparency (which still photography and cinema have in common) to

luminosity achieved through refraction, opacity and saturation: in this respect, the "opacity" of the digital pixel is closer to the opacity of pigment in painting than either is to photography.[21]

Animage and Motion Capture

This hypergenealogical position also makes it possible to study with the necessary historical perspective not only the upheavals that have taken place in the "kinematic" realm but, more precisely, the way in which these upheavals become infinitely more legible when cinema's anima is returned to the forefront, by which we mean of course animation, cinema's determinant serial fiber. The current conditions of cinema's "reunion" with this cultural series, which was not born yesterday and with which the institution cinema has always had an ambiguous, complex, and often paradoxical relationship, enables us, we believe, to better understand cinema's intermedial developments and convulsions today (and tomorrow). In our view, the film studies community has every reason to open up fully to exploring in depth what we propose to call "animage"[22] and the grip of what we view as the *animatic spirit* of the present-day media and cinema landscape.

This repressed element of the history of institutional cinema, animation, which the institution showed the door, is thus coming back through the window today to haunt cinema and call into question the boundaries of its identity. We will take just one example to illustrate this: motion capture shooting, or more precisely its improved version performance capture. For although motion capture is content to capture a real body in movement and incorporate it into a digital "set," performance capture is more precise: it is able to capture not only the movement of bodies but also an actor's facial expressions. Jean-Baptiste Massuet explains:

> Performance capture makes it possible to transcribe not only physical movements but also the performance of the actor, who is covered with light-sensitive sensors from head to foot. In addition to these tracers, which enable the 200 cameras above the film set to create a moving digital skeleton onto which the animators can

graft digital skin and a synthetic avatar, there is a small digital video camera which transcribes as faithfully as possible the actor's facial expressions.[23]

Performance capture was given a big push by Peter Jackson in 2011 for Steven Spielberg's adaptation of Hergé's graphic novels in *The Adventures of Tintin: The Secret of the Unicorn*. This experience is indicative of today's upheavals, brought about by what must be called the invasive irruption of digital technology, which involves such a great degree of convergence of certain media that it has in the end produced a degree of *confusion* in people's minds and in the situation itself. Thus no one was quite sure in which category Spielberg's *Tintin* should compete in the 2012 Academy Awards: "Even though motion capture films are not normally considered by the Academy— according to the rules, the motion capture and performance capture techniques used in *Tintin* are not seen as film animation techniques— Spielberg's *Tintin* found its way onto the list of eighteen films competing for the Oscar for best animated film."[24]

While performance capture is fully a part of the changes wrought by the digital, it is located in both the world of animated images and that of photo-realist recording. For, by recording real movement, it is part of the dominant cinematic tradition of capturing and restoring. Massuet describes this hybrid form as follows: "This is thus not really a case of animated synthetic images but rather of a new hybrid method, a cross between a cinema of real takes and computer animation, without, paradoxically, being one or the other. Actually, performance capture is a filming method that consciously blurs the line between two kinds of representation."[25] This hybrid nature of the images generated by this technique is highly revelatory. Not only does it encapsulate the "heterogeneous" spirit of our new digital visual culture, but it also confirms animation's hold on cinema today. In a sense, motion capture and its effects convey this kind of hesitant hybridization found in certain film institutions' recent changes of name.

Although they enjoy a novelty effect, motion capture and performance capture deserve a genealogical study that would be too extensive to carry out here. The same is true of the use of 3D with which they are associated. The quest for the "real" depth of the image, as

we know, has its own history. Around 1952 it was hoped the use of 3D would bring viewers back to the movie theater in the battle against the initial ravaging of attendance figures by the emergence of television as a mass medium. In the case of motion capture, we can trace the techno-cultural series to which it belongs back to rotoscoping, an animated filming technique perfected and patented by Dave and Max Fleischer in 1915. This technique, Willoughby explains, "consists in tracing image by image the phases of real takes, in particular those of an actor." He goes on to situate the operation and the issues it raises in the following manner:

> This technique makes it possible to endow drawn figures with realistic movements and to avoid thinking about the work of synthesizing movement, at the cost of a laborious image-by-image retracing. The technique produces an effect typical of redrawn cinema, which has a certain potential for aesthetic enticement through the use of silhouette, the graphic imprint of the movements of a filmed model, whose presence can still be felt.[26]

In a sense, then, rotoscoping joins the "movement" aspect of photo-realist capturing-restoring with the graphic material of the animated picture. This, in other words, gives the drawn and animated image a photo-realist effect. With motion capture something like the opposite occurs: here a photo-realist image achieves the flexibility of an animated image.

Motion capture thus reduces the photo-realist aspect of acting performances and reorients them toward animation. The technical difference between real shots and animated sequences is thus erased. We might even say that with performance capture institutional cinema must definitively abandon the fallacious pretext of technical invariables as a way of making animation peripheral to its identity or of isolating it as a satellite on planet cinema. Here we find the concept "animage" at work: deriving from what we might call *anima-realism*,[27] motion capture makes it possible to capture and transfer to the digital world every movement and facial expression. With this technique we are witnessing a dynamic hybridization of photo-realism and animation, generating this new anima-realist dimension.

Here there arises, in the end, a contrast between photo-realism and anima-realism. As Peter Jackson remarks: "We're making them look photorealistic; the fibers of their clothing, the pores of their skin and each individual hair. They look exactly like real people—but real Hergé people!"[28]

Motion capture thereby makes possible a kind of mimetic dissociation: actors are dissociated from their photo-realist appearance while photo-realist illusion is maintained. Motion capture is thus a kind of *animated imitation of real filmed images*. Pushed to the periphery of institutional cinema, today animation is returning, in a fitting piece of poetic justice, to place under its thumb the photo-realism in whose name it was once marginalized. As we shall see, however, the specific example of Spielberg's *Tintin* opens the door to other developments in this anima-realism.

Tintin: An Adaptation They Said Couldn't Be Done

To understand the efforts expended by Spielberg and Jackson to adapt Hergé's graphic novel, we must plunge into Hergé's poetics, governed by the spirit of the famous *clear line* (see fig. 7.1). This technique, often attributed to Hergé, corresponds to a specific graphic and narrative rhetoric. The expression refers to a particular kind of narrative economy, in which the storyline is made taut through a particularly efficient use of the work's boxes, strips, and pages. "Before it is a graphic line," Benoît Peeters remarks, "the famous clear line is a school of narrative fluidity." Peeters goes on to add: "It is reminiscent of Hawks or Hitchcock in his British period in the way matching cuts are made without changing the scale of the shot."[29] In this sense, Spielberg's film style seems much more charged and extroverted than Hergé's graphic novel style. The concept of the clear line itself, in fact, suggests a complex interrelation between graphic monstration and narration, something in Hergé's work that one of the present authors has previously described as *mediagenie:*[30]

> By mediagenie I mean an intense and singular interpenetration between the medium's possibilities (the potential of the identity elements and cultural series it joins) and the expressive project,

Figure 7.1 A plate from the album *Le Crabe aux pinces d'or*, part of Hergé's *Aventures de Tintin*. © Hergé/Moulinsart 2014.

employed in a given contextual genre. For a narrative to possess a strong mediagenie, it must be constructed within a medium from which it is difficult or indeed impossible to disassociate it, and vice versa.[31]

Mediagenie, located between narrative project and media configuration, is thus produced as in a *reaction*, in an almost chemical sense of the term. Let us take a look, therefore, at the mediagenie of *Les Aventures de Tintin* taking as our starting point the dynamic and singular handling of the clear line, to see how Spielberg and Jackson managed their intermedial transposition.

The graphic quality of the clear line is based on the primacy of a well-defined outline that isolates the referential information about the world to something that is both schematic and highly realistic. On the representational level there is a kind of tension between the simplification of caricature as it affects the characters and the documentary fidelity characterizing some of the decor and, in particular, the means of locomotion depicted. Trains, boats, planes, and automobiles are shown with remarkable referential precision. The characters' faces, for their part, and especially that of the hero, are often reduced to a minimal expressive effectiveness. Tintin is *nada*! Nothing! An almost empty oval figure, a complete emptiness that the reader is invited to fill as if looking in a mirror. Hence, among other consequences, the difficulty in using the clear line to create close-ups: the schematic quality of the outline and patches of color resist enlargement.

Beyond this tension between rigorous realist anchoring and the simplification of caricature, the graphiation of the clear line is also characterized by a powerful federating effect, creating homogeneity that generates consistency and a graphic verisimilitude typical of Hergé's poetics.[32] In fact the clear line is the sparse result of a system of initially dynamic and agitated strokes with clearly apparent marks of execution, as can be seen in Hergé's sketchbooks. His drawing thus proceeds from a kind of repression of the graphiator's gestural labor, but it is a repression that results in a sublimation of the original trace in the clear line.[33] The practical consequences of this dynamic are not long in coming: despite (and paradoxically

because of) the fixed sharpness of their delineation, their outline by the clear line, Tintin and Milou shift greatly in the mind of the reader, who sets in motion a mental program that imprints movement on the fixed forms from the starting point of an especially well-captured moment in the attitude of a character.[34] The drawn figures are ready to be appropriated by the viewer, ready to be teleported by his or her gaze into a comfortable projection-identification in the familiarity of a well-enclosed space and, in addition, with figurative effects that are limited, chosen, counted out, differentiated, and carefully isolated from one another. And this system is in synergy with the artist's monstrational and narrative economy—all these "graphic dolls" offered to our scopic grasp appear to be awaiting only one thing—for the reader's gaze to jump from box to box and from page to page, the way graphic novels are read.

A Mediagenic Adaptation?

Spielberg's challenge was to transpose this heterochrone graphico-narrative system into his homochrone filmic universe. It is undoubtedly in this sense that Spielberg emphasizes the intrinsic value of the scene breakdown in *Les Aventures de Tintin*: as in an inspired storyboard, he remarks (ah! cinema centrism!), everything there is designed for the story to slip from shot to shot![35] But he did not neglect to mention also the importance of the graphic style. When we come face to face with a case of mediagenie in the strong sense of the term (as we do with *Les Aventures de Tintin*), it becomes more difficult to adapt the work. How does one pry loose the system of graphic monstration and heterochrone narration from one medium to make it exist in a credible, proper, and "faithful" manner in another medium? Quite apart from any evaluation of Spielberg's film, and even if one is not a fan of his inclination toward the baroque (for example, with the great showman at the end of the film), the answer to this question lies in his adaptation technique, which we might describe as mediagenic.

We might think that the closer a work is tied to "its" medium (that is what mediagenic means), the more it will be seen as "unadaptable" and difficult to "transfer" to another medium.[36] And this is the case

with the work of Hergé, who constructed a verisimilar graphic and narrative system with a very dense self-referential consistency. Spielberg's originality lies in having strived to incorporate the spirit of this heterochrone graphic-narrative system into the homochrone world of his film. And the performance capture technique that records the movements of real actors in order to animate the characters enables him to achieve an anima-realist consistency that is said to be the filmic equivalent of Hergé's graphic-narrative consistency.

For Spielberg, the best and so to speak only way to adapt Tintin using the film technology available today is to use the procedure that combines two cultural series: that of the captured image and that of animation. On this point Spielberg remarked that "we want to give 'The Adventures of Tintin' the credibility of a film in real images. Peter and I, however, felt that shooting in these conditions would not pay tribute to the characteristic style of Hergé's heroes and his world."[37]

When we relate these remarks to the poetics of the clear line, what Spielberg appears to be saying is that real images obtained through a process of capturing and restoring, or the recording of space-time on film, are incompatible with the sublimated monstration of the clear line, whether in the case of the decor or period vehicles, which are faithful but homogenized through outlining, or, especially, in the case of the characters "idealized" by their contour lines and patches of color. One can only respect the mediagenie of *Les Aventures de Tintin* by "paying tribute" to the style of the characters and the world in which they live. This "style" is respected, precisely, by the motion capture system, in that it brings together the movements of a living person and those of an avatar or conceptual representation. The clear line, with its sparse ideality, tends to conceptualize graphic depictions to make them appear almost like ideograms while at the same time leaving them highly malleable optically. As Alain Boillat remarks,

> For Spielberg it is not a question of giving himself the means to create a world corresponding to pre-existing visual motifs but rather of being able to work the graphic dimension of the image in such a way as to also draw on Hergé's style. In this sense, Spielberg's decisions are reminiscent of the work of Warren Beatty, who

with *Dick Tracy* (1990) tried to recreate using the special effects of his day (and in particular the art of makeup) the gallery of nasty grimacing gangsters in Chester Gould's comic strips.[38]

These are Hergé characters even though they resemble "real people," Peter Jackson asserts.[39] With this goal in mind, Jackson tried to neutralize the referential and "cumbersome" realism that would result from shooting the actors' performance directly: "We wanted them to resemble Hergé's characters, but realistically."[40] In a sense, Jackson and Spielberg's team could not settle for merely putting on film, and thus on screen, a *simple profilmic reality*—because Jamie Bell's face could never resemble that oval mirror with a tuft of hair that is Tintin's head and Andy Serkis would never have been able to replicate the faces Captain Haddock makes.

At the same time, by capturing the movements of a real actor in order to transpose them digitally into a virtual graphic world, the filmmakers breathed into their work the vital animation indispensable to filmic homochrony while at the same time preserving the spirit of the clear line. Better yet, in this way the filmmakers attempted to create added value in the form of animation that is *mediagenically compatible* with the original graphic novel.

In this respect it appears significant to us, moreover, that numerous articles in the press at the time of the film's release spoke of Jamie Bell as an actor who "stood in" for Tintin. "Stand in" more than "embody"? Indeed the mistake would have been to want to have an actor *embody* Tintin in the spirit of classical photo-realist recording.[41] The idea of "standing in" suggests, on the contrary, respecting an *already existing* character. Existing in the space of the graphiation of the clear line. This is borne out by the reaction of Spielberg and Jackson to their initial production tests: "Hergé's heroes had come to life, with emotions and a soul which far surpassed anything we had seen to date in synthetic images."[42]

The pragmatic and spectatorial questions we raised above are thus preserved: Spielberg and Jackson maintain the illusion of control and the pleasure afforded by controllability connected to the overall treatment in clear lines. The characters remain graphic puppets ready to set out on an adventure. At the same time, the incorporation of

these characters into an environment endowed with "the credibility of real images" (the *Unicorn* sails on a sea more real than nature itself), in tandem with the use of 3D, makes it possible to respect the tension of Hergé's graphic poetics: reconcile the realist force manifest in certain motifs of the representation and the simplified depiction of the characters.[43] Of course, while this strategy may be described as mediagenic, critics have differing views of the final result. Benoît Peeters, for example, a specialist in the work of Hergé, had this to say about Spielberg's film: "Hergé's Tintin is not a realistic character but rather a schema. He's a mask that every reader can put on to live out the adventure with him. But this effect could not be preserved on the big screen. Spielberg's Tintin is necessarily more embodied, despite his graphic texture. He has become even stranger."[44]

With respect to the ambiguity of the stand in/embodiment dimension we raised above, Peeters brings out a rather paradoxical quality in the final product, whenever the "realistic" presence of an actor appears to some extent despite the graphic camouflage. For Peeters, this malaise takes concrete shape in certain details: "With Thomson and Thompson and Castafiore, I'm annoyed by their noses, whose graphic quality seems to me to be too apparent. They bring too much of a drawing quality into a work which employs embodiment."[45]

In any case, the use of the performance capture technique in *The Adventures of Tintin* and its synthetic images invites us to carry out more than one theoretical adjustment. Even though Spielberg described himself as respecting the original work, his film presents new filmic ideas that redeploy the cultural series animation in a vital manner. By wishing to pay tribute to the original work (a relationship of dependence and fidelity) and by viewing the graphic novel source as a super storyboard that needed to be brought up to date, Spielberg opened a path to a new kind of anima-realist illusion.

Performance Capture and Digital Makeup

Performance capture, beyond its use in *The Adventures of Tintin*, raises issues deserving of close analysis. We believe that the technique provides new perspectives for thinking about cinema and the digital image, in particular on a fundamental and ontological

level. We have described the difficult relations that digital images have with time and duration, unlike the indexical image of classical photo-realist capturing-restoring, which has a direct relation with the time of the real world. In a sense, one could argue that motion capture, and especially performance capture, reintroduce temporal depth and an element of duration into digital shooting. Indeed the multitude of motion sensors and sensors for capturing the actor's facial expressions record directly the *lived time of the body of this actor in movement*. In a certain sense, the captured "profilmic" is already a temporalized profilmic, already a human space-time captured directly from the body in movement. This may mark a return to indexicality (for some parts or aspects of the image, in any case), something that was believed lost under digital encoding. Naturally, this encoding is still at work, because the movements captured are digitalized to be used in the later animation of visual "avatars," but it remains the case that motion capture has an almost indexical relation with the moving body.

In the same vein, this putting of the recording "into phase" with the real animation of a body makes it possible to abandon the restrictive unwieldiness of the photo-realist *embodiment* of the actors while at the same time preserving their particular corporeal imprint, their spatio-temporal signature, their singular *kinematic anima*. This no doubt is what prompted Gad Elmaleh (who acted in Spielberg's film) to see motion capture, as reported in this interview with Jamie Bell, as having "brought him back to the very essence of his trade, which consists in making his body speak."[46]

At the same time, this control over the animation of his own body demanded of the actor goes hand in hand, in the filmmaking process, with considerable control over the creative process. We have already remarked on this new degree of control brought about by digital technology. The possibilities of kinematic capturing introduced by motion capture both reinforce and contribute to this control. In keeping with the spirit of the clear line, motion capture and the "digital animation"[47] associated with it offer, precisely, the opportunity to render the captured world docile by mastering the space-time of the characters. Peter Jackson explains: "You can choose the best actors for each role without worrying about whether they really resemble

Hergé's character. They are as perfectly and faithfully alive as actors in real shots, the synthetic imagery functioning like digital make-up in a sense."[48]

Here we see again the idea of the *mimetic dissociation* produced by motion capture. One is content to *imitate* perfectly real shots, achieving an iconic result equivalent to what filming real images would produce while avoiding its constraints. By preserving the singular kinematic *anima* of each actor, the film enters the realm of what we have termed *anima-realism*, or more precisely a new anima-realist verisimilitude. This mimetic dissociation thus also functions by virtue of the fact that capturing movement "as close as possible to the actor's body" and then undergoes a process of "digital makeup" and that through this an image with a photo-realist appearance is brought out (is reconstituted). In this sense, doing the "makeup" is no longer a mere cosmetic and secondary operation: it is the decisive process that restores corporeality to the captured movement, enabling animation to become reembodied.

These considerations should surely be discussed in light of the ideas of scholars such as Michel Chion. "Why use a synthetic image if it is subjugated to physical reality?" Chion asks, adopting the reservations expressed by others with respect to motion capture.[49] According to Chion, the impression that this technique is inherently paradoxical derives from the belief that formerly there was an ontological difference between a cinema made up of real shots and animated drawings. Chion, however, minimizes the importance of this break by explaining that such paradoxes can be found throughout film history. On the one hand, animation has always made wide use of human models to orchestrate the movements of its characters (as in rotoscoping, for example). On the other hand, Chion remarks, "Film actors, during and after the filming, have always been largely dispossessed of their bodies." He concludes that "the advent of the digital image based on performance capture thus appears to be a new episode in this paradoxical history: that of film actors faced with the 'mechanization' of their performance, with its immutable and fixed quality."[50]

According to Chion, cinema has thus always carried out a "dispossession . . . of the actor's body." Taking a somewhat provocative stance, he is of the view that the digital has in no way diminished

the actor's role and that "this role is more important than ever in films of synthetic images."[51] The threat announced at the time of the release of James Cameron's *Terminator 2: Judgment Day* (1991) thus did not come to pass: the actor was not exchanged for a digital substitute! In fact, Chion suggests that viewers always seek the corporeal form behind what they see on screen. This derives from what he describes as the "viewer's reverie around what we might call the 'profilmic reality': the idea that something has happened in front of the camera or in front of a microphone."[52]

These are interesting and out-of-step comments, if only because they pertain to another practice of the cultural imaginary little analyzed today: our reverie when watching filmic images created through capturing and restoring. In this sense, it would surely be worth our while to connect this question and the *Aufhebung* effect we discussed earlier. On a "filmological" level, this captivating reverie of the solitary viewer in no way prevents us from inquiring into the quite radical mutations in the profilmic, which has become increasingly diluted within the filmographic in favor of the digital. In this it is like performance capture, which joins the captured imprint (like a "digital" imprint or fingerprint) of the actor's performance with its visual reconstitution by digital animation.

This, then, is animage: an *animated image* that is already no longer an image (it is no longer an impression of the world precisely), something conveyed by the privative prefix *a*. But animage is also, and now more than ever, an image that moves to the beat of *animation*.

Animation is thus *returning* to cinema, or rather the contrary: cinema is *returning* to animation. And it is animation, as a form of cinema in the broad sense, that is rising up as cinema's primary structuring principle in the digital age. In our view, animation thus represents the path of the future for understanding and apprehending this *medium in crisis in the digital age*.

Conclusion

A Medium in Crisis in the Digital Age

Cinema does not yet exist. Our films are lead-pencil sketches.

RENÉ BARJAVEL, *CINÉMA TOTAL: ESSAI SUR LES FORMES FUTURES DU CINÉMA*, 1944

. . . between what people still call *cinema* and the thousand and one ways to show moving images in the vague field called the *visual arts* . . .

RAYMOND BELLOUR, *LA QUERELLE DES DISPOSITIFS: CINÉMA— INSTALLATIONS, EXPOSITIONS*, 2012

Just as we were finishing the present volume, a film was released in movie theaters (yes! in movie theaters!) by Michel Gondry, an adaptation of Boris Vian's *L'Écume des jours* (*Mood Indigo*, 2013). Critics were divided about the film, with many emphasizing the difficulty of adapting a work such as Vian's. In the same way that Hergé's work, as we have described, is identified with its medium, Vian's novel is constructed in the textual and expressive space provided by literature. This, it would appear, is the reason why Gondry opted to use a considerable number of mechanical special effects in his adaptation, despite being known as a master of digital effects. One might think that, faced with the same kinds of problems as Spielberg with *Tintin*, Gondry tried, like him, to find a mediagenic solution to the presumed "unadaptable" quality of Vian's novel. Gondry himself, moreover, explains that, in the present case, "Objects would not have been as interesting to watch if they had not been fabricated materially."[1] This did not necessarily win the critics over. While some admired the magical quality of the film, others spoke of excess and expressive saturation in which "virtuosity veers into showing off," as one commentator described it, describing Gondry as a "modern-day Méliès" who had created "many new special effects, perhaps a few

too many."[2] Such that the "romance" was "crushed under the deluge of visual effects," according to the title of another article on the film, which goes on to state that "the story's visual world is omnipresent: the image, set, costumes and lighting give so much supplementary information to complete our perception as viewers. But one has to leave a little room for the imagination."[3] What interests the present authors in the case of this film and its reception, beyond judgments of a qualitative or aesthetic nature, is the way in which it resonates with several of the themes we have discussed in this book.

It is as if the patchwork quality and "mechanical" dexterity of Gondry's "artisanal" effects were a way for him to create appropriate metaphors for Boris Vian's dreamlike world. Vian's novels operate as word and image factories, but also as narrative machines. Using mechanical special effects to convey this dreamlike quality, which is seen as hypertrophied and exacerbated, appears to be better suited to it in a sense, undoubtedly in part because such effects do not conceal their status as such: *these are patent special effects that do not deny their baroque nature.* These are special effects that have in a sense been caught in the act of being special effects, as if viewers today, watching *Mood Indigo*, needed to experience an emotion as intense as those who first audio-viewed Merian Cooper and Ernest Schoedsack's *King Kong* in 1933. With *Mood Indigo* we are in the presence of a manipulation that does not fear being seen for what it is and that may even take a degree of pride compared with what would undoubtedly have been smooth and impeccable digital special effects. Here we find an example of what we argued with respect to the "making of" segments added to DVDs, which often reassure us as to the prior existence of the profilmic. Look at the toil, the failures, the second thoughts, the behind-the-scenes action! Yes, many actors "inhabited" the profilmic and "performed" in front of the camera, something that the perfectly smooth images of the final product perhaps do not show enough.

We remarked above that the digital "alienates" the profilmic by placing it under the thumb of the filmographic. Gondry's approach, motivated by his personal interpretation of Vian's novel, demonstrates a degree of nostalgia for the special effect patched together within the profilmic itself before being recorded by the camera. Here

we return to what we argued, in agreement with various media theorists, with respect to the extent of the technological molting that took place with the advent of digital media. Some things of course are irreversible, but there are several instances of a "jogging effect" (people never ran as much as they have since the use of the automobile became widespread). In other words, some of the changes that digital media have brought about are irreversible, but this does not rule out a number of steps backward, a number of resurgences by way of certain "residual" practices, in a sense similar to that of Charles Acland's definition of residual media.[4]

These "go back" effects can sometimes take on considerable importance, going so far as to threaten the hegemony of a previous technological evolution. For some people, the sound quality of vinyl records (as we saw in Chapter 2) provides the quintessence of the recorded sound experience, which must be recovered at all cost, to the detriment of the CD and other contemporary media. The same sort of thing takes place when one retouches digital images to reintroduce simulated grain effect into digital projection. The mechanical special effects used by Gondry are the equivalent, in their own fashion, of a vinyl effect or a jogging effect. Such steps backward do not necessarily impede the steamroller of "progress" and of technological innovation from crushing less in vogue technology in its path; the digital world demonstrates this at every turn.

Gondry's film is an example of the pitched battle raging constantly, at least in matters concerning cinema, between attraction and narration. This battle is not dissimilar to the "heroic" era, when institutional cinema supplanted kine-attractography at the time of the medium's second birth. This tension, a driving force in the genealogy of the medium, has been revived, even in this day and age, in several critics' discussion of this adaptation of *L'Écume des jours*. Ted Hardy-Carnac, for example, comments,

> In the book there are entire pages without "special effects." Boris Vian piled invention upon invention while at the same time letting his story breathe. . . . For such guile to be visible in cinema it must occupy one or more shots, it must take its place, take the time to exist, become part of a rhythm. Film viewers cannot re-read a

sentence three times and then devour a whole scene. If a shot stops them the story suffers as a result. While enjoying an effect, viewers leave the characters behind a little.[5]

The attractional effect produced by the spectacular aspect of special effects, to the detriment of narrative economy, is in keeping with the tension we identified between the homochrone and the heterochrone. In cinema, the homochrone reinforces in a sense the insistence and overloading of the special effect: viewers in a movie theater, who have no control over the flow of audiovisual "information" being fed them, cannot escape, whereas readers can, on the contrary, alter the rhythm of their reading as they explore the narrative.

This in any event should urge caution and discernment on scholars. The novelty effect can easily go to the heads of analysts themselves. The digital world and the boundless possibilities it opens up are fascinating, but this fascination must not compromise the rigor of one's research. We should practice the art of seeing shades instead of just black and white and avoid the narrow duality of a fight to the finish between "digital-philes" and "digital-phobes." Here we share Pierre Musso's urgings to distance ourselves from the effects of technologies:

> While our hyper-technological society is constantly consuming and producing new technologies, a question has arisen around the speed of their development and accumulation. . . . We must distinguish three temporalities within this technological process: ultra-rapid and cumulative innovations, when their appropriation and use is slow and representations associated with these technologies ("technological myths") are even slower. . . . The articulation of these three rhythms shines light on the technological processes underway and can help "civilize the new worlds issuing from civilization," in the words of Georges Balandier.[6]

We should thus—and we have emphasized this point from the very outset of this volume—examine critically the "mythology" of digital technology or, to borrow Gilbert Simondon's expression, its "imaging genesis."[7] Like François Jost, for example, who has demonstrated

that the world of Twitter has not opened up a new form of democratic communication as is so often proclaimed.[8] We too discussed "twitterature" in our Chapter 3, and one might wonder at this recuperation by the "prestigious" cultural series literature of a phenomenon deriving from the digital and from new technology. This may appear to be a "media-centric" perspective or a "series-centric" desire to retake control of the phenomenon according to the cultural series one privileges. Here we can see in a sense the "expanded cinema" syndrome applied to literature, or something like *expanded literature*, which might give us a slogan worthy of Philippe Dubois: "Yes, it's literature!"

According to Jost, Twitter is a deeply nonegalitarian and undemocratic world that, in its own fashion, restores Michel Foucault's "author-function": this social medium reestablishes a highly "vertical" form of communication, because in the end the only tweets that count are those of celebrities. Supposedly egalitarian, this social medium very clearly separates those whose thoughts are worthy of being preserved, recounting current events in little bits and pieces, from those whose words evaporate immediately:

> [These] 140-character texts, which pass like lightning in the midst of the monstrous quantity of tweets sent out each second, endow everyday speech with a new legitimacy, because while it is by nature floating speech focused on the evanescence of daily events, it only has repercussions if it is tied to a name which removes it from the constant chirping din.[9]

This discussion of Gondry's adaptation of Boris Vian's novel provides an opportunity to sum up some of the ideas underlying the present volume. We might describe this summing-up as "methodological" in the etymological sense of the term: *meta-odos-logos*, or "reflection through the road travelled." Underlying each of our seven chapters can be seen several topics of discussion that to our minds are decisive. First we wished to understand the digital by trying to drive its innermost ontological entrenchments into the open and by attempting to define a kind of pragmatics of the signifying material proper to the digital image. At the same time, however, we

were concerned with breaking down the boundaries of this ontological approach in order to bring it up against today's social uses and cultural practices. In addition, we strived to grasp the upheavals in contemporary cinema's identity by trying to understand the tensions underlying the various discourses around this identity, hence our questions about the end of cinema and our putting into context the arguments of those who, like Raymond Bellour, believe that "digital technology is not enough to kill cinema. Although it may disturb it in many respects, it does not touch its essence: the screening, the movie theater, the darkness, the silence, the viewers gathered together over a period of time."[10]

Others apart from Bellour and those who share his values insist on the great increase in the number of screen spaces where films can be received:

> In less than a half century we have gone from screen-entertainment to screen-communication, from one screen to all screen. For a long time, screen-cinema was unique and incomparable. Today it is merging into a galaxy of infinite dimensions: we are entering the era of the all-over screen. . . . The new century is one of the omnipresent and many-sided screen, the planetary and multimedia screen.[11]

In order to set out and try to legitimate the middle ground we have taken here between these more or less entrenched camps, we linked our grasp of contemporary cinema to a genealogical and dynamic understanding of the medium and the cultural series running through it. As we have always maintained, it is essential to carry out a heuristic operation that puts matters into context by comparing different moments of a medium's history and the cultural series that are a part of it. This is what enables us to view those two forms of intermedial effervescence, cinema's first and third births, the latter arising out of the medium's postinstitutional "phase," as being in sympathetic vibration. In fact we believe that cinema's dynamic genealogy would benefit from being interpreted in light of its successive generations, as this Cineplex advertisement promoting the UltraAVX audiovisual experience says:

A NEW *GENERATION* OF THEATRE HAS ARRIVED

Introducing the incredible UltraAVX theatre from Cineplex. Featuring:

- Giant Wall-To-Wall Screen—The biggest we could fit!
- Crystal Clear Digital Projection
- Immersive Sound System—Hear every detail
- Large Rocker Seats—The ultimate in comfort
- Reserved Seating[12]

This advertisement is concerned first of all with the movie theater itself. A "new generation" of movie theaters is thus now on offer to viewers. We could extend this comment to the medium as a whole. What dies, what disappears on a regular basis, is a "generation": a generation stands aside and makes room for the next (sung to the tune of "The King is dead, long live the King!").

There surely remain many developments and clarifications to add to our argument, which we will address in future research. One of the subjects that appears to us to need clarification is the many-faceted and complex matter of cultural series, which poses, among others, this burning question: How does one distinguish between a *cultural series* and a *cultural practice*?[13] For us, the cultural series is a creation of historians, who grasp a theme, a form of cultural know-how (a kind of entertainment, a form or representation tied to varying degrees to an apparatus or device) and try to trace and understand the changes to its identity through its various mutations, for example: the fairy play, the circus, the projected image, the graphic image, the animated image, and opera. These forms of cultural know-how can be codified and institutionalized to varying degrees (as is the case with opera since Monteverdi), and they can also hug the contours of a medium (cinema, for example) and thus become a kind of cultural mega-series. Why a *mega-series*? Because media such as cinema, as we have argued throughout this book, are most often federations of preexisting cultural series, which for a time forge a relative and evolving uniform identity.

As for cultural *practices*, these are not autonomous entities standing in sharp distinction from cultural *series*. On the contrary, there is

a permanent interrelation (an "interfertilization") between practices and series, as new practices constantly modify series. This dynamic situation exists in parallel with that of media, which are constantly impregnated and modified by social uses that constantly contribute to (re-)defining them. We might also make use of media theory, for which social progress and technological progress are always closely related.

One of the essential points of our argument is the special importance we have granted the return to the forefront of the cultural series animation in the digital era. We have proposed the term *animage* in this respect, deriving from what we call a new *anima-realism*. This latter system of filmic representation shifts classical photo-realism toward an encoding-recomposing that blurs the established definition of the profilmic. In this respect, a technique such as performance capture offers the possibility of a "demiurge-like" control over the filmic. To continue straight on from our theory of resonances, this enables us to make a connection with a mythical figure in thinking about cinema: André Bazin. According to Bazin, what cinema sought from the beginning was a kind of "complete" reality. This, as we saw earlier, was his thesis in championing the idea, quite widespread at the time, of a *complete* cinema or a *total* cinema, in the words of René Barjavel's book title. To buttress his argument, Bazin drew on the writings of the earliest inventors of proto-cinematic devices in the nineteenth century. For Bazin, these writings all display this quest for completeness: "There are numberless writings . . . in which inventors conjure up nothing less than a total cinema that is to provide that complete illusion of life which is still a long way away."[14]

Bazin has what we might call an idealist conception of genealogy: he believes that every kinematographic adventure began with a desire to seize hold of and reconstitute life in all its complexity— a desire to "clone reality," in W. J. T. Mitchell's term.[15] Everything flows from this founding myth, Bazin assures us. This is a highly determinist Bazin, but in the opposite sense to the determinism of classical film history. For Bazin, we must reverse historical causality and "consider the basic technical discoveries as fortunate accidents but essentially second in importance to the preconceived ideas of the inventors. The cinema is an idealistic phenomenon."[16] Cinema

continued this radical quest by constantly seeking to be the image of life and the faithful copy of nature: "The guiding myth, then, inspiring the invention of cinema is . . . an integral realism, a recreation of the world in its own image, an image unburdened by the freedom of interpretation of the artist or the irreversibility of time."[17] Bazin thus identifies what cinema strives toward: something like a *hyperrealist capturing-restoring*. Or, better yet, the hyperrealism of a radical imitation-recreation. For him, the invention of cinema took place under the full and complete authority of this principle of integral realism that crystallizes in what he calls "total cinema."

With respect to this expression itself in Bazin's film theory, we believe it would be relevant to point out how his thinking evolved, something that can be seen by a comparison between the two versions of this text on the myth of total cinema, dating from 1946 and 1958. At first glance this evolution appears minute, but we believe it is of great importance. In the revised version of his text dating from 1958, Bazin discusses the opinions of the earliest "thinker-craftsmen" of cinema in the following terms: "In their imaginations they saw the cinema as a total and complete representation of reality; they saw in a trice the reconstruction of a perfect illusion of the outside world in sound, color, and relief."[18] In the initial version, however, dating from 1946, the phrase "total and complete representation of reality" is absent. Here Bazin preferred to speak of the "reconstruction of a complete illusion of reality."[19] Apart from an overall shared idea (that of a complete and total cinema), the more recent text puts forward the very twenty-first-century idea of "representation." Not a mere "reconstruction," but a "representation," with its suggestion of encoding, of "data manipulation," of arranging and reconstructing. This, moreover, is what led Bazin, in 1958, to issue his famous statement "Cinema has not yet been invented!,"[20] a now-famous claim that reworked the distinctly more "total" version of the same idea in the first version of 1946: "Cinema is still being invented."[21]

Bazin saw the invention of cinema through this radical proclamation, a kind of "mythological teleology." It was a kind of manifesto, a smack in the face. With the version published in *What is Cinema?* in 1958, he took a firmer, more intransigent and thus more idealistic

position: because the invention of cinema is still underway, it has not yet been invented, and, despite the improvements that what we call cinema has paradoxically added along the way, much still remains to be done. It is as if the gap separating us from the mythical ideal of the pure and complete recording can never be filled. There was an element of Sisyphus in the myth of total cinema—or rather an element of the paradoxes of Zeno of Elea. Cinema is somewhere on the horizon but, like the horizon, always slips out of reach of those who try to catch up with it. And yet, at the end of the revised version of his text, Bazin suggests, despite everything, the possibility (but does he really believe in it?) of seeing the myth become reality—by referencing another myth, one that has come to pass: "Thus, the myth of Icarus had to wait on the internal combustion engine before descending from the platonic heavens. But it had dwelt in the soul of everyman since he had first thought about birds. To some extent, one could say the same thing about the myth of cinema."[22]

Our interpretation of these two divergent formulations set out by Bazin on the never-ending invention of cinema also deserves to be put in relation to the change in context that had taken place between these two versions of the text. As Laurent Le Forestier has reminded us, "In 1946 everyone in France was persuaded of the imminence of radical changes in the technological features of the cinematic medium: color and 3D were around the corner."[23] Yet by 1958 one had to admit that the promised progress had not shown up. In France, color film had far from taken over, while 3D was a worldwide failure. Hence Le Forestier's hypothesis: Bazin's different formulations demonstrate a kind of "ebbing of total cinema."[24]

Does digital technology bring us any closer to the primordial radical view of total representation proposed by Bazin? In a sense, yes. Nevertheless, Bazin believed that "what is marvelous on screen is only the consequence of its realism"[25] and thus, with respect to our discussion here, of a kind of "artistic" digression in the face of the idealist quest for total cinema. We believe that digital technology makes it possible, precisely, to fuse the two systems—*artistic interpretation*, which among other things can give rise to the marvelous, and *total representation*. To borrow Bazin's own words, to "capture life as it unfolds" and "produce miracles":[26] the two actions

have now merged in a digitalized filmic, which has *ontologized* the "marvelous" quality of the special effect.

It is in this spirit of convergence, of amalgamating cross-fertilization and handling the heterogeneous that we have introduced our concept of *animage*: a kind of filmic image that has emerged from the expressive potential of the digital *and* that crystallizes the present-day flourishing of a cultural series that had been neglected by institutional cinema: animation.

In this sense, we believe we have filled the linguistic void deplored by Jacques Aumont and thereby met the implicit challenge of his remarks:

> To say that cinema no longer has exclusive claims on moving images is thus not to remark upon its disappearance, any more than its dissolution in a vaster congregate in which it is difficult to distinguish it. What is missing, in the end, to state simply this relatively simple situation, is a word—a single word that would say "diverse social uses of moving images." But this word does not exist, neither in [French,] English or Greek, and this is probably the quite idiotic reason why people want to say that cinema is everywhere: it is not the thing that people want to universalize, it is the word, for want of it.[27]

This word, as far as we are concerned, could well be *animage*, a transversal concept that has the advantage of encompassing, by incorporating and federating them, the new social uses of these *images* that are *animated* by movement: Evolving social uses that, as we have been able to see here, are shaping the identity of all our media, including cinema (without scare quotes or a question mark).

Notes

Preface

As indicated in the last paragraph of the preface, many notes through-out this volume include the remark "Find out more." This indicates that supplementary information (such as illustrations, videos, hyperlinks, quotations, and complementary notes) can be found on the website www.theendofcinema.com.

1. On the website mentioned above readers can find a list of parts of earlier texts, as brief as they may be, that have been taken up again here.

2. These organizations are, in France, the cinema laboratory (headed by Laurent Le Forestier) of the "Arts: pratiques et poétiques" group (headed in turn by Gilles Mouëllic) at Université Rennes 2, the Cinémathèque fran-çaise, and FÉMIS (École nationale supérieure des métiers de l'image et du son); in Switzerland, the "Dispositifs" group at the Université de Lausanne (headed by Maria Tortajada), the Cinémathèque suisse, and the École cantonale d'art de Lausanne; and in Canada, the GRAFICS group at the Uni-versité de Montréal (headed by André Gaudreault), the Cinémathèque québécoise, and the INIS (Institut national de l'image et du son). The Quebec group also has as partners the Faculty of Arts and Sciences at the Univer-sité de Montréal, the Observatoire du cinéma au Québec, Canal Savoir, and the National Film Board of Canada. Finally, the partners benefit from the support from the International Federation of Film Archives (FIAF). Find out more.

Introduction: The End of Cinema?

1. Peter Greenaway, "Peter Greenaway, cinema = dead," YouTube video, 2:50, filmed interview, posted on June 29, 2007. Find out more.

2. From a talk by Peter Greenaway at the Flanders Film Festival in Ghent, Belgium in 1999. Our emphasis. Quoted online at "Peter Greenaway Quotes," petergreenaway.org.uk. Find out more.

3. Philippe Dubois, "Présentation" [Presentation]. In *Le cinéma gagne du terrain* [Extended cinema], ed. Elena Biserna, Philippe Dubois, and Frédéric Monvoisin (2010), 13.

4. Without anyone using scare quotes all this time, except in very rare instances. Find out more.

5. John Belton, "*Introduction:* Digital Cinema," *Film History* 24, no. 2 (2012): 132.

6. Belton, "Digital Cinema: A False Revolution," *October* 100 (Spring 2002): 98–114. Find out more.

7. Text published on September 17, 2008, on a blog called Thornburglar: "Digital Cinema, a Revolution?" Find out more.

8. Belton, "*Introduction:* Digital Cinema," 132.

9. Stéphane Delorme, "D'une projection à l'autre," *Cahiers du cinéma* 672 (November 2011): 5. Emphasis in the original.

10. In fact *The Skin I Live In* was shot in part digitally (with a Panasonic AG-DVX100 camera, a small-scale professional camera) and partly in 35 mm (with an Arricam ST camera). The film was screened in 35 mm in some theaters and in D-Cinema (digital cinema) in others.

11. In Roger Odin's words, "The film-film (which has the status of object) is not the film-projection (all the light and sound vibrations produced by the projection apparatus to constitute the 'imaginary signifier'), which alone grants access to the film-text." Roger Odin, *De la fiction* (2000), 154.

12. One of whose intertitles reads: "Ce n'est pas une image juste, c'est juste une image" ("This is not a just image, it's just an image").

13. Chris Marker, quoted by Raymond Bellour in "La querelle des dispositifs," *Artpress* 262 (November 2000): 48.

14. Belton, "*Introduction:* Digital Cinema," 131. Our emphasis.

15. Because here we required an arbitrary date to distinguish between the eras before and after the arrival of digital media and because no one can say with any precision when exactly the digital era began, we chose a date that is already thoroughly arbitrary and that was determined in a thoroughly unscientific manner: that of cinema's supposed "centenary." Find out more.

16. Will Self, "Cut! That's All, Folks," *The Times* (London), August 28, 2010, 2.

17. DVD stands for digital versatile disc.

18. Thomas Elsaesser, "The New Film History as Media Archaeology," *Cinémas* 14, no. 2–3 (Spring 2004): 115. Our emphasis.

19. Jean-Philippe Tessé, "La révolution numérique est terminée," *Cahiers du cinéma* 672 (November 2011): 6.

20. Delorme, "D'une projection à l'autre." Emphasis in the original.

21. We borrow the expression "fragmented cinema"("cinéma éclaté") from Guillaume Soulez, who organized a study day around the question with his colleague Kira Kitsopanidou and who prefers the term to "extended cinema." The conference was entitled "Le cinéma éclaté et le levain des médias" (Fragmented cinema and the media catalyst), Institut national d'histoire de l'art, Paris, March 2012.

22. Hence its current crisis and hot-topic status at conferences.

23. This numbering system is something devised by the two authors of the present volume and has, of course, no scientific pretentions. Especially given that the number of deaths we will identify is arbitrary. For us it is a question above all of showing that these deaths were not true deaths (because, as everyone knows, you only die once—even if certain people maintain that the cinema was born twice . . .).

1. Cinema Is Not What It Used to Be

1. Will Self, "Cut! That's All, Folks," *The Times* (London), August 28, 2010, 2. Our emphasis.

2. On the forms of attraction in cinema, see André Gaudreault, *Film and Attraction: From Kinematography to Cinema*, trans. Timothy Barnard (2011 [2008]). Find out more.

3. Self, "Cut! That's All, Folks," 2.

4. Jacques Aumont, *Que reste-t-il du cinéma?* (2012), 55.

5. Self, "Cut! That's All, Folks," 2.

6. Susan Sontag, "The Decay of Cinema," *New York Times*, February 25, 1996. Find out more.

7. Paolo Cherchi Usai, *The Death of Cinema: History, Cultural Memory, and the Digital Dark Age* (2001).

8. Maxime Scheinfeigel, ed., *Cinergon* 15 (2003).

9. Maxime Scheinfeigel, "Les lauriers du cinéma," *Cinergon* 15 (2003): 41.

10. François Amy de la Bretèque, "*Cinergon* no. 15: 'Où va le cinéma?,'" *Cahiers de la cinémathèque* 76 (July 2004): 122.

11. We will explain our use of the term *digitalize* at the end of this chapter.

12. David Norman Rodowick, "La vie virtuelle du film," *Cinergon* 15 (2003): 17–35. Find out more.

13. David Norman Rodowick, *The Virtual Life of Film* (2007).

14. Philippe Dubois, "Introduction/Présentation, in Alessandro Bordina, Philippe Dubois, and Lucia Ramos Monteiro, eds., *Oui, c'est du cinéma/Yes, It's Cinema. Formes et espaces de l'image en mouvement/Forms and Spaces of the Moving Image* (Pasian di Prato: Campanotto Editore, 2009), 7.

15. Chuck Tryon, *Reinventing Cinema: Movies in the Age of Media Convergence* (2009).

16. Dudley Andrew, *What Cinema Is!* (2010).

17. Ibid., xxiv.

18. James Lastra, "What Cinema Is (for the Moment . . .)," paper presented at the conference "The Impact of Technological Innovations on the Historiography and Theory of Cinema," Cinémathèque québécoise, Montreal, November 2011. Unpublished, quoted with permission of the author. Forthcoming in Nicolas Dulac and André Gaudreault, eds., *Du média au postmédia: continuités, ruptures/From Media to Post-Media: Continuities and Ruptures* (Lausanne: L'Âge d'Homme).

19. Tom Gunning, "Let's Start Over: Why Cinema Hasn't Yet Been Invented," paper presented at the annual Film Studies Association of Canada conference, Kitchener/Waterloo, Canada, May 2012. Unpublished, quoted with permission of the author.

20. Lastra, "What Cinema Is."

21. André Bazin, "Le mythe du cinéma total," in *Qu'est-ce que le cinéma?*, vol. 1, *Ontologie et langage* (Paris: Éditions du Cerf, 1958), 19–24. Translated by Hugh Gray as "The Myth of Total Cinema" in Bazin, *What Is Cinema?* vol. 1 (Berkeley: University of California Press, 1967), 17–22.

22. In a paper presented at the 16th *Convegno internazionale di studi sul cinema* conference entitled "In the Very Beginning, at the Very End," Università degli Studi di Udine, Udine, Italy, March 2009. See André Gaudreault and Philippe Marion, "Le cinéma est encore mort! Un média et ses crises identitaires," in ed. Thierry Lancien, *MEI (Médiation et information)* 34 (2012): 27–42. Find out more.

23. Gunning, "Let's Start Over."

24. Alessandro Bordina, Philippe Dubois, and Lucia Ramos Monteiro, eds., *Oui, c'est du cinéma/Yes, It's Cinema.*

25. Gunning, "Let's Start Over."

26. Raymond Bellour, *La querelle des dispositifs: Cinéma—installations, expositions* (Paris: P.O.L, 2012).

27. Raymond Bellour, our transcription of a filmed interview entitled "La querelle des dispositifs 1," YouTube video, 18:54, dated November 26, 2012, posted by "jeanpaulhirsch" on December 13, 2012. Find out more.

28. Raymond Bellour, second title card of a video recording of a seminar at the Centre de recherches sur les arts et le langage (CEHTA/CRAL)

entitled "La querelle des dispositifs: Cinéma—installations, expositions 1/3," YouTube video, 25:30, recorded on January 9, 2013, posted by "CRAL–Centre de Recherches sur les arts et le langage." on January 22, 2013. Our emphasis. Find out more.

29. Taken from the article "Supernova" in the French-language online encyclopedia Wikipédia. Find out more.

30. Bellour, *La querelle des dispositifs*, 14.

31. Ibid.

32. Aumont, *Que reste-t-il du cinéma?*, 22.

33. Philippe Dubois, "Présentation, in Elena Biserna, Philippe Dubois, and Frédéric Monvoisin, eds., *Extended Cinema/Le cinéma gagne du terrain* (Pasian di Prato: Campanotto Editore, 2010), 13. Text repeated on the back cover.

34. Dubois, "Introduction/Présentation," in Alessandro Bordina, Philippe Dubois and Lucia Ramos Monteiro, eds., *Oui, c'est du cinéma/ Yes, It's Cinema*, 7.

35. Ibid., 7–8.

36. Bellour, *La querelle des dispositifs*, 14. Emphasis in the original. This text is repeated (without italics) on the book's back cover. The reader will remark that in addition to the "apparatus dispute" we are witnessing a veritable back-cover dispute!

37. Statement by David Lynch, "David Lynch on iPhone," YouTube video, 0:30, filmed interview, posted by "Brittney Gilbert," on January 4, 2008. The statement can also be found in the DVD bonus material for the film *Inland Empire* entitled "David Lynch's *Inland Empire*" (2007). Find out more.

38. Aumont, *Que reste-t-il du cinéma?*, 12. Our emphasis.

39. Dubois, "Présentation," in Elena Biserna, Philippe Dubois and Frédéric Monvoisin, eds., *Extended Cinema/Le cinéma gagne du terrain*, 13. This text recurs on the back cover.

40. Released on January 7, 2013, the book was in fact published in the final quarter of 2012.

41. In our joint paper presented at the conference "The Second Birth of Cinema: A Centenary Conference," organized by Andrew Shail (Newcastle University, Newcastle, Great Britain, July 2011). See André Gaudreault and Philippe Marion, "Measuring the 'Double Birth' Model Against the Digital Age," *Early Popular Visual Culture* 11, no. 2 (2013): 158–77.

42. Clifford Coonan, "Greenaway Announces the Death of Cinema— And Blames the Remote-Control Zapper," *The Independent*, October 10, 2007. Find out more.

43. The best definition of VJing we have found is that on Wikipedia (our apologies!): "VJing is a broad designation for realtime visual performance. Characteristics of VJing are the creation or manipulation of

imagery in realtime through technological mediation and for an audience, in synchronization to music." With respect to the use of Wikipedia, we can console ourselves with this comment by Michel Serres: "Do you know that there are slightly fewer mistakes on Wikipedia than there are in the Universalis encyclopedia?" Find out more.

44. A recording of a Greenaway VJing performance can be found on YouTube in a video entitled *Peter Greenaway @ STRP Festival 2006.* Find out more.

45. Chuck Tryon, "What the Fuck Are You Doing in the Dark?," *The Chutry Experiment* (blog), July 15, 2007. Find out more.

46. Aurélien Ferenczi describes Greenaway as the "king of provocation," which may also explain this lack of precision . . . See Aurélien Ferenczi, "Peter Greenaway constate la mort du cinéma," *Télérama*, October 12, 2007. Find out more.

47. In an interview published in *The Getty Iris* ("The Online Magazine of the Getty"), he was asked if it was by chance that he gave the date September 31, 1983, and he replied, in a manner more poetic than scientific (the opposite would have been astonishing!): "Yes, it is. (Sort of.) 1983 is the beginning of the digital revolution, and autumn is the time of changes." Steve Saldivar, "Six Questions for Peter Greenaway," *The Getty Iris: The Online Magazine of Getty*, February 17, 2011. Find out more.

48. Remote controls with electrical cords began to be marketed in the early 1950s, and it would appear that the first cordless remotes were marketed in 1955 or 1956.

49. Bellour, *La querelle des dispositifs*, back cover.

50. Aumont, *Que reste-t-il du cinéma?*, 82.

51. This is the case even though Greenaway, in 2011, did a true somersault by attempting to establish a connection between the *remote control* and the *digital revolution*: "1983 is the beginning of the digital revolution"; this can hardly be defended, unless one agrees with the principle "everything is a part of everything else, and vice versa"! See the interview with Greenaway in *The Getty Iris* quoted in note 47.

52. Jean-Louis Baudry, "Cinéma: Effets idéologiques produits par l'appareil de base," *Cinéthique* 7–8 (1970): 1–8, translated by Alan Williams as "Ideological Effects of the Basic Cinematographic Apparatus" in *Apparatus,* ed. Theresa Hak Kyung Cha (1980), 25–37; "Le dispositif: Approches métapsychologiques de l'impression de réalité," *Communications* 23 (1975): 56–72, translated by Jean Andrews and Bertrand Augst as "The Apparatus" in *Apparatus,* 41–62; and *L'Effet cinéma* (1978). We are well aware that the "base apparatus," in Baudry's view and according to his logic, is not limited to the moving picture camera alone and is ultimately about something completely different from cinema's mere technological hardware. Baudry makes this clear in a footnote (p. 59) to the

article "Le dispositif" (a note that was not translated in the English version of the text) when he states: "Thus the base apparatus includes the film stock, the camera, the film development, the editing in a technical sense, etc., in addition to the projection apparatus. The base apparatus is far from the camera alone, to which others have wished (one wonders why, for what bad purpose) I should limit it."

53. Jean-Louis Comolli, a series of six articles entitled "Technique et idéologie," published in *Cahiers du cinéma* in 1971 and 1972 (nos. 229, 230, 231, 233, 234–35, and 241). One of these articles was translated by Diana Matias under the title "Technique and Ideology" in *Film Reader* 2 (January 1977): 128–40, whereas another two, under the same title and by the same translator, appeared in *Narrative, Apparatus, Ideology: A Film Theory Reader*, ed. Philip Rosen, (1986), 421–33. Find out more.

54. In fact this remark was attributed to Antoine Lumière after the fact, by Louis Lumière in 1945 when speaking with the film historians Maurice Bessy and Lo Duca about his father Antoine's response when Georges Méliès, who was present at the Grand Café screening on December 28, 1895, asked him to sell him the Cinématographe patent. A footnote informs the reader that Louis Lumière, in a letter to the authors, wrote that his father had declared the following: "Young man, you should thank me. My invention is not for sale, but it would ruin you. It may be employed for some time as a scientific curiosity: beyond that it has no commercial future." See Maurice Bessy and Lo Duca, *Louis Lumière inventeur* (1948), 49. Find out more.

55. *Paris Match* 226 (July 18–25, 1953). The authors thank Martin Lefebvre of Concordia University for bringing this issue to their attention.

56. Roger Boussinot, *Le Cinéma est mort. Vive le cinéma!* (1967), 91. The authors thank Laurent Le Forestier of Université Rennes 2 for bringing this book to their attention. Note that the expression "Cinema is dead, long live the cinema" is, as one might expect, quite common. They are the last words of the presentation by James Lastra in Montreal in 2011 mentioned above ("What Cinema Is [for the Moment . . .]"): [Cinema is dead? Long live the cinema]; they also form the title of an article by Jacques Kermabon ("Le cinéma est mort, vive le cinéma," *24 images* 142 [2009]: 20–21). Greenaway also expresses the same idea: "The cinema is dead, long live the cinema" ("*Peter Greenaway, cinema = dead,*" YouTube video, 2:50, filmed interview, posted on June 29, 2007). Find out more.

57. Boussinot, *Le cinéma est mort. Vive le cinéma!*, 44.

58. In the case of the two present authors, this has almost reached the point of becoming a tic. We are far from alone, however. Quotation marks are used this way a number of times in Aumont (*Que reste-t-il du cinéma?*, 21, 24, and 25), but are swarming in Dubois, (in *Extended Cinema*, ed.

Elena Biserna, Philippe Dubois, and Frédéric Monvoisin, 13 [six occurrences] and 14 [one occurrence]).

59. Boussinot, *Le cinéma est mort. Vive le cinéma!*, 91.

60. When we discuss the device invented by the Lumière brothers, we will refer to it by name, the Cinématographe. To refer to the moving picture camera in general, and more specifically to the "culture" that appeared with it, or to the entire period of film history before cinema was institutionalized, we will use the term kinematograph.

61. Boussinot, *Le cinéma est mort. Vive le cinéma!*, 49. Emphasis in the original.

62. Rodowick, *The Virtual Life of Film*, 93.

63. Boussinot, *Le cinéma est mort. Vive le cinéma!*, 68.

64. Ibid., 68–69. On the Eidophor, see for example Kira Kitsopanidou, "The Widescreen Revolution and 20th Century-Fox's Eidophor in the 1950s," *Film History* 15 (2003): 32–56. Find out more.

65. We write "so-called silent cinema" because silent cinema was actually quite noisy. See Rick Altman's summa, *Silent Film Sound* (2004).

66. Édouard Arnoldy, *À perte de vues: Images et "nouvelles technologies," d'hier et d'aujourd'hui* (2005), 30.

67. Lucien Wahl, "Le navet d'aujourd'hui sera demain qualifié chef-d'oeuvre," *Cinémagazine* 24 (June 15, 1928): 426.

68. Pierre Desclaux, "Le film parlant," *Mon Ciné* 353 (November 22, 1928): 11. Our emphasis.

69. At the first international conference of the Centre for Research into Intermediality, "La nouvelle sphère intermédiatique," Musée d'art contemporain, Montreal, 1999. See André Gaudreault and Philippe Marion, "A Medium is Always Born Twice," trans. Timothy Barnard, *Early Popular Visual Culture* 3 (May 2005): 3–15. Find out more.

70. Alexandre Arnoux, "J'ai vu, enfin, à Londres un film parlant." *Pour Vous* 1 (November 22, 1928): 3. Find out more.

71. Victor Hugo wrote: "The one will kill the other. The book will kill the building." *The Hunchback of Notre Dame* (New York: Courier Dover Publications, 2012 [1831]), 143. Find out more.

72. Pierre Leprohon, *Histoire du cinéma*, vol. 1, *Vie et mort du Cinématographe (1895–1930)* (1961), 87. (Republished under the title *Histoire du cinéma muet* [Paris: Éditions d'Aujourd'hui, 1982].)

73. Leprohon wrote: "[t]he kinematograph [*cinématographe*]—by which I mean silent cinema." *Histoire du cinéma*, 8.

74. Leprohon concludes his foreword with this remark: "The kinematograph is a dead language." Ibid., 9.

75. André Gaudreault, "*Les vues cinématographiques* selon Georges Méliès, ou: comment Mitry et Sadoul avaient peut-être raison d'avoir tort (même si c'est surtout Deslandes qu'il faut lire et relire) . . . ," in *Georges*

Méliès, l'illusionniste fin de siècle? ed. Jacques Malthête and Michel Marie (1997), 115–16.

76. Gaudreault, *Film and Attraction*, 4.

77. Andrew, *What Cinema Is!*, xii–xiv.

78. Gaudreault, *Film and Attraction*, 56n. 32. Note that the English translator of Morin's book (*The Cinema, or the Imaginary Man*, trans. Lorraine Mortimer [2005 (1956)]) has chosen to use the terms *Cinematograph, cinematography,* and *cinematographic,* thereby risking confusion with quite different contemporary meanings, in the latter two cases, and with the Lumière Cinématographe alone in the other. By choosing to use *kinematograph,* we and our translator believe we have sidestepped these problems by using a widespread period term in English no longer in general use to suggest a more general phenomenon.

79. Even though it is true, as Jean-Jacques Meusy reports, that fairground cinema would survive, in France at least, with a degree of vigor until the war. See his volume *Cinémas de France 1894–1918: Une histoire en images* (2009).

80. "Surdiffusion" in the French. See Laurent Le Forestier, *Aux Sources de l'industrie du cinéma: Le modèle Pathé 1905–1908* (Paris: L'Harmattan, 2006). Le Forestier's volume is a direct and well-documented discussion of most aspects of the 1907–1908 crisis, and we refer the reader to his work.

81. François Valleiry, "La nouvelle pellicule," *Phono-Ciné-Gazette* 46 (February 15, 1907): 70. Note that Valleiry wrote on the subject again a few months later in an article squarely entitled "Le Cinématographe n'est pas encore né" ("The Kinematograph Is Not Yet Born," *Phono-Ciné-Gazette* 55 (July 1, 1907): 250. The authors thank Valentine Robert of the Université de Lausanne for bringing Valleiry's articles to their attention.

82. According to Richard Abel, "François Valleiry" was a pseudonym of Edmond Benoît-Lévy, founder and editor of the very influential trade journal *Phono-Ciné-Gazette*. Abel indicates in footnote that "Benoît-Lévy apparently also wrote under the pseudonym of François Valleiry." Richard Abel, "Booming the Film Business," in *Silent Film,* ed. Richard Abel (1996), 123.

83. We might say that Bazin's famous saying, "Cinema has not yet been invented!" is a late echo of Valleiry's "The kinematograph has not yet been born"!

84. Valleiry, "Le Cinématographe n'est pas encore né," 250. Our emphasis.

85. Ibid. Our emphasis.

86. Gérard Lefort, "Révolutions," *Libération,* Wednesday, May 11, 2011, 2. Note that the editorial is reproduced in its entirety here.

87. To administer digitalis in a dosage sufficient to achieve the maximum therapeutic effect without producing toxic symptoms.

2. Digitalizing Cinema from Top to Bottom

1. Let us picture it with wings, like the butterfly of chaos theory and Tinker Bell! Let's imagine also that she is a descendant of Raoul Dufy's Electricity Fairy!

2. Edgar Morin, *Method: Towards a Study of Humankind*, vol. 1, *The Nature of Nature*, trans. J. L. Roland Bélanger (1992 [1977]), 100. Emphasis in the original. In this systemic spirit, the whole always exceeds the sum of its part. This is also true of media culture and intermediality as systems.

3. Ibid.

4. By *intermedia* we mean the complex system resulting from intermedial relations and exchanges in a given media ecosystem. Intermedia are thus tied to the porosity of media and to the relative abolition of the boundaries separating them. The result of amalgamating exchanges caused by convergence (of media and platforms), intermedia are in a sense the condition of our hypermedia.

5. By feedback we mean the return into the system of information that arose from it.

6. On this topic see the critical overview provided by Jean-Pierre Meunier, *Approches systémiques de la communication* (2003).

7. See the entry on "irreversibility" in "Abécédaire," *Les cahiers de médiologie* 6 (1998): 275.

8. The vocabulary used in "mobilography" having not yet been stabilized, we asked a specialist in the field, Richard Bégin of the Université de Montréal, for details. This was his response (e-mail to André Gaudreault on April 10, 2013): "I use the term 'mobilogram' to speak of films shot *with* a telephone. With respect to people who watch films on their telephone or who use their phone for a 'mobilographic' or 'mobilogame' experience, the term 'mobilosurfer' appears to be the best suited (it is sometimes used in the press; I should collect examples). I call the person who creates with a telephone a 'mobilographer,' because they 'write' in a sense their own mobility. Don't forget *mobilogenius* and *mobilophile* (a mobilosurfer to the power of ten)!" Find out more.

9. See André Gaudreault, *Film and Attraction: From Kinematography to Cinema*, trans. Timothy Barnard (2011).

10. The call for papers can be consulted on the site of the École supérieure d'art d'Aix-en-Provence. Find out more.

11. Pierre Musso, "La 'révolution numérique': Techniques et mythologies," author's manuscript available online on the site of the Institut Mines-Télécom, 2010, 1 (published in *La Pensée* 355 [2008]) 103–20. Find out more.

12. Roland Barthes, *Mythologies*, trans. Annette Lavers (1972 [1957]).

13. Serge Tisseron, *Petites Mythologies d'aujourd'hui* (2000).

14. Jérôme Garcin, ed., *Nouvelles Mythologies* (2007).

15. See in particular Patrice Flichy, *L'Innovation technique* (1995) and, more recently, *L'Imaginaire d'Internet* (2005).

16. Musso, "La 'révolution numérique,'" 13.

17. This at least is how InnoviSCOP interprets the work of Michael L. Tushman and Philip Anderson, "Technological Discontinuities and Organizational Environments," *Administrative Science Quarterly* 31, no. 3 (September 1986): 439–65. Find out more.

18. Entry for "technological rupture" published by InnoviSCOP on its website. Our emphasis. Find out more.

19. Ibid.

20. See Michel Serres, *Petite Poucette* (2012). Find out more.

21. Laurent Sorbier, "Introduction: Quand la révolution numérique n'est plus virtuelle . . . ," *Esprit*, May 2006, p. 123. Find out more.

22. Marshall McLuhan, *Understanding Media: The Extensions of Man* (1994 [1964]), 7.

23. Nicholas Negroponte, *Being Digital* (1995).

24. Sorbier, "Quand la révolution numérique n'est plus virtuelle," 123.

25. Gilles Deleuze and Félix Guattari, *A Thousand Plateaus: Capitalism and Schizophrenia*, trans. Brian Massumi (1987 [1980]).

26. Michel Serres, *Atlas* (1994).

27. Manuel Castells, *La galaxie Internet* (2002).

28. Sorbier, "Quand la révolution numérique n'est plus virtuelle," 122.

29. Musso, "La 'révolution numérique,'" 13.

30. By *spectactor* (with an additional *c*) we mean a spectator who actively participates in an audiovisual medium with an interactive dimension. In a strong sense, we might say that *spectators* are actors in the "spectacle" or monstration they coconstruct. See also Réjean Dumouchel, "Le s*pectacteur* et le *contactile*," *Cinémas* 1, no. 3 (Spring1991): 38–60.

31. At this point in our discussion we might mention the widespread distinction that exists in French today between *médium* and *média*. Apart from the original distinction based on number as found in Latin and observed in English (*media* being the plural of *medium*)—French today makes a rather subtle distinction between *médium* and *média*, one that while it has no equivalent in English, seems to us quite indicative of the need to rethink the position of cinema in the digital context. By the term *médium* French means a kind of language (the *médium* is what is found "between," media scholars remind us) or, if one prefers, a material (technological in the present instance) and semiotic apparatus that can sometimes make possible artistic expression. The French word *médium* thus makes it possible to bring out the material and techno-linguistic part of the media process alone. For its part, the French word *média* refers to an institutionalized system of communication (entertainment, industry,

venue, trades, etc.). Naturally these two levels overlap and interpenetrate. In keeping with usage in English, we will not maintain the possibility of making this nuance in the translation of this volume, limiting ourselves to the classical pairing of *a medium* and *several media*.

32. Jacques Aumont, *Que reste-t-il du cinéma?* (2012), 55.

33. Ibid., 12.

34. Ibid., 56. Despite the distance we place between us and some of Aumont's hypotheses and opinions, we readily adopt these terms, which appear to us to be ideal for describing images today.

35. Ibid.

36. Ibid., 60.

37. The official site can be consulted online. Find out more.

38. Definition of twitterature on the site of the Institut de twittérature comparée. Find out more.

39. See the article by Fabien Deglise entitled "Des Nouvelles inédites en 140 caractères," *Le Devoir*, February 2, 2013, announcing the online publication of *25 histoires 25 auteurs en 140 ca.* (edited by Fabien Deglise). Find out more.

40. See Richard Bégin, "Mobilogénie du désastre," *Artpress* 2, no. 29 (May 2013): 50–52. "Mobile digital devices thus make possible in a sense a form of writing particular to disaster; more precisely, they inscribe the mobility of the witness. The disaster aesthetic thus requires a 'mobilographical' study which would make it possible to understand how an event is constructed by individual mobility alone, inscribed by the portable device. The 'mobilography' of disaster informs us in this sense of the undeniable aesthetic contribution of the 'smart' mobile digital device."

41. We might mention, as has been pointed out to us by Sophie Rabouh of the Université de Montréal and Université Paris 1, the mobile telephone application Vine, on Twitter makes it possible to share videos of a maximum six seconds in length by playing them in a loop. The Tribeca film festival has recently placed these Vine films in competition and created an award for them. Find out more.

42. Serge Kaganski and Jean-Marc Lalanne, "Entretien avec David Lynch: 'Mes films sont mes enfants,'" *Les Inrockuptibles* 830 (October 26, 2011). Find out more.

43. Kim Nguyen's film *Rebelle* (*War Witch*, 2012), nominated for an Academy Award as Best Foreign Picture (Canada) in 2013, is one film that has been shot with this camera. Find out more.

44. D. N. Rodowick, *The Virtual Life of Film* (2009), 166.

45. Ibid., 173.

46. Jacques Aumont, *Que reste-t-il du cinéma?*, 62.

47. Ibid., 63.

48. On this topic see Philippe Marion, *Traces en cases: Travail graphique, figuration narrative et participation du lecteur* (1993).

49. See in particular Benoît Peeters, Jacques Faton, and Philippe de Pierpont, *Storyboard—Le cinéma dessiné* (1992).

50. Philippe Marion, "Scénario de bande dessinée: La différence par le média," *Études littéraires* 26, no. 2 (December 1993): 87. Find out more.

51. André Bazin et al., *La politique des auteurs: Les entretiens* (2001), 155–56.

52. These ideas are developed in more detail in Philippe Marion, "Scénario de bande dessinée."

53. Aumont appears to share this idea when he mentions Gus Van Sant's remarks emphasizing (with respect to his "digitized" remake of *Psycho*) that "he had the opportunity to do what Hitch would have wanted to do but couldn't, for lack of means." See Aumont, *Que reste-t-il du cinéma?*, 64.

54. This digital storyboard can be viewed online. Our thanks to Olivier Asselin of the Université de Montréal for bringing these examples to our attention. Find out more.

55. Quoted in Nicolas Marcadé, *Chronique d'une mutation: Conversations sur le cinéma (2000–2010)* (2010), 14.

56. Information found in an e-mail from the filmmaker and Université de Montréal professor Olivier Asselin to Philippe Marion, March 19, 2013. Asselin also pointed out to us that Avid's ProTools software program remains to this day the principal editing and mixing software used in film. Find out more.

57. Didier Péron, "Cannes à la croisette des chemins," *Libération*, May 11, 2011, 2. Find out more.

58. Stefan Jovanovic, "The Ending(s) of Cinema: Notes on the Recurrent Demise of the Seventh Art," *Offscreen* 7, no. 4, (April 2003), online. The title of the article itself announces quite a program! Find out more.

59. See Laurent Le Forestier, "Le DVD, nouveau jouet d'optique?" in *In the Very Beginning, at the Very End: Film Theories in Perspective*, ed. Francesco Casetti, Jane Gaines, and Valentina Re (2010), 165. There Le Forestier remarks:

> Deleuze, as is well known, tried to extend Foucault's ideas by remarking, in essence, that if Foucault were still here today he would be studying the passage from the disciplinary society to the control society. We might thus offer the following definition: a control society is one in which reading and all creative acts are not imposed but quite simply harnessed, pacified and channeled. From this perspective the DVD, in both its technological and ideological dimensions, is, like optical toys in their day, an exemplary sign of the state of our society.

60. Michel de Certeau, *The Practice of Everyday Life*, trans. Steven Rendall (Berkeley: University of California Press, 1988 [1980]).

61. Simon Thibodeau, Université de Montréal, in an e-mail to the authors of the present volume dated May 15, 2013. Find out more.

62. A Digital Cinema Package is a hard drive that contains the digital files of the "film" being screened (the image "track," the sound "track," the subtitles and various metadata useful to the projectionist) and that is delivered to digitized movie theaters the way reels of film were in the days of celluloid. The files are encoded and, especially, encrypted. As a rule, the digital "key" for decrypting the "message" (and thus for screening the "film") is valid only for a limited and predetermined period of time. Note that the number of words adorned here with scare quotes gives a good idea of how language today is barely keeping up with the changes underway.

3. A Brief Phenomenology of "Digitalized" Cinema

1. This is the metaphor used by Pierre Musso in his text "La 'révolution numérique': Techniques et mythologies" (2010, p. 6), a manuscript accessible online on the site of the Institut Mines-Télécom. (Published in *La Pensée* 355 [2008]: 103–20.) Find out more.

2. Marie-Julie Catoir and Thierry Lancien, "Multiplication des écrans et relations aux médias: De l'écran d'ordinateur à celui du Smartphone," *MEI (Médiation et information)* 34 (2012): 56.

3. Here we might think of information storage sites such as *MegaUpload*, which gave rise to a complete political and legal saga. Find out more.

4. Jeremy Rifkin, *The Age of Access: The New Culture of Hypercapitalism, Where All of Life Is a Paid-for Experience* (2001).

5. Michel Marie, personal e-mail to André Gaudreault on March 9, 2013. Find out more.

6. Philippe Dubois, *L'Acte photographique* (1983), 9.

7. Laurent Le Forestier, "Le DVD, nouveau jouet d'optique?" in *In the Very Beginning, at the Very End: Film Theories in Perspective*, ed. Francesco Casetti, Jane Gaines, and Valentina Re, *In the Very Beginning, at the Very End: Film Theories in Perspective* (Udine: Forum, 2010), 163.

8. W. J. T. Mitchell, *Cloning Terror: The War of Images, 9/11 to the Present* (2011).

9. Philippe Marion, moreover, has previously distanced his work from that of Philippe Dubois by rehabilitating the photograph's iconic dimension as a "mechanical" capturing of reality and by reserving indexicality for the graphic line (at work in the graphic novel, contiguous with the artist's gesture). See *Traces en cases: Travail graphique, figuration narrative et participation du lecteur* (1993).

10. D. N. Rodowick, *The Virtual Life of Film* (2007), 170.
11. Ibid.
12. Ibid., 166.
13. Ibid., 169.
14. Roland Barthes, *Camera Lucida: Reflections on Photography*, trans. Richard Howard (1981 [1980]), 85.
15. Rodowick, *The Virtual Life of Film*, 167.
16. "Simulation refers to various computer methods for modeling other aspects of reality beyond visual appearance." Lev Manovich, *The Language of New Media* (2001), 17. Find out more.
17. Jacques Aumont, *Que reste-t-il du cinéma?* (2012), 53.
18. Jean-Philippe Tessé, "La révolution numérique est terminée," *Cahiers du Cinéma* 672 (November 2011): 8.
19. This quotation can be found online. Find out more.
20. Michael Oliveira, "*The Hobbit*: Richard Armitage fasciné par le nouveau format 3D," *La Presse* (Montreal), December 4, 2012. Find out more.
21. Even though, we should recall, 3D technology is nothing new. We need only think of the 1950s, when there was an unsuccessful attempt to have 3D take over the market in the battle against television.
22. "As a rule, media comfort can be identified with the illusion of immediacy." Daniel Bougnoux, *Sciences de l'information et de la communication* (1993), 531.
23. This quotation can be found online. Find out more.
24. Philippe Berry, "*The Hobbit*: Le nouveau format vidéo gâche-t-il la magie du film?"; article posted on the site 20minutes.fr on December 10, 2012. Find out more.
25. A comment found in the *Huffington Post* and quoted in Philippe Berry, "*The Hobbit*."
26. Berry, "*The Hobbit*."
27. Philippe Marion, "Scénario de bande dessinée: La différence par le média," *Études littéraires* 26, no. 2 (December 1993): 84. Find out more.
28. In the album *Voyage à Tulum sur un projet de Federico Fellini pour un film en devenir* by Milo Manara (1993).
29. Federico Fellini, "Federico Fellini sage comme la lune," *Le Soir*, 1 August 1990, 3. Find out more.
30. See Marion, *Traces en cases*, 287.
31. E. H. Gombrich, "Mediations on a Hobby Horse or the Roots of Artistic Form" (1951), in *Art Theory and Criticism: An Anthology of Formalist, Avant-Garde, Contextualist and Post-Modernist Thought*, ed. Sally Everett (1995), 45.
32. Rodolphe Töpffer, *Réflexions et menus propos d'un peintre genevois, ou Essai sur le beau dans les arts* (1998 [1848]), 259.

33. Kevin Webb. "The Hobbit's New High Frame Rate Format Fails to Impress." *Atlanta Blackstar*, December 11, 2012. Find out more.

34. Tessé, "La révolution numérique est terminée," 8.

35. Rodowick, *The Virtual Life of Film*, 166.

36. Babette Mangolte, "Afterword: A Matter of Time," in *Camera Obscura, Camera Lucida: Essays in Honor of Annette Michelson,* ed. Richard Allen and Malcolm Turvey (2002), 263. Quoted in Rodowick, *The Virtual Life of Film*, 163.

37. Rodowick, *The Virtual Life of Film*, 100.

38. This would account in part for the renewed interest today in this older format. Find out more.

39. Laurent Guido and Olivier Lugon, "Introduction," in *Fixe/animé: Croisements de la photographie et du cinéma au xxe siècle,* ed. Laurent Guido and Olivier Lugon (2010), 11.

40. In French the authors use the expression *image mouvementée*. The latter term can mean stirring, lively, or eventful, but taken literally would mean "made to move." It is, as they point out, virtually never used with respect to the cinematic moving image, but they argue it could be used to express an idea such as "an image put into motion."—Trans. Find out more.

41. See Maria Tortajada, "Le statut du photogramme et l'instant prégnant au moment de l'émergence du cinéma," in *In the Very Beginning, at the Very End*, ed. Francesco Casetti, Jane Gaines, and Valentina Re (2012), 23–32. See also Maria Tortajada, "Photographie/cinéma: Paradigmes complémentaires du début du xxe siècle," in *Fixe/animé*, ed. Guido and Lugon (2010), 47–61.

42. Caroline Chik, *L'Image paradoxale: Fixité et mouvement* (2011).

43. "Dispositif" in a sense close to that with which it is used by François Albera and Maria Tortajada, translated here as "dispositive": "The technical dimension, approached through the question of the dispositive, brings together a) the spectator, the environment, the user; b) the machine, the device or devices; c) the institution or institutions." (Translation modified slightly—Trans.) François Albera and Maria Tortajada, (eds., *Cine-Dispositives: Essays in Epistemology Across Media* (forthcoming).

44. Philippe Marion, "Narratologie médiatique et médiagénie des récits," *Recherches en communication* 7 (1997): 82. Find out more.

45. Ibid., 83.

46. With respect to radio, we should introduce a nuance here arising from the joint evolution of its uses and technologies. As Simon Thibodeau of the Université de Montréal has pointed out to us, with an iPhone application (TuneIn Radio) one can interrupt radio's flow by hitting pause and going back ten seconds if one has missed a passage, to record an excerpt, etc. In this way, the radically homochrone nature of radio can be

mitigated. In addition, as Marnie Mariscalchi of the Université de Montréal has pointed out to us, radio has ceased to be broadcast only live and can be played back in the form of podcasts, autonomous capsules that can be listened to on demand, downloaded, and stored (for example, the BBC World News hourly news bulletins).

47. Aumont, *Que reste-t-il du cinéma?*, 75.

48. Ibid., 82–83.

49. We use the word *epiphany* in its sense derived etymologically from the Greek verb *phaino*: "to appear, seem, be seen." One could also speak here of *cinephany*, borrowing the fine neologism coined by Marc Joly-Corcoran, based on Mircea Eliade's model "hierophany," meaning "emergence of the sacred." See Marc Joly-Corcoran, "La cinéphanie et sa réappropriation: L'affect originel' et sa réactualisation par le fan, un spectateur néoreligieux," (PhD diss., Université de Montréal, 2013). Find out more.

50. Magali Boudissa, "La bande dessinée entre la page et l'écran: Étude critique des enjeux théoriques liés au renouvellement du langage bédéique sous influence numérique" (PhD diss., Université Paris 8 Vincennes-Saint-Denis, 2010), 58. Find out more.

51. On the notion of screen amnesia, see Raphaël Lellouche, "Théorie de l'écran," *Traverses* 2, (April 1997). Find out more.

52. Boudissa, "La bande dessinée," 63.

53. Ibid., 94.

54. Guido and Lugon, "Introduction," *Fixe/animé*, 12–13.

55. Guido and Lugon, "Introduction" *Fixe/animé*, 22. Gunning's article is entitled "L'instant 'arrêté': Entre fixité et mouvement," 37–46.

56. Guido and Lugon, ibid.

57. On this topic, see the video *Last Call by 13th Street the First Interactive Theatrical*. Available on YouTube. Find out more.

58. Olivier Asselin, "The Thrill of the Real: On the Use of Metalepsis in Mixed-Reality Film and Games," paper presented at the Magis Gorizia Spring School, Gorizia, Italy, March 2013. Quoted with permission of the author. Forthcoming in *Post-photographie, Post-cinéma*, ed. Philippe Dubois and Beatriz Furtado.

4. From Shooting to Filming: The *Aufhebung* Effect

1. Oxymoronic in the sense that the second term appears to contradict the first: before the arrival of *home theater*, cinema was normally consumed in a public theater, not in a private home.

2. Oxymoronic here too, in the sense that the second term, "agora," appears to contradict the first, "tele": before "not-film" entertainment was

introduced to movie theaters, a filmed opera or ballet was normally consumed in private, *at home*, on television, and not in a public theater. It is not easy to determine with absolute certainty whether these two expressions fulfill every criterion to be an oxymoron, in particular because definitions of the oxymoron vary considerably from one author to the next. In any event we can say that they have an "oxymoronic quality." Find out more.

3. Christophe Huss, "Metropolitan Opera—Votre cinéma n'est pas un cinéma," *Le Devoir*, December 17, 2007. Find out more.

4. See the promotional poster for the ballet *Cinderella* online. Find out more.

5. On October 18, 2010, on France 2. Online. Find out more.

6. Étienne Souriau, "Preface," in *L'Univers filmique,* ed. Étienne Souriau (1953), 8–9.

7. Text found on the invitation to the first public screenings organized by the Lumière brothers in December 1895 in the Salon indien of the Grand Café in Paris. Reproduced in Maurice Bessy and Lo Duca, *Louis Lumière inventeur* (1948), 107.

8. Our emphasis. This text is the principal element of program notes for the Robert-Houdin theater, today available at France's Bibliothèque nationale (*Théâtre Robert-Houdin: Grandes Matinées de Prestidigitation,* program, n.d., Bibliothèque nationale de France, Arts du spectacle department, 8-RO-17411), which can be dated to 1907, according to Jacques Malthête (personal e-mail to André Gaudreault on July 19, 2012). Find out more.

9. Erwin Panofsky, *Three Essays on Style*, ed. Irving Lavin (1995), 93. Our emphasis.

10. See in particular Roger Odin, "Le film documentaire, lecture documentarisante," in *Cinéma et réalités,* ed. Jean-Charles Lyant and Roger Odin (1984), 263–78.

11. In the text from which we quote, Odin explains that one of the specificities of the documentizing reading "is that the reader constructs the image of the Enunciator and presupposes the reality of this Enunciator" (p. 267). The documentizing mode of reading found in our archiving reading is minimally distinct because of two of its aims: collecting and preserving documents, as preserving something with a view to later consultation is a common feature of any definition of the word *archive*. Find out more.

12. Live on November 7, 2009, and prerecorded on December 5, 2009.

13. This opera is the first we have been able to document to date. Since 2009, the tradition has continued and the Met continues to produce cast sheets that completely overlook the question of who made the video of the performance that viewers are getting ready to watch. There is no mention,

therefore, of the name of the "author" of the putting into images and of the broadcast/transmission operation itself. Find out more.

14. Christophe Huss, "Le Metropolitan Opera au cinéma: Pour les yeux d'Elina," *Le Devoir*, January 18, 2010. Find out more.

15. Huss, "Votre cinéma n'est pas un cinéma."

16. Ibid.

17. Christophe Huss, "Metropolitan Opera: La *Damnation* de Lepage: Un échec affligeant," *Le Devoir*, November 24, 2008. Find out more.

18. Ibid.

19. Riciotto Canudo, "Triomphe du cinématographe," in *L'Usine aux images*, ed. Jean-Paul Morel (1995 [1908]), 23–31. Emphasis in the original.

20. See André Gaudreault and Philippe Marion, "The Mysterious Affair of Styles in the Age of Kine-Attractography," trans. Timothy Barnard, *Early Popular Visual Culture* 8, no. 1 (February 2010): 17–30.

21. This film may be consulted online. Find out more.

22. In the present discussion, the German word *Aufhebung* is understood in the sense of surpassing. It is important to specify this, in light of the fact that this concept in Hegel's philosophical system is not always easy to grasp because it means both one thing and, in a sense, its opposite. Find out more.

23. André Malraux, *Esquisse d'une psychologie du cinéma* (2003), 42. An initial version of this text was published in *Verve* 8 (1940) and a final version in 1946. Our emphasis. (A published English translation exists but is deficient—Trans.)

24. For a discussion of the allo- and autographical, see André Gaudreault, "Cinema, an Art More *Photo*graphic than *Auto*graphic," trans. Timothy Barnard, *Cinéma & Cie–International Film Studies Journal* 12, no. 18 (Spring 2012): 83–89.

25. Souriau, *L'Univers filmique*, 7.

26. Ibid.

27. Paul Ricoeur, *Time and Narrative*, vol. 1, trans. Kathleen McLaughlin and Daniel Pellauer (1984 [1983]).

28. Naturally, absolute respect for extramedial reality is impossible, because every capturing by shooting is of course the result, even if only minimally, of an *interpretation* of the world, even when this shooting makes a display of a near zero degree, as does a simple putting on record.

29. Marie-Ann Chabin goes even further than we do, judging by the title of her book: *Je pense donc j'archive* (I think, therefore I archive) (2000).

30. Christophe Huss, "Musique classique: *Salomé* ouvre la saison du Met dans les cinémas," *Le Devoir*, October 11–12, 2008. Our emphasis.

31. Alain Carou, *Le cinéma français et les écrivains: Histoire d'une rencontre (1906–1914)* (2002).

32. Ibid., 244.

33. The response of Dumas' heirs was just as significant, but this time in the opposite sense, that of taking into account cinema's singularity as a new adaptive medium: "Unlike illustration, the cinematic projection of a dramatic work gives rise to the depiction of an animated scene" (ibid., 245). Find out more.

34. The term *cinematographiation* is derived from the neologism *graphiation* introduced by Philippe Marion in his study of the graphic singularity of the graphic novel. The term places the graphic monstration of the graphic novel under the pragmatic sign of an always-already signed graphic *énonciation*: graphiation. See Philippe Marion, *Traces en cases: Travail graphique, figuration narrative et participation du lecteur* (1993), 31. Find out more.

35. Gaudreault and Marion, "The Mysterious Affair of Styles."

36. André Bazin, "Le cinéma est-il mortel?," *L'Observateur politique, économique et littéraire* 170 (August 13, 1953): 24. Reprinted in *Trafic* 50 (Summer 2004): 246–60.

37. In the case of *Cinderella*, this is seen in the excerpts from the passage rebroadcast on French television, presented on the site quoted in note 5. Find out more.

38. Christophe Huss, "Le Metropolitan Opera au cinéma–Un Rossini enlevant," *Le Devoir*, April 11, 2011. Find out more.

5. A Medium Is Always Born Twice . . .

1. André Gaudreault and Philippe Marion, "A Medium is Always Born Twice," trans. Timothy Barnard, *Early Popular Visual Culture* 3, no. 1 (2005): 3–15. See also by the same authors "Cinéma et généalogie des médias," *Médiamorphoses* 16 (April 2006): 24–30.

2. Jacques Aumont, *Que reste-t-il du cinéma?* (2012), 39–40. Emphasis in the original.

3. Here we develop certain ideas proposed by André Gaudreault in *Film and Attraction: From Kinematography to Cinema*, trans. Timothy Barnard (2011 [2008]).

4. A concept initially developed by André Gaudreault in his volume *From Plato to Lumière: Narration and Monstration in Literature and Cinema*, trans. Timothy Barnard (2009 [1988]) and that also involves an "extrinsic narrativity" we will address below.

5. See André Gaudreault and Philippe Marion, "Pour une nouvelle approche de la périodisation en histoire du cinéma," *Cinémas* 17, nos. 2–3 (Spring 2007): 215–32.

6. "In the documentary the basic material has been created by God, whereas in the fiction film the director is the god." François Truffaut, *Hitchcock* (1967), 70. Find out more.

7. It is quite apparent that any capturing through filming shows an *interpretation* of the world, as we remarked above.

8. Roger Odin, *De la fiction* (2000), 162.

9. Laurent Jullier, *L'Écran post-moderne: Un cinéma de l'allusion et du feu d'artifice* (1997), 37. Quoted in Odin, *De la fiction*, 162.

10. Quoted by Odin, *De la fiction*, 108.

11. On this topic see, for example, Paul Ricoeur, *Oneself as Another*, trans. Kathleen Blamey (1992 [1990]).

12. Some members of OULIPO would speak here of "plagiarism by anticipation" (we would never think such a thing of course!). François Le Lionnais, for example: "Occasionally, we discover that a structure we believed to be entirely new had in fact already been discovered or invented in the past, sometimes even in a distant past. We make it a point of honor to recognize such a state of things in qualifying the text in question as '*plagiarism by anticipation.*' Thus justice is done, and each is rewarded according to his merit." Our emphasis. François Le Lionnais, "Second Manifesto," in *Oulipo: A Primer of Potential Literature*, ed. and trans. Warren F. Motte Jr. (Lincoln: University of Nebraska Press, 1986), 31.

13. Alexandre Arnoux, "J'ai vu, enfin, à Londres un film parlant," *Pour Vous* 1 (22 November 1928): 3.

14. Jean-Pierre Chartier, "Art et réalité au cinéma. I.–Le cinéma inventé deux fois . . . ," *Bulletin de l'IDHEC* 1 (May 1946): 4. The authors thank Laurent Le Forestier for having brought this article to their attention.

15. Ibid.

16. Ibid.

17. Ibid.

18. André Bazin, "Le cinéma est-il mortel?," *L'Observateur politique, économique et littéraire* 170 (13 August 1953): 24. We quoted the second sentence in the previous chapter. Our emphasis on the expression "second birth."

19. Pierre Leprohon, *Histoire du cinéma*, vol. 1, *Vie et mort du Cinématographe (1895–1930)* (1961).

20. Edgar Morin, *The Cinema, or the Imaginary Man*, trans. Lorraine Mortimer (2005 [1956]).

21. Just before the authors submitted the manuscript for this volume to its initial French publisher, Frank Kessler informed us that he had found the following in Christian Metz's notes for his seminar on Rudolf Arnheim in 1982 concerning the distinction to be made between cinema as reproduction technology and cinema as a means of artistic expression: "Étienne Souriau at the Filmology congress in 1955: there was a *double birth of cinema*; a technological invention does not found an art but requires the art to be reinvented." Personal e-mail to André Gaudreault, June 14, 2013. Our emphasis. Find out more.

22. François Jost, *Comprendre la télévision et ses programmes* (2009 [2005]). Find out more.

23. Doron Galili, "Seeing by Electricity: The Emergence of Television and the Modern Mediascape 1878–1939," (PhD diss., University of Chicago, 2011).

24. Christophe Gauthier, "Le devenir média du Web et le webfilm," in *Cinéma et audiovisuel se réfléchissent: Réflexivité, migrations, intermédialité,* ed. François Amy de la Bretèque et al. (2012), 229–39.

25. James Lastra, "What Cinema Is (for the Moment . . .)," paper presented at the conference "Impact of Technological Innovations on the Theory and Historiography of Cinema," Cinémathèque québécoise, Montreal, November 2011. Unpublished, quoted with the author's permission. Forthcoming in *Du Média au postmédia: Continuités, ruptures* [From media to post-media: Continuities and ruptures], ed. Nicolas Dulac and André Gaudreault (Lausanne: L'Âge d'Homme).

26. Gyula Maksa, "Mediativitás, médiumidentitás, 'képregény'" [Media identity, mediativity and the graphic novel]. PhD diss., University of Debrecen, 2008. Find out more.

27. This blog can be consulted online. Find out more.

28. This enables him to take up, on the same site, the debate around the always problematic use of the term *revolution.* Find out more.

29. Lastra, "What Cinema Is."

30. We might also legitimately ask ourselves, as Grégoire Gaudreault of the Université de Montréal suggests, whether that almost instantaneous photographic device, the Polaroid camera, could not be seen as an ancestor of what today is called the smart phone, given that taking photographs is undoubtedly one of the device's most popular functions.

31. A multifunction gadget with ever-increasing applications. Find out more.

32. Galili, "Seeing by Electricity," 143.

33. See in particular André Leroi-Gourhan, *Le geste et la parole,* vol. 1, *Technique et langage* (1964). See also Jean Lohisse, *Les systèmes de communication: Approche socio-anthropologique* (1998).

34. Charles Acland, "Introduction: Residual Media," in *Residual Media,* ed. Charles Acland (2007), xii–xxviii.

35. In our paper presented at the conference "The Second Birth of Cinema: A Centenary Conference" (Newcastle University, Newcastle, Great Britain, July 2011) entitled "Le modèle de la 'double naissance' à l'aune du numérique. Ou: Tout ce que vous voulez savoir sur 'tout ce qui est advenu aux images depuis l'arrivée de l'ordinateur et du téléphone' [Dubois et alii.] et que vous n'avez jamais osé demander . . ." See André Gaudreault and Philippe Marion, "Measuring the 'Double Birth' Model against the Digital Age," *Early Popular Visual Culture* 11, no. 2 (2013): 158–77.

36. Lastra, "What Cinema Is."

37. Ibid.

38. Ibid. The example of the cell phone, which we discussed above, appears illuminating on the level of repeated changes to a medium's identity. If one wishes to preserve at all cost the telephone's specific identity (a telephone is, first and foremost, a . . . telephone!), one runs the risk of neglecting the new identity it has acquired in the course of its transformation into a data terminal and of depriving oneself of its texting and Internet functions in particular.

39. In its genealogy and in its history, one should perhaps say, but this is pointless in the sense that, for us, a medium's genealogy is in a state of constant transformation. This is why its identity as a medium is never definitively fixed.

40. See André Gaudreault and Philippe Marion, *The Kinematic Turn: Film in the Digital Era and Its Ten Problems*, trans. Timothy Barnard (2012).

41. Note that the same university offers a master's program, established in the 1990s (one had to come before the other), with the more prosaic name "Master of Arts in Film Studies." The two programs, which coexist within the same department, draw on the same team of professors and pursue the same teaching and research goals; only their level of study is different.

42. This is the case of the famous School of Cinema-Television at USC (University of Southern California), now rebaptized the "USC School of Cinematic Arts." Find out more.

6. New Variants of the Moving Image

1. In order not to be lapidary and engage in approximation, we would need to undertake lengthy historical research (into movie theaters between 1910 and 1950), something that was impossible to carry out for the present volume.

2. Laurent Gervereau, *Histoire du visuel au xxe siècle* (2003), 34–35. Our emphasis.

3. The authors thank Marnie Mariscalchi of the Université de Montréal for bringing cloud computing, becoming more and more popular, to their attention. It will undoubtedly serve as an excellent storage "medium" for making accessible to users films once DVDs, perhaps, have disappeared from the surface of the Earth.

4. Francesco Casetti, "Back to the Motherland: The Film Theatre in the Postmedia Age," *Screen* 52, no. 1 (Spring 2011): 6.

5. Ibid.

6. As for the "purchase" of a "copy" of a film on the Internet, this purchase as we know remains in the realm of the virtual. Or one streams the film, in which case one can only audio-view it while online, and once the viewing is over nothing remains of the film, even if it remains for a while on our computer. Or one purchases a file directly, which becomes our property, except that legally we do not have the right to transfer it to another computer or bequeath it to our heirs. Find out more.

7. Thomas Elsaesser, "La notion de genre et le film comme produit 'semi-fini': L'exemple de *Weihnachtsglocken* de Franz Hofer (1914)," *1895* 50 (2006). Find out more.

8. In the end manufacturers agreed that it was in their interests to break this system of the direct sales of films to exhibitioners, because doing so made them lose all control over the fate of the product they had made. Find out more.

9. John Collier, "Cheap Amusements," published initially on April 11, 1908, in *Charities and Commons* and reproduced in Richard Abel, *The Red Rooster Scare: Making Cinema American, 1900–1910* (Berkeley: University of California Press, 1999), 75–76.

10. To adopt the English-language term "picture palace" (which was also found in French, as in the case of the popular Gaumont Palace in Paris), in current use from the 1910s to the 1950s.

11. This, at least, is the view of John Eberson, an American movie theater architect working between 1915 and 1950: "Here we find ourselves today . . . building super-cinemas of enormous capacities, excelling in splendor, in luxury and in furnishings the most palatial homes of princes and crowned kings for and on behalf of His Excellency—the American Citizen." Quoted by Karal Ann Marling, "Fantasies in Dark Places: The Cultural Geography of the American Movie Palace," in *Textures of Place: Exploring Humanist Geographies,* ed. Paul C. Adams, Steven Hoelscher, and Karen E. Till (2001), 10.

12. The Pathé Kok (1912) and Pathé-Baby (1922) were two home movie systems, for the well-off of course. The former used 28-mm film and the latter 9.5-mm film.

13. The authors thank Kim Décarie of GRAFICS at the Université de Montréal for bringing this model of home theater avant la lettre to their attention. Find out more.

14. Édouard Arnoldy, *À perte de vues: Images et "nouvelles technologies,"* *d'hier et d'aujourd'hui* (2005), 31.

15. Bruno Icher, "Le cinéma, produit d'appel des nouvelles technologies," *Libération,* May 16, 2007. Find out more.

16. The first part of this sentence dates from a few years ago (for a presentation at a conference), when people were already carrying out such an activity less and less. Today, people only rarely rent a DVD, given

all the other choices available. The media galaxy is in a period of transition, when one new practice quickly replaces another, which is often not that old.

17. Taken from a promotional document produced by Air France. Our emphasis. Find out more.

18. Albert Camus, "*On a Philosophy of Expression* by Brice Parain" (1944), in *Lyrical and Critical Essays*, ed. Philip Thody and trans. Ellen Conroy Kennedy (1969), 231.

19. Christophe Huss, "Metropolitan Opera—Votre cinéma n'est pas un cinéma . . . ," *Le Devoir*, December 17, 2007.

20. For a definition of the concept cultural paradigm, see André Gaudreault, *Film and Attraction: From Kinematography to Cinema*, trans. Timothy Barnard (2011), 64ff.

21. "Individual receivers were quite rare at first and they had a very small screen. As a result reception of their programming was public: one lined up in order to file past the tiny screen of a receiver placed in a public venue. Television then became a form of entertainment that brought audiences together in the same place." François Jost, *Comprendre la télévision et ses programmes* (2009 [2005]), 25. Find out more.

22. Promotional e-mail dated November 10, 2011, bearing the title "Cineplex: De Retour avec sa Programmation pour le Temps des Fêtes/ Back with a Special Holiday Season Programming." Our emphasis on the expression *cinema events*, which is a translation from the French version of the e-mail. The English version of the same press release does not refer to this concept, although it appears often in the company's other English press releases (as "cinematic event" or "cinema event"). Find out more.

23. Emphasis in the original.

24. One can consult the company's site, which is of course constantly changing. Find out more.

25. The trailer for this production can be viewed on YouTube. Find out more.

26. "CielEcran change de nom et devient Pathé Live," hdnumerique. com, May 25, 2011. Find out more.

27. These three videos are on YouTube. Find out more.

28. All reference to the "Musée de l'image en mouvement" has now disappeared from the website of the Cinémathèque québécoise. Here is what could have been found there earlier: "Devoted to the past and headed for the future, the Cinémathèque québécoise is Montreal's museum of the moving image." Find out more.

29. Pierre Jutras, at the time program director and curator of international cinema, television and new media, in a personal e-mail to André Gaudreault on May 27, 2010. Find out more.

30. Yolande Racine, at the time executive director of the Cinémathèque québécoise, in a personal e-mail addressed to André Gaudreault on October 15, 2010. Find out more.

31. "The Cinémathèque québécoise and the Daniel Langlois Foundation arrange to ensure the conservation and accessibility of the Foundation's collection," Montreal, Cinémathèque québécoise, October 11, 2011. Our emphasis. Find out more.

32. See the website of the Society for Cinema and Media Studies. Our emphasis. Find out more.

33. For more information on this topic, see the additional material online. Find out more.

34. François Valleiry, "La nouvelle pellicule," *Phono-Ciné-Gazette* 46 (February 15, 1907), 70.

35. See the first epigraph to Chapter 3 of the present volume.

36. William Uricchio, in a personal e-mail to André Gaudreault, August 4, 2012. Find out more.

37. Olivier Séguret, "Le mot de la fin," *Libération*, July 11, 2007. Find out more.

38. Arnoldy, *À perte de vues*, 90.

7. "Animage" and the New Visual Culture

1. Jacques Aumont, *Que reste-t-il du cinéma?* (2012), 84. Emphasis in the original.

2. See in particular André Gaudreault and Philippe Marion, "Cinéma et généalogie des médias," *Médiamorphoses* 16 (April 2006): 24–30.

3. Christian Metz, *Language and Cinema*, trans. Donna Jean Umiker-Sebeok (1974 [1971]), 26.

4. Francesco Casetti, "Theory, Post-theory, Neo-theories: Changes in Discourses, Changes in Objects," *Cinémas* 17, nos. 2–3 (Fall 2007): 37. Our emphasis.

5. Ibid.

6. Ibid., 36.

7. André Gaudreault and Philippe Marion, "En guise d'ouverture sur la problématique cinéma/bande dessinée," in *Cinema e fumetto*/Cinema and comics, ed. Leonardo Quaresima, Laura Ester Stangalli, and Federico Zecca (2009), 23–29. See also Philippe Marion, "Emprise graphique et jeu de l'oie: Fragments d'une poétique de la bande dessinée," in *La bande dessinée: une médiaculture*, ed. Éric Maigret and Matteo Stefanelli (2012), 175–99.

8. Described initially by André Gaudreault and Philippe Gauthier in their presentation at the 2010 DOMITOR conference in Toronto. See André Gaudreault and Philippe Gauthier, "Les séries culturelles de la

conférence-avec-projection et de la projection-avec-boniment: Continuités et ruptures," in *Beyond the Screen: Institutions, Networks and Publics of Early Cinema*, ed. Marta Braun et al. (2012), 233–38.

9. Roger Child Bayley, *Modern Magic Lanterns: A Guide to the Management of the Optical Lantern for the Use of Entertainers, Lecturers, Photographers, Teachers and Others*, 2nd ed. (1900), 102. Our emphasis.

10. This question of series-centrism is readily apparent and tangible in the relations between the kinematograph and early twentieth-century trade journals. See in particular André Gaudreault, "The Culture Broth and the Froth of Cultures of So-called Early Cinema," in *A Companion to Early Cinema*, ed. Nicolas Dulac, André Gaudreault, and Santiago Hidalgo (2012), 18–20. Find out more.

11. Giusy Pisano, "The Théâtrophone, an Anachronistic Hybrid Experiment or One of the First Immobile Traveler Devices?" in *A Companion to Early Cinema*, ed. Nicolas Dulac, André Gaudreault, and Santiago Hidalgo (2012), 82.

12. Mireille Berton and Anne-Katrin Weber, ed., *La télévision du Téléphonoscope à YouTube* (2009), back cover.

13. Lev Manovich, *The Language of New Media* (2001), 255. Find out more.

14. Ibid., 259.

15. Alan Cholodenko, "*Who Framed Roger Rabbit*, or The Framing of Animation," in *The Illusion of Life: Essays on Animation,* ed. Alan Cholodenko (1991), 213. Emphasis in the original.

16. André Gaudreault, in a paper presented at the Society for Cinema and Media Studies conference in Los Angeles in March 2010, argued that only since cinema's institutionalization has animation been seen as an independent or relatively independent province of the medium. Find out more.

17. Dominique Willoughby, *Le cinéma graphique: Une histoire des dessins animés des jouets d'optique au cinéma numérique* (2009), back cover. Our emphasis.

18. Ibid.

19. This "graphic *anima*" would itself benefit from being examined in conjunction with what we call "cinematographiation" in Chapter 4.

20. Willoughby, *Le cinéma graphique*, 269.

21. Thomas Elsaesser, "Between Knowing and Believing: The Cinematic Dispositif after Cinema," in *Cine-Dispositives: Essays in Epistemology Across Media,* ed. François Albera and Maria Tortajada (forthcoming).

22. A concept initially proposed by André Gaudreault in his presentation as part of the "Technique et idéologie: 40 ans plus tard" panel discussion at the conference "The Impact of Technological Innovations on the Theory and Historiography of Cinema," Cinémathèque québécoise, Montreal, November 2011. Unpublished.

23. Jean-Baptiste Massuet, "L'Impact de la *performance capture* sur les théories du cinéma d'animation," *Écranosphère* 1 (Winter 2014), online. Find out more.

24. Quotation taken from the site Neuvieme-art.com. *Bande dessinée, manga, comics.* Find out more.

25. Massuet, "L'Impact de la *performance capture.*"

26. Willoughby, *Le cinéma graphique*, 197.

27. A concept introduced by Philippe Marion in "Tintin façon Spielberg: Une nouvelle manière de penser le cinéma?" presented at the conference "The Impact of Technological Innovations on the Theory and Historiography of Cinema," Cinémathèque québécoise, Montreal, November 2011. Forthcoming in Nicolas Dulac and André Gaudreault, ed., *Du Média au postmédia: Continuités, ruptures* [From media to post-media: Continuities and ruptures].

28. Peter Jackson, quoted by Alain Lorfèvre in "Spielberg et Jackson pour Tintin," *La Libre Belgique*, May 16, 2007. Find out more.

29. Benoît Peeters, "Retrouver la ligne claire," *Cahiers du cinéma* 672 (November 2011): 46.

30. For a more complete definition of mediagenie, see Philippe Marion, "Narratologie médiatique et médiagénie des récits," *Recherches en communication* 7 (1997): 61–88. Find out more.

31. Marion, "Emprise graphique et jeu de l'oie," 180.

32. We should recall that the agent of graphiation, which we discussed in Chapter 4 in the case of "cinematographiation," is the particular enunciative agent that deploys the graphic material that makes up the monstration of the graphic novel and reflexively imparts to it the imprint of its singular creativity, the mark of its own style. See Philippe Marion, *Traces en cases: Travail graphique, figuration narrative et participation du lecteur* (1993), 30ff.

33. The *graphiator* is the agent responsible for the graphiation. See also Marion, *Traces en cases.*

34. A term used by Pierre Fresnault-Deruelle to underscore the legibility of the clear line, which conveys "only what tells (or is the most telling)." Pierre Fresnault-Deruelle, *Hergéologie: Cohérence et cohésion du récit en image dans les aventures de Tintin* (2011), 16.

35. Spielberg's presentation of the film to journalists in Paris, July 20, 2011. Broadcast on the second French-language Belgian television network, RTBF.

36. On this topic, we refer the reader to André Gaudreault and Philippe Marion, "Transécriture et médiatique narrative: L'Enjeu de l'intermédialité," in *La transécriture: Pour une théorie de l'adaptation,* ed. André Gaudreault and Thierry Groensteen (1998), 31–52.

37. Steven Spielberg, quoted by Alain Lorfèvre, "Spielberg et Jackson pour Tintin." Find out more.

38. Alain Boillat, "Prolégomènes à une réflexion sur les formes et les enjeux d'un dialogue intermédial: Essai sur quelques rencontres entre la bande dessinée et le cinéma," in *Les cases à l'écran: Bande dessinée et cinéma en dialogue*, ed. Alain Boillat (2010), 29.

39. Peter Jackson, quoted by Alain Lorfèvre, "Spielberg et Jackson pour Tintin."

40. Preface by Peter Jackson to Chris Guise, *Artbook: Les Aventures de Tintin* (Wellington: Éditions Weta/Moulinsart, 2011), 14.

41. As was the case in 1964 with the film *Tintin et les oranges bleues*, directed by Philippe Condroyer with Jean-Pierre Talbot in the role of Tintin.

42. Steven Spielberg, quoted by Alain Lorfèvre, "Spielberg et Jackson pour Tintin."

43. Ibid.

44. Peeters, "Retrouver la ligne claire," 46–47.

45. Ibid., 47.

46. Gad Elmaleh's comments were relayed in an interview with Jamie Bell by Philippe Manche in the daily newspaper *Le Soir* ("Jamie Bell: 'Tintin est très complexe,'" *Le Soir*, October 26, 2011). Find out more.

47. An expression used by Peter Jackson himself. See his preface in Guise, *Artbook: Les Aventures de Tintin*, 14.

48. Ibid.

49. Michel Chion, "Un autre corps que le sien," *Positif* 617–18 (July–August 2012): 69.

50. Ibid.

51. Ibid., 70.

52. Ibid., 69. Find out more.

Conclusion

1. From an Agence France-Presse news release entitled "Adapter 'L'Écume des jours,' le dernier défi de Michel Gondry," dated April 20, 2013. Find out more.

2. Léo Pajon, "Pour ou contre 'L'Écume des jours,' de Michel Gondry?" *Francetv info*, 24 April 2013. Find out more.

3. Ted Hardy-Carnac, "'L'Écume des jours' de Gondry: Une romance écrasée sous un déluge d'effets visuels," *Le Nouvel Observateur*, April 29, 2013. Find out more.

4. Charles Acland, "Introduction: Residual Media," in *Residual Media*, ed. Charles Acland (2007), xii–xxviii.

5. Hardy-Carnac, "'L'Écume des jours' de Gondry."

6. Pierre Musso, "La 'révolution numérique': Techniques et mythologies," author's manuscript available online at the site of the Institut

Mines-Télécom, 2010, 24 (published in *La Pensée* 355 [2008]: 103–20). The concept "new New Worlds," coined by Georges Balandier, is sometimes written with capital letters, quotation marks, or no special mark.

7. Gibert Simondon, quoted by François Albera and Maria Tortajada: "In this genesis, one finds imagination, the project, conception: Simondon calls this ensemble an 'imaging genesis' and sees a virtual dimension in it." François Albera and Maria Tortajada, "The Dispositive Does Not *Exist*!," in *Cine-Dispositives: Essays in Epistemology Across Media,* ed. François Albera and Maria Tortajada (forthcoming). Find out more.

8. François Jost, "Twitter, un univers faussement égalitaire," *Le Monde,* June 21, 2012. Find out more.

9. Ibid.

10. Raymond Bellour, *La Querelle des dispositifs: Cinéma—installations, expositions* (Paris: P.O.L, 2012), 19.

11. Gilles Lipovetsky and Jean Serroy, *L'Écran global: Culture-médias et cinéma à l'âge hypermoderne* (2007), 10.

12. Online publicity by Cineplex to promote the UltraAVX audiovisual experience, translated from the French. Our emphasis on the word *generation*. Find out more.

13. The authors thank Frank Kessler and Laurent Le Forestier, with whom they have had many fruitful exchanges on the question of the difference between *cultural practice* and *cultural series*.

14. André Bazin, "Le mythe du cinéma total et les origines du cinématographe," *Critique* 6 (1946): 555. A very similar passage can be found in the later version of Bazin's text and thus in the English translation: André Bazin, *What is Cinema?*, vol. 1, trans. Hugh Gray (1967), 20.

15. W. J. T. Mitchell, *Cloning Terror: The War of Images, 9/11 to the Present* (2011).

16. Bazin, *What is Cinema?*, 17.

17. Ibid., 21.

18. Ibid., 20. Our emphasis.

19. Bazin, "Le mythe du cinéma total," (1946 version), 555.

20. Bazin, *What Is Cinema?*, 21.

21. Bazin, "Le mythe du cinéma total," (1946 version), 556.

22. Bazin, *What Is Cinema?*, 22.

23. Laurent Le Forestier, personal e-mail to André Gaudreault, May 11, 2013. Find out more.

24. Ibid.

25. André Bazin, "Le mythe du cinéma total," (1946 version), 557.

26. In the original version of his text (p. 557), Bazin writes: "From a machine to capture life as it unfolds it became, with Georges Méliès, an instrument for producing miracles, meaning to insert the impossible into reality."

27. Jacques Aumont, *Que reste-t-il du cinéma?* (2012), 59–60.

Acknowledgments

This book was written in a number of cities and towns (Brussels, Fréhel [thanks to Jocelyne at L'Air de Vent], Gorizia, L'Estérel, Lille, Louvain-la-Neuve, Montreal, Paris, Udine [thanks to Leonardo at the University of Udine and to Isabelle at the Ambassador], Santiago de Compostela, and several others). It is nevertheless rooted in our respective laboratories (at the Université de Montréal and the Université catholique de Louvain), and in particular in GRAFICS in Montréal, where a team of collaborators backed up the two authors throughout the writing and translation process with documentation and editorial assistance. We are extremely grateful to them. Their many tireless efforts contributed to the underlying research taking shape in book form. This research began with an empirical study (using a number of contemporary periodicals) and by observing on a daily basis cinema's "digitalization" and its effects on the transformation of planet cinema. The two authors sincerely thank Stéphane Tralongo, Carolina Lucchesi Lavoie, and Marnie Mariscalchi for their excellent documentation work. Thanks also to Timothy Barnard, Nicolas Dulac, and Gabrielle Tremblay-Baillargeon for their assistance in establishing the bibliography of this English edition. We also thank Joël Lehmann for his steadfast technical support.

We must make special mention of three GRAFICS assistants who threw themselves into the whirlwind of preparing the definitive version of this work, assisting us with revision, finding images and obtaining permission to reproduce them, putting together the manuscript, suggesting subtitles,

and especially, providing editorial advice. Without their contribution and hard work this volume would not have appeared on time or in its present form. We refer here to Simon Thibodeau (who took on the role of publication coordinator and established the index), Marnie Mariscalchi (assistant coordinator), and Sophie Rabouh (coordination assistance). They were remarkable in every respect, and we wish to express to them our deepest thanks.

Thanks also to our two revisers and copy editors, Anne Bienjonetti and Andrée A. Michaud, who became personally involved in turn in this writing project by demonstrating a concern for precision and a professional conscientiousness that reflects great credit on them.

Special thanks go to Michel Marie, who believed in this project from the beginning, to Laurent Le Forestier (Université Rennes 2) for his involvement and advice, and to Kim Décarie, who brilliantly coordinates the wonderful team of GRAFICS assistants. We also thank Jennifer Crewe, president and director of Columbia University Press, for providing us with the opportunity to publish an English edition of our book.

Thanks to all those who granted us permission to reproduce an excerpt from their e-mail correspondence with one of the authors.

Thanks finally to Anne Goliot-Lété (Université Paris 7) and Margrit Tröhler (Universität Zürich) for their providential assistance, which was indispensable in the final stages of this journey.

Selected Bibliography

"Abécédaire." *Les cahiers de médiologie* 6 (1998): 263–83.

Abel, Richard. "Booming the Film Business." In *Silent Film*, edited by Richard Abel, 109–24. New Brunswick: Rutgers University Press, 1996.

Acland, Charles. "Introduction: Residual Media." In *Residual Media*, edited by Charles Acland, xiii–xxvii. Minneapolis: University of Minnesota Press, 2007.

Albera, François, and Maria Tortajada. "The Dispositive Does Not *Exist*!" In *Cine-Dispositives: Essays in Epistemology Across Media*, edited by François Albera and Maria Tortajada. Amsterdam: Amsterdam University Press, forthcoming.

Altman, Rick. *Silent Film Sound.* New York: Columbia University Press, 2004.

Amy de la Bretèque, François. "*Cinergon* no. 15: 'Où va le cinéma?'" *Cahiers de la cinémathèque* 76 (2004): 122–23.

Andrew, Dudley. *What Cinema Is!* Malden: Wiley-Blackwell, 2010.

Arnoldy, Édouard. *À perte de vues: Images et "nouvelles technologies," d'hier et d'aujourd'hui.* Brussels: Labor, 2005.

Arnoux, Alexandre. "J'ai vu, enfin, à Londres un film parlant." *Pour Vous* 1 (1928): 3.

Asselin, Olivier. "The Thrill of the Real: On the Use of Metalepsis in Mixed-Reality Film and Games." In *Post-photographie, Post-cinéma*, edited by Philippe Dubois and Beatriz Furtado, forthcoming.

Aumont, Jacques. *Que reste-t-il du cinéma?* Paris: Vrin, 2012.

Barjavel, René. *Cinéma total: Essai sur les formes futures du Cinéma.* Paris: Denoël, 1944.

Barthes, Roland. *Mythologies.* Translated by Annette Lavers. London: Jonathan Cape, (1957) 1972.

——. *Camera Lucida: Reflections on Photography.* Translated by Richard Howard. New York: Hill and Wang, (1980) 1981.

——. "Leaving the Movie Theater." In *The Rustle of Language,* translated by Richard Howard, 345–49. Berkeley: University of California Press, (1984) 1986.

Baudry, Jean-Louis. "Ideological Effects of the Basic Cinematographic Apparatus." In *Apparatus,* edited by Theresa Hak Kyung Cha and translated by Alan Williams, 25–37. New York: Tanam, 1980.

——. "The Apparatus." In *Apparatus,* edited by Theresa Hak Kyung Cha and translated by Jean Andrews and Bertrand Augst, 41–62. New York: Tanam, 1980.

——. *L'Effet cinéma.* Paris: Albatros, 1978.

Bayley, Roger Child. *Modern Magic Lanterns: A Guide to the Management of the Optical Lantern for the Use of Entertainers, Lecturers, Photographers, Teachers and Others,* 2nd edition. London: L. Upcott Gill/Charles Scribner's Sons, 1900.

Bazin, André. "Le mythe du cinéma total et les origines du cinématographe." *Critique* 6 (1946): 552–57.

——. "Le cinéma est-il mortel?" *L'Observateur politique, économique et littéraire* 170 (1953): 23–24. Reprinted in *Trafic* 50 (2004): 248–50.

——. "The Myth of Total Cinema." In *What Is Cinema?* Translated by Hugh Gray, 2 vols. 1:17–22. Berkeley: University of California Press, 1967.

—— et al. *La politique des auteurs: Les entretiens.* Paris: Cahiers du Cinéma, 2001.

Bégin, Richard. "Mobilogénie du désastre." *Artpress* 2, no. 29 (2013): 50–52.

Bellour, Raymond. "La querelle des dispositifs." *Artpress* 262 (2000): 48–52.

——. "La querelle des dispositifs 1." YouTube video, 18:54, filmed interview, dated November 26, 2012, posted by "jeanpaulhirsch." Posted December 13, 2012. https://www.youtube.com/watch?v=4Fauir0Od7o.

——. "Raymond Bellour, La querelle des dispositifs. Cinéma—installations, expositions 1/3." YouTube video, 25:30, video recording of a seminar at the Centre de recherches sur les arts et le langage (CEHTA/CRAL) on January 9, 2013, posted by "CRAL–Centre de Recherches sur les arts et le langage." Posted January 22, 2013. https://www.youtube.com/watch?v=eq_QCi4d3sE.

Belton, John. "Digital Cinema: A False Revolution." *October* 100 (2002): 98–114.

———. "*Introduction:* Digital Cinema." *Film History* 24, no. 2 (2012): 131–34.

Berry, Philippe. "*The Hobbit*: Le nouveau format vidéo gâche-t-il la magie du film?" 20minutes.fr, December 10, 2012. http://www.20minutes.fr /high-tech/1058213-the-hobbit-nouveau-format-video-gache-t-il-magie-film.

Berton, Mireille, and Anne-Katrin Weber, editors. *La télévision du Téléphonoscope à YouTube.* Lausanne: Éditions Antipodes, 2009.

Bessy, Maurice, and Lo Duca. *Louis Lumière inventeur.* Paris: Éditions Prisma, 1948.

Boillat, Alain. "Prolégomènes à une réflexion sur les formes et les enjeux d'un dialogue intermédial: Essai sur quelques rencontres entre la bande dessinée et le cinéma." In *Les cases à l'écran: Bande dessinée et cinéma en dialogue*, edited by Alain Boillat, 25–121. Geneva: Georg Éditeur, 2010.

Bordina, Alessandro, Philippe Dubois, and Lucia Ramos Monteiro, editors. *Oui, c'est du cinéma/*Yes, It's Cinema. Formes et espaces de l'image en mouvement/Forms and Spaces of the Moving Image. Pasian di Prato: Campanotto Editore, 2009.

Bordwell, David. *Pandora's Digital Box: Films, Files, and the Future of Movies.* Madison: The Irvington Way Institute Press, 2012.

Boudissa, Magali. "La bande dessinée entre la page et l'écran: Étude critique des enjeux théoriques liés au renouvellement du langage bédéique sous influence numérique." PhD diss., Université Paris 8 Vincennes-Saint-Denis, 2010.

Bougnoux, Daniel. *Sciences de l'information et de la communication.* Paris: Larousse, 1993.

Boussinot, Roger. *Le cinéma est mort. Vive le cinéma!* Paris: Denoël, 1967.

Camus, Albert. "On a Philosophy of Expression by Brice Parain" (1944). In *Lyrical and Critical Essays*, edited by Philip Thody and translated by Ellen Conroy Kennedy, 228–41. New York: Alfred A. Knopf, 1969.

Canudo, Riciotto. "Triomphe du cinématographe." In *L'Usine aux images*, edited by Jean-Paul Morel, 23–31. Paris: Seguier and Arte, (1908) 1995.

Carou, Alain. *Le cinéma français et les écrivains: Histoire d'une rencontre (1906–1914).* Paris: École nationale des Chartes/Association française de recherche sur l'histoire du cinéma, 2002.

Casetti, Francesco. "Theory, Post-theory, Neo-theories: Changes in Discourses, Changes in Objects." *Cinémas* 17, no. 2–3 (2007): 33–45.

———. "Back to the Motherland: The Film Theatre in the Postmedia Age." In *Screen* 52, no. 1 (2011): 1–12.

Castells, Manuel. *La galaxie Internet.* Paris: Fayard, 2002.

Catoir, Marie-Julie, and Thierry Lancien. "Multiplication des écrans et relations aux médias: de l'écran d'ordinateur à celui du Smartphone." *MEI (Médiation et information)* 34 (2012): 53–66.

de Certeau, Michel. *The Practice of Everyday Life.* Translated by Steven Rendall. Berkeley: University of California Press, (1980) 1988.

Chabin, Marie-Ann. *Je pense donc j'archive.* Paris: L'Harmattan, 2000.

Chartier, Jean-Pierre. "Art et réalité au cinéma. I.–Le cinéma inventé deux fois . . ." *Bulletin de l'IDHEC* 1 (1946): 5.

Cherchi Usai, Paolo. *The Death of Cinema: History, Cultural Memory, and the Digital Dark Age.* London: British Film Institute, 2001.

Chik, Caroline. *L'Image paradoxale: Fixité et mouvement.* Villeneuve d'Ascq: Presses universitaires du Septentrion, 2011.

Chion, Michel. "Un autre corps que le sien." *Positif* 617–18 (2012): 68–70.

Cholodenko, Alan. "*Who Framed Roger Rabbit*, or The Framing of Animation." In *The Illusion of Life: Essays on Animation*, edited by Alan Cholodenko, 209–42. Sydney: Power Publications, 1991.

"CielEcran change de nom et devient Pathé Live." hdnumerique.com, May 25, 2011. http://www.hdnumerique.com/actualite/articles/9276 -cielecran-change-de-nom-et-devient-pathe-live.html.

Collier, John. "Cheap Amusements." *Charities and Commons* (1908). Reprinted in *The Red Rooster Scare: Making Cinema American, 1900–1910*, edited by Richard Abel, 75–76. Berkeley: University of California Press, 1999.

Comolli, Jean-Louis. "Technique and Ideology." Translated by Diana Matias. *Film Reader* 2 (1977): 128–40.

———. "Technique and Ideology." Translated by Diana Matias. In *Narrative, Apparatus, Ideology: A Film Theory Reader*, edited by Philip Rosen, 421–33. New York: Columbia University Press, 1986.

Coonan, Clifford. "Greenaway Announces the Death of Cinema—and Blames the Remote-Control Zapper." *The Independent*, October 10, 2007.

Daney, Serge. "Beauté du téléphone." *Libération*, January 23, 1991. Reprinted in Serge Daney, *Devant la recrudescence des vols de sacs à mains; Cinéma, télévision, information.* Lyon: Aléas, 1992.

Deglise, Fabien. "Des nouvelles inédites en 140 caractères." *Le Devoir*, February 2, 2013.

Deleuze, Gilles, and Félix Guattari. *A Thousand Plateaus: Capitalism and Schizophrenia.* Translated by Brian Massumi. Minneapolis: University of Minnesota Press, (1980) 1987.

Delorme, Stéphane. "D'une projection à l'autre." *Cahiers du cinéma* 672 (2011): 5.

Denis, Fernand, and Luc Honorez. "Federico Fellini sage comme la lune." *Le Soir*, August 1, 1990.

Desclaux, Pierre. "Le film parlant." *Mon Ciné* 353 (1928): 11–12.

Dubois, Philippe. *L'Acte photographique*. Paris: Nathan/Labor, 1983.

——. "Introduction/Présentation" In *Oui, c'est du cinéma*/Yes, It's Cinema. *Formes et espaces de l'image en mouvement/Forms and Spaces of the Moving Image*, edited by Alessandro Bordina, Philippe Dubois, and Lucia Ramos Monteiro, 7–12. Pasian di Prato: Campanotto Editore, 2009.

——. "Présentation." In *Extended Cinema/Le cinéma gagne du terrain*, edited by Elena Biserna, Philippe Dubois, and Frédéric Monvoisin, 13. Pasian di Prato: Campanotto Editore, 2010.

Dumouchel, Réjean. "Le *spectacteur* et le *contactile*." *Cinémas* 1, no. 3 (1991): 38–60.

Elsaesser, Thomas. "The New Film History as Media Archaeology." *Cinémas* 14, no. 2–3 (Spring 2004): 75–117.

——. "La notion de genre et le film comme produit 'semi-fini': L'exemple de *Weihnachtsglocken* de Franz Hofer (1914)." *1895* 50 (2006): 67–85.

——. "Between Knowing and Believing: The Cinematic Dispositif after Cinema." In *Cine-Dispositives: Essays in Epistemology across Media*, edited by François Albera and Maria Tortajada. Amsterdam: Amsterdam University Press, forthcoming.

Fabre, Clarisse. "Le 'high frame rate,' un format inattendu." *Le Monde*, December 11, 2012. http://www.lemonde.fr/culture/article/2012/12/11/le-high-frame-rate-un-format-inattendu_1804629_3246.html.

Flichy, Patrice. *L'Innovation technique*. Paris: La Découverte, 1995.

——. *L'Imaginaire d'Internet*. Paris: La Découverte, 2005.

Fresnault-Deruelle, Pierre. *Hergéologie: Cohérence et cohésion du récit en image dans les aventures de Tintin*. Tours: Presses universitaires François-Rabelais, 2011.

Galili, Doron. "Seeing by Electricity: The Emergence of Television and the Modern Mediascape 1878–1939." PhD diss., University of Chicago, 2011.

Garcin, Jérôme, editor. *Nouvelles mythologies*. Paris: Seuil, 2007.

Gaudreault, André. "*Les vues cinématographiques* selon Georges Méliès, ou: Comment Mitry et Sadoul avaient peut-être raison d'avoir tort (même si c'est surtout Deslandes qu'il faut lire et relire) . . . " In *Georges Méliès, l'illusionniste fin de siècle?*, edited by Jacques Malthête and Michel Marie, 124–32. Paris: Colloque de Cerisy/Presses de la Sorbonne Nouvelle, 1997.

——. *From Plato to Lumière: Narration and Monstration in Literature and Cinema*. Translated by Timothy Barnard. Toronto: University of Toronto Press, (1988) 2009.

——. *Film and Attraction: From Kinematography to Cinema*. Translated by Timothy Barnard. Urbana: University of Illinois Press, (2008) 2011.

————. "Cinema, an Art More *Photo*graphic than *Auto*graphic." Translated by Timothy Barnard. *Cinéma & Cie—International Film Studies Journal* 12, no. 18 (2012): 83–89.

————. "The Culture Broth and the Froth of Cultures of So-called Early Cinema." Translated by Timothy Barnard. In *A Companion to Early Cinema*, edited by Nicolas Dulac, André Gaudreault, and Santiago Hidalgo, 15–31. Malden: Wiley-Blackwell, 2012.

Gaudreault, André, and Philippe Gauthier. "Les séries culturelles de la conférence-avec-projection et de la projection-avec-boniment: Continuités et ruptures." In *Beyond the Screen: Institutions, Networks and Publics of Early Cinema*, edited by Marta Braun et al., 233–38. Eastleigh: John Libbey, 2012.

Gaudreault, André, and Philippe Marion. "Transécriture et médiatique narrative: L'Enjeu de l'intermédialité." In *La transécriture: Pour une théorie de l'adaptation*, edited by André Gaudreault and Thierry Groensteen, 31–52. Quebec City and Angoulême: Nota Bene/Centre national de la bande dessinée et de l'image, 1998.

————. "A Medium Is Always Born Twice." Translated by Timothy Barnard. *Early Popular Visual Culture* 3 (2005): 3–15.

————. "Cinéma et généalogie des médias." *Médiamorphoses* 16 (2006): 24–30.

————. "Pour une nouvelle approche de la périodisation en histoire du cinéma." *Cinémas* 17, no. 2–3 (2007): 215–32.

————. "En guise d'ouverture sur la problématique cinéma/bande dessinée." In *Cinema e fumetto* [Cinema and comics], edited by Leonardo Quaresima, Laura Ester Stangalli, and Federico Zecca, 23–29. Udine: Forum, 2009.

————. "The Mysterious Affair of Styles in the Age of Kine-Attractography." Translated by Timothy Barnard. *Early Popular Visual Culture* 8, no. 1 (2010): 17–30.

————. "Le cinéma est encore mort! Un média et ses crises identitaires." *MEI (Médiation et information)* 34 (2012): 27–42.

————. *The Kinematic Turn: Film in the Digital Era and Its Ten Problems.* Translated by Timothy Barnard. Montreal: caboose, 2012.

————. "Measuring the 'Double Birth' Model Against the Digital Age." Translated by Timothy Barnard. *Early Popular Visual Culture* 11, no. 2 (2013): 158–77.

Gauthier, Christophe. "Le devenir média du Web et le webfilm." In *Cinéma et audiovisuel se réfléchissent: Réflexivité, migrations, intermédialité*, edited by François Amy de la Bretèque et al., 229–39. Paris: L'Harmattan, 2012.

Gervereau, Laurent. *Histoire du visuel au xxe siècle.* Paris: Seuil, 2003.

Gombrich, E. H. "Mediations on a Hobby Horse or the Roots of Artistic Form." (1951). In *Art Theory and Criticism: An Anthology of Formalist, Avant-Garde, Contextualist and Post-Modernist Thought*, edited by Sally Everett, 41–54. Jefferson, NC: McFarland, 1995.

Greenaway, Peter. "*Peter Greenaway, cinema = dead.*" YouTube video, 2:50, filmed interview. Posted June 29, 2007. https://www.youtube.com /watch?v=-t-9qxqdVm4.

———. "Peter Greenaway Quotes." petergreenaway.org.uk. http://petergreenaway.org.uk/quotes.htm.

Guido, Laurent, and Olivier Lugon. "Introduction." In *Fixe/animé: Croisements de la photographie et du cinéma au xxe siècle*, edited by Laurent Guido and Olivier Lugon, 11–20. Lausanne: L'Âge d'Homme, 2010.

Gunning, Tom. "L'Instant 'arrêté': Entre fixité et mouvement." In *Fixe/ animé: Croisements de la photographie et du cinéma au xxe siècle*, edited by Laurent Guido and Olivier Lugon, 37–46. Lausanne: L'Âge d'Homme, 2010.

———. "Let's Start Over: Why Cinema Hasn't Yet Been Invented." Paper presented at the Annual Film Studies Association of Canada Conference, Kitchener/Waterloo, Canada, May 2012.

Hardy-Carnac, Ted. "'L'Écume des jours' de Gondry: Une romance écrasée sous un déluge d'effets visuels." *Le Nouvel Observateur*, April 29, 2013.

Huss, Christophe. "Metropolitan Opera—Votre cinéma n'est pas un cinéma . . . " *Le Devoir*, December 17, 2007.

———. "Musique classique: *Salomé* ouvre la saison du Met dans les cinémas." *Le Devoir*, October 11–12, 2008.

———. "Metropolitan Opera: La *Damnation* de Lepage: Un échec affligeant." *Le Devoir*, November 24, 2008.

———. "Le Metropolitan Opera au cinéma: Pour les yeux d'Elina." *Le Devoir*, January 18, 2010.

———. "Le Metropolitan Opera au cinéma—Un Rossini enlevant." *Le Devoir*, April 11, 2011.

Icher, Bruno. "Le cinéma, produit d'appel des nouvelles technologies." *Libération*, May 16, 2007.

Jackson, Peter. "Préface." In Chris Guise, *Artbook: Les Aventures de Tintin*, 14–15. Wellington and Brussels: Éditions Weta/Moulinsart, 2011.

Joly-Corcoran, Marc. "La cinéphanie et sa réappropriation: L''affect originel' et sa réactualisation par le fan, un spectateur néoreligieux." PhD diss., Université de Montréal, 2013.

Jost, François. *Comprendre la télévision et ses programmes*. Paris: Armand Colin, (2005) 2009.

———. "Twitter, un univers faussement égalitaire." *Le Monde*, June 21, 2012.

Jovanovic, Stefan. "The Ending(s) of Cinema: Notes on the Recurrent Demise of the Seventh Art." *Offscreen* 7, no. 4, (April 2003). http://offscreen.com/view/seventh_art1.

Jullier, Laurent. *L'Écran post-moderne: Un Cinéma de l'allusion et du feu d'artifice*. Paris: L'Harmattan, 1997.

Kaganski, Serge, and Jean-Marc Lalanne. "Entretien avec David Lynch: 'Mes films sont mes enfants.'" *Les Inrockuptibles* 830, October 26, 2011.

Kermabon, Jacques. "Le cinéma est mort, vive le cinéma." *24 images* 142 (2009): 20–21.

Kitsopanidou, Kira. "The Widescreen Revolution and 20th Century-Fox's Eidophor in the 1950s." *Film History* 15 (2003): 32–56.

Lastra, James. "What Cinema Is (for the Moment . . .)." In *Du Média au postmédia: Continuités, ruptures* [From media to post-media: Continuities and ruptures], edited by Nicolas Dulac and André Gaudreault. Lausanne: L'Âge d'Homme, forthcoming.

Le Forestier, Laurent. *Aux Sources de l'industrie du cinéma: Le modèle Pathé 1905–1908*. Paris: L'Harmattan, 2006.

——. "Le DVD, nouveau jouet d'optique?" In *In the Very Beginning, at the Very End: Film Theories in Perspective*, edited by Francesco Casetti, Jane Gaines, and Valentina Re, 159–66. Udine: Forum, 2010.

Lefort, Gérard. "Révolutions." In *Libération*, May 11, 2011.

Leprohon, Pierre. *Histoire du cinéma*, vol. 1, *Vie et mort du Cinématographe (1895–1930)*. Paris: Éditions du Cerf, 1961.

Leroi-Gourhan, André. *Le geste et la parole*, vol. 1, *Technique et langage*. Paris: Albin Michel, 1964.

Lipovetsky, Gilles, and Jean Serroy. *L'Écran global: Culture-médias et cinéma à l'âge hypermoderne*. Paris: Seuil, 2007.

Lohisse, Jean. *Les systèmes de communication: Approche socio-anthropologique*. Paris: Armand Colin, 1998.

Lorfèvre, Alain. "Spielberg et Jackson pour Tintin." *La Libre Belgique*, May 16, 2007.

Lynch, David. "David Lynch on iPhone." YouTube video, 0:30, filmed interview, posted by "Brittney Gilbert." Posted January 4, 2008. https://www.youtube.com/watch?v=wKiIroiCvZo&fmt=18.

Maksa, Gyula. "*Mediativitás, médiumidentitás, 'képregény.'*" PhD diss., University of Debrecen, 2008.

Malraux, André. *Esquisse d'une psychologie du cinéma*. Paris: Nouveau Monde Éditions, (1940) 2003.

Manara, Milo. *Voyage à Tulum sur un projet de Federico Fellini pour un film en devenir*. Tournai: Casterman, 1993.

Manche, Philippe. "Tintin est très complexe." *Le Soir*, October 26, 2011.

Mangolte, Babette. "Afterward: A Matter of Time." In *Camera Obscura, Camera Lucida: Essays in Honor of Annette Michelson*, edited by

Richard Allen and Malcolm Turvey, 261–74. Amsterdam: University of Amsterdam Press, 2002.

Manovich, Lev. *The Language of New Media.* Cambridge: MIT Press, 2001.

Marcadé, Nicolas. *Chronique d'une mutation: Conversations sur le cinéma (2000–2010).* Paris: Fiches du Cinéma éditions, 2010.

Marion, Philippe. "Scénario de bande dessinée: La différence par le média." *Études littéraires* 26, no. 2 (1993): 77–89.

——. *Traces en cases: Travail graphique, figuration narrative et participation du lecteur.* Louvain-la-Neuve: Bruylant-Academia, 1993.

——. "Narratologie médiatique et médiagénie des récits." *Recherches en communication* 7 (1997): 61–88.

——. "Emprise graphique et jeu de l'oie: Fragments d'une poétique de la bande dessinée." In *La bande dessinée: Une médiaculture,* edited by Éric Maigret and Matteo Stefanelli, 175–99. Paris: Armand Colin/ INA Éditions, 2012.

——. "Tintin façon Spielberg: Une nouvelle manière de penser le cinéma?" In *Du Média au postmédia: Continuités, ruptures* [From media to post-media: Continuities and ruptures], edited by Nicolas Dulac and André Gaudreault. Lausanne: L'Âge d'Homme, forthcoming.

Marling, Karal Ann. "Fantasies in Dark Places: The Cultural Geography of the American Movie Palace." In *Textures of Place: Exploring Humanist Geographies,* edited by Paul C. Adams, Steven Hoelscher, and Karen E. Till, 8–23. Minneapolis: University of Minnesota Press, 2001.

Massuet, Jean-Baptiste. "L'Impact de la *performance capture* sur les théories du cinéma d'animation." *Écranosphère* 1 (2014). http://www .ecranosphere.ca/article.php?id=19.

McLuhan, Marshall. *Understanding Media: The Extensions of Man.* Cambridge: MIT, (1964) 1994.

Metz, Christian. *Language and Cinema.* Translated by Donna Jean Umiker-Sebeok. The Hague: Mouton, (1971) 1974.

Meunier, Jean-Pierre. *Approches systémiques de la communication.* Brussels: De Boeck, 2003.

Meusy, Jean-Jacques. *Cinémas de France 1894–1918: Une histoire en images.* Paris: Arcadia Éditions, 2009.

Mitchell, W. J. T. *Cloning Terror: The War of Images, 9/11 to the Present.* Chicago: University of Chicago Press, 2011.

Morin, Edgar. *The Cinema, or the Imaginary Man.* Translated by Lorraine Mortimer. Minneapolis: University of Minnesota Press, (1956) 2005.

——. *Method: Towards a Study of Humankind,* vol. 1, *The Nature of Nature.* Translated by J. L. Roland Bélanger. New York: Peter Lang, (1977) 1992.

Musso, Pierre. "La 'révolution numérique': Techniques et mythologies." *La Pensée* 355 (2008): 103–20.

Negroponte, Nicholas. *Being Digital*. New York: Knopf, 1995.

Odin, Roger. "Le film documentaire, lecture documentarisante." In *Cinéma et réalités*, edited by Jean-Charles Lyant and Roger Odin, 263–78. Saint-Étienne: CIEREC and Université de Saint-Étienne, 1984.

———. *De la fiction*. Paris: De Boeck, 2000.

Oliveira, Michael. "*The Hobbit*: Richard Armitage fasciné par le nouveau format 3D." *La Presse*, December 4, 2012.

Pajon, Léo. "Pour ou contre 'L'Écume des jours,' de Michel Gondry?" *Francetv info*, April 24, 2013. http://www.francetvinfo.fr/pour-ou -contre-lecume-des-jours-de-michel-gondry_307915.html.

Panofsky, Erwin. *Three Essays on Style*. Edited by Irving Lavin. Cambridge: MIT Press, 1995.

Paris Match 226 (1953).

Peeters, Benoît. "Retrouver la ligne claire." *Cahiers du cinéma* 672 (2011): 46–47.

Peeters, Benoît, Jacques Faton, and Philippe de Pierpont. *Storyboard—Le cinéma dessiné*. Brussels: Yellow Now, 1992.

Péron, Didier. "Cannes à la croisette des chemins." *Libération*, May 11, 2011.

Pisano, Giusy. "The Théâtrophone, an Anachronistic Hybrid Experiment or One of the First Immobile Traveler Devices?" In *A Companion to Early Cinema*, edited by Nicolas Dulac, André Gaudreault, and Santiago Hidalgo, 80–98. Malden: Wiley-Blackwell, 2012.

"Plus de 3 millions d'entrées pour le Tintin de Spielberg." Neuvième-art.com. *Bande-dessinée,manga,comics*,November 6,2011.http://www.neuvieme -art.com/actu/tintin-spielberg-box-office-3-millions-entrees-1189.

Ricoeur, Paul. *Time and Narrative*, vol. 1. Translated by Kathleen McLaughlin and Daniel Pellauer. Chicago: University of Chicago Press, (1983) 1984.

———. *Oneself as Another*. Translated by Kathleen Blamey. Chicago: University of Chicago Press, (1990) 1992.

Rifkin, Jeremy. *The Age of Access: The New Culture of Hypercapitalism, Where All of Life Is a Paid-for Experience*. New York: Tarcher, 2001.

Rodowick, D. N. "La vie virtuelle du film." *Cinergon* 15 (2003): 17–35.

———. *The Virtual Life of Film*. Cambridge: Harvard University Press, 2007.

Scheinfeigel, Maxime. "Les lauriers du cinéma." *Cinergon* 15 (2003): 35–45.

Séguret, Olivier. "Le mot de la fin." *Libération*, July 11, 2007.

Self, Will. "Cut! That's All, Folks." *The Times*, August 28, 2010.

Serres, Michel. *Atlas*. Paris: Julliard, 1994.

———. *Petite Poucette*. Paris: Le Pommier, 2012.

Sontag, Susan. "The Decay of Cinema." *New York Times*, February 25, 1996.

Sorbier, Laurent. "Introduction: Quand la révolution numérique n'est plus virtuelle . . . " *Esprit* (2006): 121–27.

Souriau, Étienne, editor. *L'Univers filmique*. Paris: Flammarion, 1953.

Tessé, Jean-Philippe. "La révolution numérique est terminée." *Cahiers du cinéma* 672 (2011): 6–8.

Théâtre Robert-Houdin: Grandes Matinées de Prestidigitation. Program, n.d. [1907].

Thornburglar. "Digital Cinema, a Revolution?" *Thornburglar* (blog), September 17, 2008. http://thornburglar.hubpages.com/hub/Digital CinemaArticleReview.

Tisseron, Serge. *Petites Mythologies d'aujourd'hui*. Paris: Aubier, 2000.

Töpffer, Rodolphe. *Réflexions et menus propos d'un peintre genevois, ou Essai sur le beau dans les arts*. Paris: École nationale supérieure des beaux-arts, (1848) 1998.

Tortajada, Maria. "Photographie/cinéma: Paradigmes complémentaires du début du xxe siècle." In *Fixe/animé: Croisements de la photographie et du cinéma au xxe siècle*, edited by Laurent Guido and Olivier Lugon, 47–61. Lausanne: L'Âge d'Homme, 2010.

———. "Le statut du photogramme et l'instant prégnant au moment de l'émergence du cinéma." In *In the Very Beginning, at the Very End*, edited by Francesco Casetti, Jane Gaines, and Valentina Re, 23–32. Udine: Forum, 2010.

Truffaut, François. *Hitchcock*. New York: Simon and Schuster, 1967.

Tryon, Chuck. "What the Fuck Are You Doing in the Dark?" In *The Chutry Experiment* (blog), July 15, 2007. http://www.chutry.wordherders.net /wp/?p=1670.

———. *Reinventing Cinema: Movies in the Age of Media Convergence*. New Brunswick: Rutgers University Press, 2009.

Valleiry, François. "La nouvelle pellicule." *Phono-Ciné-Gazette* 46 (February 15, 1907): 70.

———. "Le Cinématographe n'est pas encore né." *Phono-Ciné-Gazette* 55, July 1, 1907.

Wahl, Lucien. "Le navet d'aujourd'hui sera demain qualifié chef-d'œuvre." *Cinémagazine* 24 (1928): 426.

Webb, Kevin. "The Hobbit's New High Frame Rate Format Fails to Impress." *Atlanta Blackstar*, December 11, 2012. http://atlantablackstar .com/2012/12/11/the-hobbits-new-high-frame-rate-format-fails-to-impress/.

Selected Bibliography

Wikipédia, l'encyclopédie libre, s.v. "Supernova." Anonymous. http://fr
.wikipedia.org/wiki/Supernova.

Wikipedia. The Free Encyclopedia, s.v. "VJing." Anonymous. http://
en.wikipedia.org/wiki/VJing.

Willoughby, Dominique. *Le cinéma graphique: Une histoire des dessins
animés des jouets d'optique au cinéma numérique*. Paris: Textuel, 2009.

Index

Abel, Richard, 197n82
Acland, Charles, 120, 179
Adventures of Tintin: The Secret of the Unicorn, The (Steven Spielberg, 2011), 8, 164, 166, 170–172, 177
Albera, François, 204n43, 218n7
Altman, Rick, 196n65
Amy de la Bretèque, François, 16
Andrew, Dudley, 17, 34, 152
animation: animage, 151–152, 163, 165, 175, 184, 187, 215n22; cinema's media identity and, 158–164, 166, 175, 187; as a dominant cultural series, 78, 184; motion capture and, 71, 163–166, 170–175, 184; photo-realism and, 165–166, 170–174, 184; series-centrism and, 159–161
archives, film, 135; digital era and, 7, 9, 144
Arnheim, Rudolf, 209n21
Arnoldy, Édouard, 31, 136, 150

Arnoux, Alexandre: on death of cinema, 31–32, 60; and the double birth model, 114
Asselin, Olivier, 59, 83, 201n54, 201n56
attraction, 110, 111, 113, 161, 191n2; attractional mode, 14; attractional packages, 92–93, 97, 100; kine-attractography, 100–101, 124, 131, 179
Aumont, Jacques: on cinema's decline, 15, 19, 22, 52, 200n34; on cinema's media identity, 21, 25, 80, 106, 153, 187, 195n58; on digital cinema, 53, 56–57, 70, 201n53; on extended cinema, 20–21; on film reception, 20, 52
Avatar (James Cameron, 2009), 8

Balandier, Georges, 46, 180, 217n6
ballet retransmission, 85–87, 100
Barjavel, René, 104, 177, 184
Barthes, Roland: on mythology, 46; on movie theaters, 84; on reality effect, 66–67, 95

base apparatus, 26, 95, 106, 194n52
Baudry, Jean-Louis, 26, 194n52
Bazin, André: on cinema's media identity, 8, 10, 17–18, 197n83; and the double birth model, 115; and extended cinema, 18; on the kinematograph, 100; on total cinema, 71, 184–186
Beatty, Warren: *Dick Tracy* (1990), 170–171
Beaudine, William: *Sparrows* (1926), 89
Bégin, Richard: 198n8, 200n40
Bell, Jamie, 171, 173
Bellour, Raymond: on digital crisis, 19, 182; on cinema's media identity, 19–21, 25, 153, 177; on extended cinema, 19–21; on film reception, 20
Belton, John, 3–4, 7
Benjamin, Walter, 46
Benoît-Lévy, Edmond, 147, 197n82. *See also* François Valleiry
Berry, Philippe, 72
Bessy, Maurice, 195n54
Blanc-Tailleur, Romain, 143
Boillat, Alain, 170
Bordwell, David, 63
Boudissa, Magali, 80–81
Boussinot, Roger: on death of cinema, 13, 29; on talking cinema, 31; on television, 26–30, 104; on video playback machines, 26–30, 129

camera, moving picture, 88–89, 93–96, 99–102, 108
Cameron, James, 4, 8, 175; *Avatar* (2009), 8; *Terminator 2: Judgment Day* (1991), 175
Camus, Albert, 138–139
Canudo, Ricciotto, 91, 96, 115
Carmen (Bizet), 140
Carou, Alain, 97
Casetti, Francesco, 130, 154
Castells, Manuel, 50
CD (Compact Disc), 76
CD-ROM, 9

celluloid film. *See* film, celluloid
Certeau, Michel de, 61
Chabin, Marie-Ann, 207n29
Chabrol, Claude, 57
Chartier, Jean-Pierre, 114–115
Cherchi Usai, Paolo, 16, 127
Chik, Caroline, 78
Child Bayley, Roger, 157
Chion, Michel, 174–175
Cholodenko, Alan, 159–160
Cinderella (Rudolf Nureyev), 86–87, 90, 101, 208n37
cinema, death of. *See* death of cinema
cinema, digital. *See* digital cinema
cinema, genealogy of:
—double birth of cinema, 104–11
—invention of the base apparatus, 105–107, 115, 145
—institutionalization of cinema: death of cinema and, 33–35; double birth model and, 105–112, 133–134, 179; post-, 111–112, 123–124, 126, 156, 161, 215n16;
—and identity crisis, 2–3, 11, 18;
—series-centrism and, 156–162, 215n10
—third birth of cinema, 112, 120–123, 126, 156, 161, 182
cinema, home. *See* home cinema
cinema, institutional, 44–45, 121–122, 163, 161, 179, 187
cinema's media identity
—definitions of: extended cinema, 1, 11, 17–18, 152–153, 156, 191n21; as theoretical construction, 11, 153–156. *See also* cinema, genealogy of
—invariables deemed essential to: film projection, 5, 10, 84, 133–134, 147; homochrony, 78–82, 110, 169–171, 180; movie theater, 14–15, 20, 28, 103, 127–128, 182 (*see also* movie theater); moving images, 2, 12, 14–15, 52–53; moving picture camera, 12, 107; narrativity, 14, 108–111

—and other cultural series:
animation, 158–165, 174–
175; contemporary art, 19;
opera, 93; performing arts, 12;
photography, 100; television,
9, 11, 20, 133–134, 147. *See
also* event retransmission
Coe, Jonathan, 13
Coleridge, Samuel Taylor, 73
Collier, John, 132
Comolli, Jean-Louis, 26
Condroyer, Philippe: *Tintin et
les Oranges bleues* (1964),
217n41
Cooper, Merian: *King Kong* (with
Ernest Schoedsack, 1933), 178
cultural series: vs. cultural practice,
183–184; genealogy of media
and, 32, 120–121, 183; series-
centrism, 154–161, 181,
215n10

Damnation of Faust, The (Berlioz), 91
Daney, Serge, 127
Dart, Harry Grant, 42
death of cinema
—digital technologies and: loss of
hegemony, 12–16; decline of
movie theaters, 20, 38–39,
127; end of celluloid film,
8, 147–148; end of classical
narrative cinema, 1–2, 23
—discourses around the: death as
a new birth, 32, 35, 60, 104,
120, 152; various assertions
of death, 12–13, 60, 105, 121,
182–183, 191n23
—historical causes of the:
institutionalization, 33–35;
Lumière Cinématographe, 26,
37; remote control, 1, 22–25,
139; film rental system,
35–37; talking cinema, 31–33,
196n74; television, 26–29,
104; video playback machine,
29–30
Debray, Régis, 46
Décarie, Kim, 212n13

Deleuze, Gilles, 50, 61, 201n59
Delorme, Stéphane, 10, 190n9
Desclaux, Pierre, 31
Dick Tracy (Warren Beatty, 1990),
170–171
digital cinema: animation and,
76–82, 159–162, 204n40;
discursive effect of, 110; and
fractured duration, 16, 55,
76, 173; image capture and,
6, 16, 55, 64–69, 173 (*see
also* motion capture); intrinsic
plasticity of, 55, 162; and
"ontologized" special effects,
55–56, 187. *See also under*
reception, film
digital cinema, passage to: celluloid
film and, 7, 147, 150; dating
of the, 148, 190n15, 194n47;
hybridization, 2, 11, 104,
122–124, 145; and other identity
crisis 32–33, 37, 121, 148; as
a process of digitalization, 11,
33, 37–38, 44–45, 146–150; as
a revolution, 3–5, 7, 9, 44–45,
51–53
digital filmmaking: accessibility,
59, 201n56; creative control,
54–59, 173
digital media, passage to:
digitalization, 38, 40, 45,
191n11; media convergence,
42–44, 46, 53–54, 124–126,
136–138, 163; media
hybridity, 33, 42, 122–124,
155, 158
digital revolution: criticism of the term,
46–52; definition of, 45–49
dispositif, 78, 204n43
distribution, film
in the digital age, 9, 15, 52, 64,
129;
institutional cinema and,
132–133;
personal film purchase and,
135–136;
sales vs. rental systems, 35–36,
131–136, 212n8;

Index

documentary images, 88–89, 109,
 208n6
Dubois, Philippe: on extended
 cinema, 1–2, 11, 17–21,
 156–157, 181, 195n58; on
 photography, 65, 202n9
Dumas, Alexandre, 97, 98, 208n33
Dumont, Bruno: *Hors Satan*
 (2011), 10
DVD: celluloid film and, 125; film
 reception and, 9, 24, 44,
 64–65, 129–131, 201n59

Eberson, John, 212n11
Écume des jours, L' (Michel Gondry,
 2013), 177–179
Edison Kinetograph, 106
Edison, Thomas, 92, 106, 127
Eidophor, 29–30, 140, 196n64
Eliade, Mircea, 205n49
Elmaleh, Gad, 173
Elsaesser, Thomas, 9, 132, 162–163
event retransmission: filmed vs.
 filmic, 86–87, 90–94, 99–103,
 106, 206n13; live broadcast,
 3, 44, 138–142; tele-agora,
 85–86, 89–90, 102, 121,
 138–143, 206n13; various
 types of, ballet, 85–87, 100;
 various types of, opera, 44,
 85–86, 90–94, 99–103, 138–
 141, 206n13; various types of,
 sporting events, 85–86
exhibition, film: in the digital age,
 9, 38, 44–45, 62; event
 retransmission and, 85,
 138–143, 213n22; rental
 system and, 133–136; kine-
 attractography era and, 132,
 134. *See also* movie theater

Fairbanks, Douglas, 88
fairground cinema, 35, 197n79
Fellini, Federico, 74
film adaptation, 98, 164, 166,
 168–172
film studies, 10, 19, 22, 64,
 145–146

film institutions, names of, 10,
 144–146, 164
film, celluloid: cinema's media
 identity and, 44, 84, 95, 124,
 127–128, 147; end of, 3, 7–9,
 10, 138, 147, 150; digital
 cinema and, 6, 37–38, 54–56,
 76, 148, 202n62; film-film,
 7, 33, 190n11; film reception
 and, 63–64, 70, 133; live
 retransmissions and, 85
filming process: as an archiving
 process, 88–93; *Aufhebung*
 effect and, 83–84, 94–95,
 98, 100, 175, 207n22;
 cinematographiation and,
 98, 102, 208n34, 216n32;
 as expressive archiving,
 93, 95–96, 98–99, 115;
 as reproductive archiving,
 95–97, 99, 102, 109–110,
 207n28, 209n7; reproductive
 vs. expressive archiving and,
 92–103, 160–161
Fleischer, Dave and Max, 165
Flichy, Patrice, 46
Foucault, Michel, 181, 201n59
Franquin, André, 56
Fresnault-Deruelle, Pierre, 216n34

Galili, Doron, 117–119
Garcin, Jérôme, 46
Gates, Bill, 137
genealogy of media. *See* media,
 genealogy of
Guattari, Félix, 50
Gaudreault, Grégoire, 210n30
Gauthier, Christophe, 117
Gelb, Peter, 138
Gervereau, Laurent, 127
·Giordani, Marcello, 97
Godard, Jean-Luc, 7, 37; *Vent d'est*,
 (1969), 7
Gombrich, E.H., 74
Gondry, Michel, 177–179, 181;
 L'Écume des jours, (2013),
 177–179
Gould, Chester, 170–171

236

graphic novels: digital cinema and, 52, 56–57, 81; double birth model and, 116–117; film adaptation of, 164, 166, 168–172, and graphiation, 167–169, 171, 208n34; as heterochrone media, 79–81, 169–170; reader's input, 73–74

Greenaway, Peter, 1–2, 11, 22–25, 139, 194n51, 195n56

Grégoire, Daniel D., 58

Griffith, D.W., 23

Guido, Laurent, 77, 81–82

Gunning, Tom, 17–18, 82

Halvorson, Gary, 90–91, 97, 102

Hardy-Carnac, Ted, 179–180

Hawks, Howard, 166

Hegel, Georg Wilhelm Friedrich, 207n22

Hergé, 56–57, 164–174, 177, 216n34; Les Aventures de Tintin, 167–170, 172

Hitchcock, Alfred, 57–58, 109, 166, 201n53

Hobbit: An Unexpected Journey, The (Peter Jackson, 2012), 70–72, 75

home cinema: contemporary, 15, 17, 29–30, 85, 129–130, 139; early, 135, 212n12

Hors Satan (Bruno Dumont, 2011), 10

Hugo, Victor, 32

Huss, Christophe, 90–91, 93, 97, 102

Icher, Bruno, 137

Indiana Jones and the Kingdom of the Crystal Skull (Steven Spielberg, 2008), 58

Internet, 46, 49–50, 68, 117, 129

Jackson, Peter, 72, 164, 166–168, 170–171, 173–174; The Hobbit: An Unexpected Journey (2012), 70–72, 75

Jetée, La (Chris Marker, 1962), 78

Joly-Corcoran, Marc, 205n49

Jost, François, 117, 180–181, 213n21

Jovanovic, Stefan, 13, 60

Jullier, Laurent, 112

Jutras, Pierre, 144, 213n29

Katerine, Philippe, 58

Kermabon, Jacques, 195n56

Kessler, Frank, 209n21, 218n13

kinematograph: and institutional cinema, 34, 101, 116, 119; and double birth of cinema, 34–37, 107, 109–111, 197n83, 196n60, 197n78; intermediality and the, 121–124, 126, 145, 155; as a recording device, 87–88, 91–92, 94, 100–103, 105, 109–110; and series-centrism, 156–157, 214n8, 215n10

Kinetoscope, 92, 160

King Kong (Merian Cooper and Ernest Schoedsack, 1933), 178

King, Paul, 72–73

Kitsopanidou, Kira, 191n21, 196n64

Lancien, Thierry, 63

Langlois, Daniel, 145

Large, Brian, 97

Last Call (Milo, 2010), 82

Lastra, James, 17–18, 117–118, 122–123, 195n56

Le Forestier, Laurent, 186, 195n56, 209n14, 218n13; on institutionalization of cinema, 36, 197n80; on users' control, 61, 65, 201n59

Le Lionnais, François, 209n12

Lecomte, Julien, 117

Lee, Ang: Life of Pi (2012), 72

Lefebvre, Martin, 195n55

Lefort, Gérard, 38

Lellouche, Raphaël, 205n51;

Leprohon, Pierre, 32–33, 116, 196n74

Leroi-Gourhan, André, 46, 119

Les Aventures de Tintin (Hergé), 167–170, 172

Index

Lescaut, Manon, 97
Levine, James, 97
Lévy, Pierre, 42, 50
Life of Pi (Ang Lee, 2012), 72
Lipovetsky, Gilles, 182
Lo Duca, Joseph-Marie, 195n54
Locher, Hans-Nikolas, 71
Lonjeon, Bernard, 160
Lucas, George, 4
Lugon, Olivier, 77, 81
Lumière Cinématographe, 33, 88,
 128, 196n73; Antoine Lumière
 on the, 26, 195n54; invention
 of the, 29, 105–106, 116, 157
Lumière, Antoine, 26, 37, 100, 102,
 116, 195n54
Lumière, Louis, 67, 195n54
Lumière, Louis and Auguste, 26, 88,
 106, 127, 196n60, 206n7
Lynch, David, 15, 21, 54

magic lantern, 23, 88, 124, 145, 157
Malraux, André, 95–96
Manara, Milo, 74
Mangolte, Babette, 41, 76
Mannoni, Octave, 73, 95
Manovich, Lev, 69, 81, 159
Marie, Michel, 64
Mariscalchi, Marnie, 204n46,
 211n3
Marker, Chris, 7, 78; *Jetée, La*
 (1962), 78
Maksa, Gyula, 117
Massuet, Jean-Baptiste, 163–164
McLuhan, Marshall, 49
media, double birth of: advent of a
 media institution, 107–108,
 114, 116, 121–124, 133–134;
 appearance of a technological
 process, 107–109, 113,
 116–117, 120, 145; definition
 of the model, 104–114;
 emergence of a media
 apparatus, 107–108, 113–118,
 123; extension of the model,
 116–123; precursors of the
 double birth, 31–37, 114–116,
 209n21

media, genealogy of: intermedial
 phases, 33, 112–114, 121–
 124, 126, 155–156, 182;
 media identity, 32, 112–114,
 120–126, 211n38, 211n39;
 mediagenie, 166–172, 216n30;
 series-centrism, 154–156;
 system theory and, 41–42. *See
 also* media, double birth of
Méliès, Georges, 34–35, 56, 88, 177,
 186, 218n26; and the Lumière
 Cinématographe, 100, 116,
 195n54
Metz, Christian, 108, 153, 209n21
Meunier, Jean-Pierre, 198n6
Meusy, Jean-Jacques, 197n79
Mitchell, Bill, 47
Mitchell, W.J.T., 66, 184
Morin, Edgar, 34–35, 41–42, 116,
 197n78
motion capture: animation and,
 71, 163–166, 170–175, 184;
 digital cinema and, 4, 8, 54
movie theaters: cinema's
 institutionalization and, 35,
 132–134, 212n10, 212n11;
 in the digital age, loss of
 hegemony, 3, 15, 38, 64,
 84–85, 138; in the digital age,
 new generation of theaters,
 183; in the digital age, vs.
 other means of consumption,
 9, 30, 44, 127–130; in the
 digital age, various kinds of
 entertainment, 3, 84–87, 103,
 138–139, 142–143. *See also*
 event retransmission
Musso, Pierre, 46–47, 51, 63,
 118, 180

Nadar, 116
Negroponte, Nicholas, 47, 49–50
Niépce, Nicéphore, 116
Nureyev, Rudolf, 86–87, 90

Odin, Roger, 89, 111–112, 154,
 190n11, 206n11
Oliveira, Michael, 71

opera retransmissions, 44, 85–86, 90–94, 99–103, 138–141, 206n13
optical toys, 65, 161–162, 201n59; phenakistiscope, 159; Théâtre optique, 159–160

Panofsky, Erwin, 88
Peeters, Benoît, 166, 172
Peirce, Charles S., 64–66, 131
Péron, Didier, 41, 59–60
Perrault, Charles, 87
phonograph, 31, 95, 100, 115
photo-realism: animation and, 165–166; digital encoding and, 16, 65–67, 69, 76; indexical nature of, 66–69
photography: and indexicality, 65–67, 88, 91, 95, 202n9; double birth model and, 116
Pickford, Mary, 88–89
Pisano, Giusy, 158
Plateau, Joseph, 159
projection, film: digital, 5–8, 52, 62, 70–71, 150, 202n62; HFR (High Frame Resolution), 70–75; IMAX, 110; 3D projection, as novelty, 14, 38, 164–165, 186, 203n21; 3D projection, realism of, 71, 75; 3D projection, reception of, 62, 71–72
Psycho (Gus Van Sant, 1998), 201n53

Rabouh, Sophie, 200n41
Racine, Yolande, 144–145, 214n30
radio, 31, 79–80, 204n46
reception, film
—classical: darkness, 1–2, 21, 24, 182; movie theater, 3, 84–86,103, 136, 139, 142; paid admission, 52, 127–128; passive viewers, 20, 24–25, 128, 130, 136; projection of moving images, 20–21, 128, 182; in public, 15, 21, 86, 127–128, 137, 182

—digital cinema and: accessibility of images, 63–64, 67–68; digital projection, 5–8, 52; impression of coldness, 69–71, 75; mobility, 129–130, 136–137, 150; multiple means of consumption, 9, 24, 44, 127–138, 150, 212n16; users' control, 61–62, 79, 82, 130, 136–137, 139, 149
—kinematograph proceedings, 132–134
—on television: users' limited control, 61, 79, 127–130; in private, 30, 134, 140, 150, 213n21
remote control, 9, 22–25, 61, 139, 149, 194n51
Reynaud, Émile, 159–162
Ricoeur, Paul, 96, 112
Rifkin, Jeremy, 63
Ring des Nibelungen, Der (Wagner), 90
Rodowick, D. N., 16, 29, 55, 66, 76

Sadoul, Georges, 37
Sandow (Edison, 1894), 92
Sandow, Eugene, 92
Scheinfeigel, Maxime, 16
Scorsese, Martin, 23
scriptwriting, 74, 111
Séguret, Olivier, 149
Self, Will, 9, 13–15
Serkis, Andy, 171
Serres, Michel, 48–50
Serroy, Jean, 182
Sher, Bartlett, 102
Schoedsack, Ernest: King Kong (with Merian Cooper, 1933), 178
silent cinema, 5, 23, 31–33, 104, 148, 196n65, 196n73
Simondon, Gilbert, 180, 218n7
social media, 53, 82, 200n38, 200n41
Sontag, Susan, 15, 84
Sorbier, Laurent, 49–50
Soulez, Guillaume, 191n21
Souriau, Étienne, 88, 95–96, 209n21

Index

Sparrows (William Beaudine,
 1926), 89
special effects, 14, 55–56, 59, 152,
 159, 162
Spielberg, Steven, 8, 58, 164, 166,
 168–172, 177; *The Adventures
 of Tintin: The Secret of the
 Unicorn* (2011), 8, 164, 166,
 170–172, 177; *Indiana Jones
 and the Kingdom of the
 Crystal Skull* (2008), 58
Stevens, Dana, 75
storyboard, 57–58, 169, 172,
 201n54

Talbot, Jean-Pierre, 217n41
talking cinema, 3–5, 31–33, 37, 114,
 121, 148
telephone, mobile: double birth
 model and, 117–118, 211n38;
 cinema's media identity and,
 12, 17, 21, 60; film reception
 on, 14, 20–21, 38, 82–83, 150,
 200n41; mobilography, 38, 44,
 53, 59–61, 198n8, 200n40;
 nomadic consumption, 129,
 137; and other media, 118,
 204n46, 210n30, 211n38
television: digital cinema and,
 148–150; double birth model
 and, 117–118; emergence of,
 11; and the end of celluloid
 film, 7, 11, 44, 133, 147; and
 extended cinema, 21, 82, 124–
 125, 146; and movie theaters
 in decline, 15, 20, 24–30,
 44, 85–86, 165. *See also* film
 reception: on television
Terminator 2: Judgment Day (James
 Cameron, 1991), 175
Tessé, Jean-Philippe, 10, 70, 75
Théâtrophone, 158
Thibodeau, Simon, 61–62, 204n46
Tintin et les oranges bleues (Philippe
 Condroyer, 1964), 217n41

Tisseron, Serge, 46
Töpffer, Rodolphe, 74, 117
Tortajada, Maria, 78, 204n43, 218n7
Traviata, La (Verdi), 140
Tristan (Wagner), 91
Truffaut, François, 57, 59–60
Tryon, Chuck, 17, 24
Turnock, Julie, 7

university degree programs, 77, 125,
 146, 211n41, 211n42
Uricchio, William, 148

Valleiry, François, 36–37, 63, 115,
 147, 197n81, 197n82, 197n83
Van Sant, Gus: *Psycho* (1998),
 201n53
Vent d'est (Jean-Luc Godard,
 1969), 7
Vian, Boris, 177–181
video art, 125, 146
video games, 9, 14, 78, 82, 137
video playback machine, 25, 28–30,
 78, 81, 129, 137
videocassette, 9, 24, 30, 129, 131,
 133, 136
Vinci, Leonardo da, 142
vinyl records, 76, 179
Viola, Bill, 23
VJing, 23–24, 193n43

Wagner, Richard, 90–91; *Ring des
 Nibelungen, Der*, 90;
 Tristan, 91
Wahl, Lucien, 31
Wenders, Wim, 152
Williams, Raymond, 120
Willis Sweete, Barbara, 91, 97
Willoughby, Dominique, 161–162,
 165

Youngblood, Gene, 21

Zemeckis, Robert, 4
Zinman, Gregory, 4

FILM AND CULTURE
A series of Columbia University Press
Edited by John Belton

What Made Pistachio Nuts? Early Sound Comedy and the Vaudeville Aesthetic
 Henry Jenkins
Showstoppers: Busby Berkeley and the Tradition of Spectacle
 Martin Rubin
Projections of War: Hollywood, American Culture, and World War II
 Thomas Doherty
Laughing Screaming: Modern Hollywood Horror and Comedy
 William Paul
Laughing Hysterically: American Screen Comedy of the 1950s
 Ed Sikov
Primitive Passions: Visuality, Sexuality, Ethnography, and Contemporary Chinese Cinema
 Rey Chow
The Cinema of Max Ophuls: Magisterial Vision and the Figure of Woman
 Susan M. White
Black Women as Cultural Readers
 Jacqueline Bobo
Picturing Japaneseness: Monumental Style, National Identity, Japanese Film
 Darrell William Davis
Attack of the Leading Ladies: Gender, Sexuality, and Spectatorship in Classic Horror Cinema
 Rhona J. Berenstein
This Mad Masquerade: Stardom and Masculinity in the Jazz Age
 Gaylyn Studlar
Sexual Politics and Narrative Film: Hollywood and Beyond
 Robin Wood
The Sounds of Commerce: Marketing Popular Film Music
 Jeff Smith
Orson Welles, Shakespeare, and Popular Culture
 Michael Anderegg
Pre-Code Hollywood: Sex, Immorality, and Insurrection in American Cinema, 1930–1934
 Thomas Doherty
Sound Technology and the American Cinema: Perception, Representation, Modernity
 James Lastra
Melodrama and Modernity: Early Sensational Cinema and Its Contexts
 Ben Singer
Wondrous Difference: Cinema, Anthropology, and Turn-of-the-Century Visual Culture
 Alison Griffiths
Hearst Over Hollywood: Power, Passion, and Propaganda in the Movies
 Louis Pizzitola
Masculine Interests: Homoerotics in Hollywood Film
 Robert Lang
Special Effects: Still in Search of Wonder
 Michele Pierson
Designing Women: Cinema, Art Deco, and the Female Form
 Lucy Fischer

Cold War, Cool Medium: Television, McCarthyism, and American Culture
Thomas Doherty
Katharine Hepburn: Star as Feminist
Andrew Britton
Silent Film Sound
Rick Altman
Home in Hollywood: The Imaginary Geography of Hollywood
Elisabeth Bronfen
Hollywood and the Culture Elite: How the Movies Became American
Peter Decherney
Taiwan Film Directors: A Treasure Island
Emilie Yueh-yu Yeh and Darrell William Davis
Shocking Representation: Historical Trauma, National Cinema, and the Modern Horror Film
Adam Lowenstein
China on Screen: Cinema and Nation
Chris Berry and Mary Farquhar
The New European Cinema: Redrawing the Map
Rosalind Galt
George Gallup in Hollywood
Susan Ohmer
Electric Sounds: Technological Change and the Rise of Corporate Mass Media
Steve J. Wurtzler
The Impossible David Lynch
Todd McGowan
Sentimental Fabulations, Contemporary Chinese Films: Attachment in the Age of Global Visibility
Rey Chow
Hitchcock's Romantic Irony
Richard Allen
Intelligence Work: The Politics of American Documentary
Jonathan Kahana
Eye of the Century: Film, Experience, Modernity
Francesco Casetti
Shivers Down Your Spine: Cinema, Museums, and the Immersive View
Alison Griffiths
Weimar Cinema: An Essential Guide to Classic Films of the Era
Edited by Noah Isenberg
African Film and Literature: Adapting Violence to the Screen
Lindiwe Dovey
Film, A Sound Art
Michel Chion
Film Studies: An Introduction
Ed Sikov
Hollywood Lighting from the Silent Era to Film Noir
Patrick Keating
Levinas and the Cinema of Redemption: Time, Ethics, and the Feminine
Sam B. Girgus
Counter-Archive: Film, the Everyday, and Albert Kahn's Archives de la Planète
Paula Amad

Indie: An American Film Culture
 Michael Z. Newman
Pretty: Film and the Decorative Image
 Rosalind Galt
Film and Stereotype: A Challenge for Cinema and Theory
 Jörg Schweinitz
Chinese Women's Cinema: Transnational Contexts
 Edited by Lingzhen Wang
Hideous Progeny: Disability, Eugenics, and Classic Horror Cinema
 Angela M. Smith
Hollywood's Copyright Wars: From Edison to the Internet
 Peter Decherney
Electric Dreamland: Amusement Parks, Movies, and American Modernity
 Lauren Rabinovitz
Where Film Meets Philosophy: Godard, Resnais, and Experiments in Cinematic Thinking
 Hunter Vaughan
The Utopia of Film: Cinema and Its Futures in Godard, Kluge, and Tahimik
 Christopher Pavsek
Hollywood and Hitler, 1933–1939
 Thomas Doherty
Cinematic Appeals: The Experience of New Movie Technologies
 Ariel Rogers
Continental Strangers: German Exile Cinema, 1933–1951
 Gerd Gemünden
Deathwatch: American Film, Technology, and the End of Life
 C. Scott Combs
After the Silents: Hollywood Film Music in the Early Sound Era, 1926–1934
 Michael Slowik
"It's the Pictures That Got Small": Charles Brackett on Billy Wilder and Hollywood's Golden Age
 Edited by Anthony Slide
Plastic Reality: Special Effects, Technology, and the Emergence of 1970s Blockbuster Aesthetics
 Julie A. Turnock
Maya Deren: Incomplete Control
 Sarah Keller
Dreaming of Cinema: Spectatorship, Surrealism, and the Age of Digital Media
 Adam Lowenstein
Motion(less) Pictures: The Cinema of Stasis
 Justin Remes